A Brief History of the Masses

Columbia Themes in Philosophy, Social Criticism, and the Arts

Columbia Themes in Philosophy, Social Criticism, and the Arts presents monographs, essay collections, and short books on philosophy and aesthetic theory. It aims to publish books that show the ability of the arts to stimulate critical reflection on modern and contemporary social, political, and cultural life. Art is not now, if it ever was, a realm of human activity independent of the complex realities of social organization and change, political authority and antagonism, cultural domination and resistance. The possibilities of critical thought embedded in the arts are most fruitfully expressed when addressed to readers across the various fields of social and humanistic inquiry. The idea of philosophy in the series' title ought to be understood, therefore, to embrace forms of discussion that begin where mere academic expertise exhausts itself, where the rules of social, political, and cultural practice are both affirmed and challenged, and where new thinking takes place. The series does not privilege any particular art, nor does it ask for the arts to be mutually isolated. The series encourages writing from the many fields of thoughtful and critical inquiry.

Lydia Goehr and Daniel Herwitz, eds.
The Don Giovanni Moment: Essays on the Legacy of an Opera

Robert Hullot-Kentor
Things Beyond Resemblance: Collected Essays on Theodor W. Adorno

Gianni Vattimo
Art's Claim to Truth
edited by Santiago Zabala, translated by Luca D'Isanto

John T. Hamilton
Music, Madness, and the Unworking of Language

A Brief History
of the Masses

[Three Revolutions]

Stefan Jonsson

Columbia University Press
New York

Columbia University Press
Publishers Since 1893
New York Chichester, West Sussex

First published by Norstedts, Sweden, in 2005 as *Tre revolutioner: En kort historia om folket 1789, 1889, 1989.* Copyright © 2005 Stefan Jonsson. This text published by agreement with Norstedts Agency.

Cover and interior art by James Ensor © 2008 Artists Rights Society (ARS), New York/ SABAM, Brussels.

English Translation copyright © 2008 Columbia University Press

Library of Congress Cataloging-in-Publication Data
 Jonsson, Stefan, 1961–
 [Tre revolutioner. English]
 A brief history of the masses : three revolutions / Stefan Jonsson.
 p. cm. — (Columbia themes in philosophy, social criticism, and the arts)
 Includes bibliographical references and index.
 ISBN 978-0-231-14526-8 (cloth : alk. paper) —
 ISBN 978-0-231-51792-8 (e-book : alk. paper)
 1. Art and history—Europe. 2. History, Modern, in art. 3. Social classes in art.
 4. Social movements—Europe. 5. Revolutions—Europe. I. Title. II. Series.

N72.H58J6613 2008
704.9'4990908—dc22 2008000485

Columbia University Press books are printed on permanent and durable acid-free paper.
This book is printed on paper with recycled content.
Printed in the United States of America
c 10 9 8 7 6 5 4 3 2 1

Contents

Illustrations

Color insert follows page 106

A Brief History of the Masses

1789

Jacques-Louis David, *The Tennis Court Oath*

Good citizens are rare.

—BARUCH SPINOZA

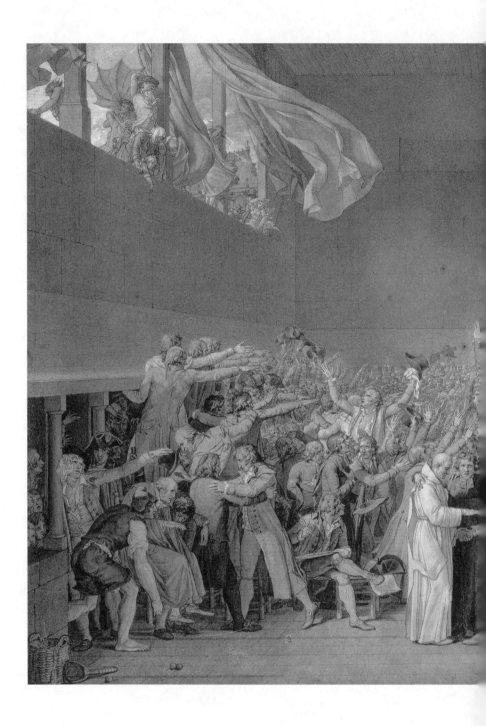

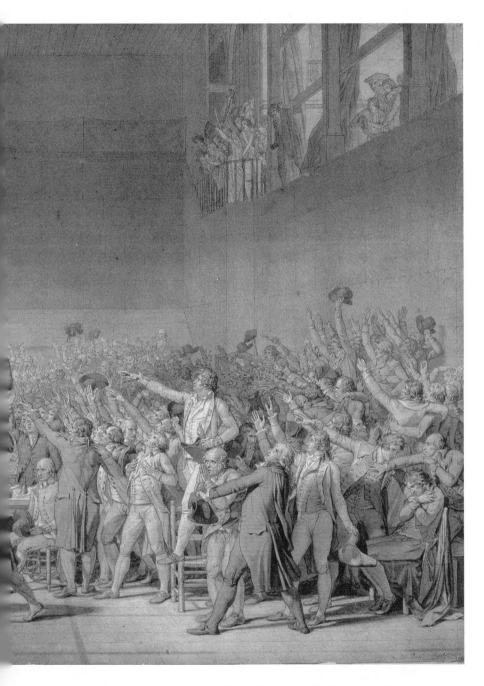

Figure 1.1. Jacques-Louis David, *The Tennis Court Oath* (*Le Serment du Jeu de Paume à Versailles le 20 juin 1789*), 1791–. Versailles, châteaux de Versailles et de Trianon. Photo RMN / © Gérard Blot. Also see color plates.

[1] Seizing the Floor

They are many. Move closer! Let's join the crowd. People are lining up, pressing together, spreading out, piling themselves on top of one another, their bodies suggesting sheer quantity. The ones at the top, waving and cheering through the large windows high on the walls, extend the assembly beyond the depicted hall and pull it toward the open. Who could tell where this human aggregation begins or ends? The National Assembly of France rises over the edges of the image and floods the field of vision (see figure 1.1).

The centrifugal force that expands the assembly outward is countered by a vector going in the opposite direction, symbolized by the innumerable arms stretching toward the center. The man in the middle—the scientist Jean-Sylvain Bailly, slightly elevated above the others as he stands on a table—solemnly pronounces an oath. The other delegates, some six hundred in number, are to swear the oath after him. They are about to promise not to separate until they have crafted a new constitution for France.

The act is explained by the title: *Le Serment du Jeu de Paume, The Tennis Court Oath*. Jacques-Louis David (1748–1825) recognized the gravity of the moment and the enthusiasm it released. He caught history in the making. Faces and bodies are frozen in an instant of the highest emotional intensity. The delegates are possessed by a common mission, which consists in preserving their newly won unity. The oath sworn in the tennis court outside the royal palace in Versailles on June 20, 1789, some three weeks before the storming of the Bastille, marks the beginning of the French Revolution.

A revolution is an event both dignified and rebellious. *The Tennis Court Oath* is at once expansion and contraction, infinite numbers and complete

accord. Language is at a loss as one tries to capture David's visualization of a unity manifesting itself as quantity. But isn't it precisely this peculiar synthesis—the many becoming equal to the one, and the one equal to the many—that presents itself every time we attempt to describe democracy, and especially when we wish to grasp those strange moments, 1789 or 1989, when the power of the people erupts to push history forward.

The pages in this book revolve around size-XXL artworks. At the center of each part is an image seething with idealism. This idealism doesn't spring from the artist's wish to leap out of history or from his willingness to embrace timeless ideals. On the contrary, these three artists have immersed themselves so deeply in society that they have thought themselves able to distinguish the very motor of history, a human power that they all associate with democracy. "Peer through the heart of the people and you will discover truth," Victor Hugo exclaimed in 1862.[1]

My aim in this book is to explore the truth of society as these artists saw it. I also want to discuss how their renditions of the people, democracy, and society disclose blind spots in contemporary discourse on politics and society. The three artists, as well as the arts more generally, offer a lesson on politics that we cannot learn elsewhere, least of all from politicians and political experts. The artists sketch the beginnings of politics: society degree zero. They also gesture toward the ultimate end of politics: a self-sustaining democracy, or a permanent revolution. Power belongs to all.

David calculated that his painting, once completed, would measure at least ten by six meters, or some thirty-five by twenty-five feet. Since the height of the ceiling in his studio in the Louvre was insufficient, the revolutionary government put a small cathedral at his disposal. Why the enormous size? To accommodate all the people, or to make room for the people as a whole. Or, at least, for all the people who counted. How do we know who counts? In selecting his motif and delimiting the surface of the canvas, the painter is also framing his image of society and the people. From his work we learn how a community encloses itself within a boundary in order to view itself as a unity. This book is dedicated to the uncounted and countless ones who have ended up outside the frame. But above all, this book is about the frame, about the ways in which human beings are partitioned, separated, and divided, about the visible and invisible lines drawn through the social terrain that prohibit the majority from approaching the center of the picture.

[2] The Shadow of Democracy

Representations of popular sovereignty were already at the outset accompanied by a shadow. We sense it in David as well—in the unruly and swarming character of his painting. From the French Revolution onward the treasured will of the people has gone hand in hand with the wicked rule of the mob. At the very moment when the people makes its glorious entry, the stage of history is also crowded by its darker double, the threatening mass.

Artists, writers, social theorists, and politicians have often quarreled about how to distinguish the one from the other. Where some have listened to the divine voice of the people, others have heard the raucous masses. Their contempt for the masses has often led them to reject democracy.

When David made his painting, all educated persons took it as self-evident that the majority below them was helplessly dimwitted and irresponsible. They feared the example of the revolution. Expressing their fears, they kept repeating the same words: the mob and the crowd and the mass, *la populace, la foule, la canaille.* Such words evoked moral depravity and political unrest. They bred associations of vandalism and terror, forces that the state must tame, subdue, or even annihilate. According to many of the best writers and social thinkers of the nineteenth and twentieth century, it was urgent to define the masses and the threats they posed to society. "The mass" and "the masses" soon became scientific concepts, upheld as objects worthy of investigation. "The mass" and "the masses" also turned into stereotypes that fueled hazardous political fantasies. Regardless of what these masses have looked like in reality—indeed, regardless of whether they have ever really existed—they have lived a life of their own in intellectual history, in political traditions, and in art, literature, theater, and cinema. And they go on living there, though they carry new names.

The mass is a pliable matter. Or to be more precise, the "mass" is a word that has been bent and stretched in all conceivable directions. Already during the decades after David's attempt to visualize the revolution, the word's usage changed several times, each time attracting new meanings. At first, the mass was associated with quantity, numbers, and population figures. A second phase, "the masses" came to imply those who Victor Hugo called "*les misérables*," the poor and destitute millions at the bottom of society. From 1848 onward, the masses were associated with the organized labor movement. After 1871 and the Paris Commune, finally, the masses were defined as pathological elements. A number of influential scientists and social theorists now asserted that the lower classes ran the risk of being contaminated with "mass insanity," an illness characterized by the regression of the rational faculties to the effect that the primitive instincts were set loose. Mental epidemics of this kind afflicted all human beings who appeared in groups or acted collectively, and the disease was most common in the politically organized part of the lower classes, these experts argued. Here, in its fourth phase, the mass was identified as a band of fools.

But I'm getting ahead of my argument.

[3] The Number of People

The British historian E. P. Thompson opens his classic work *The Making of the English Working Class* by discussing the founding document of the London Corresponding Society from 1792. Behind this society were "Tradesmen, Shopkeepers, and Mechanics," who wished to promote parliamentary reforms that would extend voting rights to the common people. Thompson quotes the first of the leading rules that Thomas Hardy, secretary of the society, and a shoemaker by profession, set down in print: "That the number of our Members be unlimited."[2]

Today, such a rule appears as an empty statute: not so in England of 1792. As the London Corresponding Society invited "unlimited numbers" to further political reforms, it presented a revolutionary challenge to a governmental system in which political rights were tied to rank, name, title, and wealth. Thomas Hardy was promptly sentenced on charges of high treason and sent to the Tower. E. P. Thompson writes that the first rule of the London Corresponding Society is "one of the hinges upon which history turns."[3]

History turns from a world in which political decisions were made by an exclusive elite behind closed doors to a world in which political participation is open to all. History turns from a system where political representation was based upon inherited social identities to a system in which political representation is based on the principle of equality of all citizens, regardless of what identities society has ascribed to them. History also turns toward more abstract forms of power: whereas the sovereign formerly manifested himself in regal symbols and lavishly ornamented ceremonies, the new sovereign is a phantom whose qualities can be discerned only through the bare fact of numbers.

The reason for this abstraction process lies in the modern concept of

democracy, which requires that the social body be broken down into numeric units. Popular sovereignty extends political rights to every member of the people. These rights are derived from no other source than the bare fact of inclusion into the polity. Therefore, no citizen can have greater or lesser political rights than any other. Such is democracy's principle of equality: it equalizes each human being, making him or her independent of all differences concerning class, wealth, talent, faith, and identity. But it also makes him or her exchangeable. Deprived of substance, the individual is posited as a pure political subject. Correspondingly, society is desubstantialized, freed from the ties of traditions and organic communities that once gave it shape and weight. As the human being is liberated from older social bonds, society seems to disintegrate. From now on, society is understood as the sum total of a number of similar individuals equipped with similar rights.

It is a strange turn of history. At the very moment when sovereignty is transferred to the people, the people loses its essence. Its character as a dense and organic human community evaporates, and the people henceforth makes itself known only as a series of abstract units added up according to arithmetic principles.[4]

There is an elective affinity between democracy and numbers that in today's era of opinion polls has become so self-evident that we have stopped thinking about it. At the end of the eighteenth century, the relation between the power of the people and the power of numbers was newly discovered and liberating. To the political explosion of 1789 was paired an eruption of counting, an enthusiasm for numbers, which in retrospect has struck many as bizarre. The best-known case is the invention of a new way to count time, the revolutionary calendar, in which the week had ten days, the months were renamed, and human history made a clean break and started anew from year One. Another instance is the initial plan for an administrative reform of France, submitted to the National Assembly in September 1789. The commission that studied the issue suggested that France be divided into eighty-one identically square *départements*, each of which should be divided into nine equally square cantons.[5] Are they going to erase all natural boundaries and beautiful landmarks and replace them with geometrical abstractions? the British philosopher Edmund Burke asked horrified.[6] In their revolutionary spirit, the French also standardized their measures, in this case with lasting result. The old measures of length and distance that had been derived from the human body—the extension of the thumb, hand, and foot, or the distance traveled a day on foot or on horseback—were discarded and replaced pre-

cisely by a geometrical abstraction, the meter system, which proclaimed equality in the realm of space.[7]

The revolution was a period of "statistical imperialism," says the historian Louis Chevalier. He relates the following story from year IX (September 1800–September 1801). A mayor in the provinces was asked if he really could provide all the statistical data demanded by the government. "I will carry it out, and I would carry it out ten times more if I was ordered to," the mayor answered. "If the government asked me to find out the number of birds flying over the surface of my region each year, I would tell them on the spot that I would not err on a single lark."[8]

When confronted with the problems of representing history and society, the *lumières* and *ideologues* of the late eighteenth century tended to seek mathematical solutions. "Political arithmetic" was a common designation of inquiries into the relationship between demographic facts and social conditions.[9] The scientist Buffon investigated the relation between agricultural production, birth rates, mortality rates, and other social factors in what he called a "moral arithmetic."[10] The mathematician Condorcet for his part envisioned a "social mathematics," believing that conflicting social interests could be resolved by applying statistical calculations and laws of probability.[11] When Emmanuel Joseph Sieyès, who is also among the delegates in David's painting, argued for political reforms in his highly influential pamphlet *What Is the Third Estate?* (*Qu'est-ce que le tiers état?* [1789]), he relied on numeric evidence to prove that the bourgeoisie represented the general interest of the French nation. While the estates of the nobility and the clergy only represented their own members, or 200,000 people combined, the third estate spoke for all the rest, approximately twenty-five million people, who were all deprived of political influence, Sieyès calculated.[12]

A generation later such exercises in calculating social data were refined by Adolphe Quételet, the founder of population statistics in the modern sense. Quételet collected all relevant demographic and biometric data of a given population. He then computed the average for each parameter. By adding these averages together he successfully fabricated an image of average man, *l'homme moyen*, around which all individuals of a given population are statistically distributed. Quételet believed he had discovered the golden mean of the human race, a human model valid at all times and in all places.[13]

Quételet's conception of *l'homme moyen* offered a solution to the problem of describing and representing the people. "Average man" serves as a mirror in which a given population may contemplate an ideal statistical

reflection of itself, purged of individual aberrations and signs of social and regional origin. Average man thus establishes a standard of commonality, a universal norm that may be claimed by any human agent seeking to establish itself as the true face and voice of the popular will. The class or party that is able to associate itself with the general standard of the people may go on to reject other groups by describing them as undesired and corrupted forms of the pure and proper stock. In this view, failure to conform to *l'homme moyen* may be exploited as a stigma. "Average man" becomes a measure and a ruler, marking the boundary between the true members of the community and others.

Quételet also presents us with the first definition of the legendary man in the crowd, or the mass man. We all know him from countless novels and films: the evasive creature that populates the world of modernity, the person who never stands out and always disappears into the background. *L'homme moyen* is also a man of the crowd in the sense that he is produced by a social imagination that presupposes a radical abstraction of society. For in order to construct *l'homme moyen*, the concrete population of men and women, with their different identities, professions, and qualities, must be decomposed into smaller units that can be measured and compared and finally transposed into numeric entries in statistical calculations, from which there emerges, through a mysterious act of regeneration, the Average Human Being. The social imagination at work here is essentially similar to the democratic imagination of the revolution, which decomposed an allegedly natural order, leveling social hierarchies and abolishing feudal privileges in order to redefine the human being as a free individual equipped with inalienable rights and to define the people anew as a community of equals.

The discovery of the power of number, as recorded in political treatises and in the social imagination more generally around the end of the eighteenth century, also led to an intensive debate about the masses. Just a light tuning of the terms is needed—and, as we shall see, Edmund Burke is the first one to show how—to move from the idea that democratic society is ruled by "numbers unlimited" to the view that it is ruled by the many, by the multitude, or by the mass.

At the time of the French Revolution, these terms belonged primarily to the mathematical domain. In 1789, the English word "mass," like the French "*masse*," denoted a large unspecified quantity of any substance. With the advent of the revolution's democratic aspirations, social observers and political theorist began using these mathematical words to render

the presence of the unlimited numbers of people who suddenly intruded upon the political arena.

Of course, the masses did not emerge as the simple effect of the rise of democratic ideas. Rather, to put the matter in correct historical sequence, democratic ideas emerged at this time because innumerable people, or masses of people, asserted their presence in society. As industrialization and capitalism eroded the guild system and transformed rural patterns of life, uprooting peasants, artisans, and laborers and releasing the great migration from country to city, a handful of European cities became urban and industrial centers, their inhabitants living in dense concentrations and their social classes so closely juxtaposed that they could not avoid stepping on the toes of one another. Although wealthier citizens locked their doors, withdrew into their apartments, and closed their velvet curtains, they could not, in the long run, evade the smoke from the industrial plants, the factory horns that marked the rhythm of the working day, or the sights, noises, and smells of the populous working classes.

But with this description we have already arrived in the archetypical universe of modernity: the metropolis, with its collisions of events, classes, accents, professions, and lifestyles. In this sense, nineteenth-century Paris came to symbolize a world of discontinuities, contrasts, unexpected encounters, sudden accidents, and urban adventures—a spirit of the modern first registered and affirmed by Charles Baudelaire: "The pleasure of being in a crowd is a mysterious expression of sensual joy in the multiplication of Number. *All* is Number. Number is in *all*. Number is in the individual. Ecstasy is a number."[14]

The urban world that so entranced Baudelaire was the same one that filled Gustave Flaubert with disgust: "one element prevails to the detriment of all the rest: *Number* dominates over mind, education, race, and money itself—and even *that* is preferable to *Number*."[15]

However, at the time Baudelaire and Flaubert wrote these lines, that is, around the middle of the century, the crowd had already become far more than a question of numbers. "The mass" is a magnetic term. During the first half of the nineteenth century it rapidly accrues new meanings. It, too, belongs to the hinges of the past mentioned by E. P. Thompson. "The masses" is one of the terms around which modern history turns.

[4] The Swinish Multitude

Edmund Burke's *Reflections on the Revolution in France* was published in November 1790 and immediately stirred controversy. In England, an intense debate broke out over Burke's verdict against France's newly won freedom, and prominent writers like Tom Paine and Mary Wollstonecraft took pen in hand to repudiate his pamphlet.

Burke's accomplishment, if that is what it is, was to link together the idea of a social order founded on numeric might with the fear of social chaos and violence.

The revolution tore apart the social fabric by violating its sacred institutions: king, church, and property. According to Burke, these institutions were "natural" because they were inherited—"derived to us from our forefathers, and to be transmitted to our posterity."[16] Subjection of the common people was a natural part of this sacred order, Burke wrote:

> Good order is the foundation of all good things. To be enabled to acquire, the people, without being servile, must be tractable and obedient. The magistrate must have his reverence, the laws their authority. The body of the people must not find the principles of natural subordination by art rooted out of their minds. They must respect that property of which they cannot partake. They must labour to obtain what by labour can be obtained; and when they find, as they commonly do, the success disproportioned to the endeavour, they must be taught their consolation in the final properties of eternal justice.[17]

In Burke's time, it seemed reasonable to compare different social groups with different animal species—"for each kind an appropriate food, care, and employment." It was foolish to treat "sheep, horses, and oxen" as if

they were one and the same species, "to abstract and equalize them all into animals," Burke maintained.[18] But such was precisely the madness of revolutionary France, he continued. France's new leaders have "attempted to confound all sorts of citizens, as well as they could, into one homogeneous mass."[19] Blinded by their democratic delusions, they have induced common people to think themselves equal to their masters and they have thus been "authorizing treasons, robberies, rapes, assassinations, slaughters, and burnings throughout their harassed land."[20]

Burke's reflections move on two levels. He presents a theoretical argument concerning the dangers of putting abstract notions of liberty and equality in the stead of inherited institutions. He also reports on current events in France, emphasizing its most violent ingredients. In Burke's text, these two strands merge and diverge according to a logic of their own. The author imperceptibly shifts from intellectual analysis to emotional reflexes. Sometimes the leap takes place between two sentences in a running argument: "It is said, that twenty-four millions ought to prevail over two hundred thousand. True; if the constitution of a kingdom be a problem of arithmetic. This sort of discourse does well enough with the lamp-post for its second: to men who *may* reason calmly, it is ridiculous."[21] In this way, Burke dismisses Sieyès's statistical argument for democratic reforms by associating it with a couple of rare criminal cases from the summer of 1789, when officials were seized and hanged from lamp-posts.

Each time Burke approaches the current situation in France, his voice loses its moderation and gets a higher pitch. Marked by a rhetoric of fear, the discourse starts to reek. This culminates in his account of October 6, 1789, when working-class women of Paris and the National Guard marched to Versailles to force the king and queen to return to the capital. It was passages like the following one, where each piece of information is either invented or distorted, that made many of Burke's contemporaries dismiss his book as caricature:[22]

Instantly he [the sentinel guarding the queen's quarters] was cut down. A band of cruel ruffians and assassins, reeking with his blood, rushed into the chamber of the queen, and pierced with an hundred strokes of bayonets and poinards the bed, from whence this persecuted woman had but just time to fly almost naked, and through ways unknown to the murderers had escaped to seek refuge at the feet of a king and husband, not secure of his own life for a moment. This king, to say no more of him, and his queen, and their infant children (who once would have been the pride and hope of a great and generous people) were then

forced to abandon the sanctuary of the most splendid palace of the world, which they left swimming in blood, polluted by massacre, and strewed with scattered limbs and carcasses.[23]

Burke does not use the word "crowd" in his account of the revolution. He also does not use "the masses" in its modern pejorative sense. In 1790, "mass" and "masses" are still neutral terms designating unspecified quantities of people or things.[24] Instead, in rendering the acts of the people, Burke uses a baroque and premodern idiom, sometimes sinister, sometimes condescending. "The mob" appears on every other page. The supporters of the revolution are compared now with savages, now with wild beasts, now with ignorant children. The one canonized expression is "the swinish multitude."

Still, Burke should be counted among the first modern analysts of mass politics and crowd behavior. His *Reflections on the Revolution in France* paved the way for an idea that was gradually modified and sharpened during the following decades, and at the end of the nineteenth century it was finally presented as a scientific theory under the name of mass psychology.

In this first incarnation, the masses name the result of a process in which the new principles of democracy and equality flatten out all hierarchies and transform society into a level field where exchangeable human atoms—so-called individuals—aggregate into larger units. In this view, individual and mass are not opposites, for they relate to each other as the singular to the plural. A similar view of the mass as sheer quantity returns in Alexis de Tocqueville's *Democracy in America* (*De la Démocratie en Amerique*, published in two parts in 1835 and 1840). Tocqueville analyses the rise of the masses and the birth of individualism as two aspects of one and the same process of abstraction. "Aristocracy had made a chain of all the members of the community, from the peasant to the king," he argues. Democracy, by contrast, "breaks that chain and severs every link of it."[25]

If Tocqueville weighed the pros and cons of this transformation, Burke abhorred it. According to Burke, democracy's abstract notion of humanity and its principle of majority rule were to blame for the collective violence that followed in the wake of the revolution. After Burke, "the mass" could no longer be taken as a neutral designation of large quantities, but the term now also pointed in a different direction. On the one hand, "the mass" referred to the presence of numberless collectives within politics. On the other hand, "the mass" alluded to the violence and unrest that often erupted when the lower classes acted politically to protest against injustices. These two phenomena were sealed together by Burke; ever since,

it has been impossible to take them apart. They will not uncouple because around 1789 there emerges a discourse about society, which Burke is the first one to systematize, in which political collectives and social unrest are seen as intrinsically related. For instance, Tocqueville connects numbers unlimited to lynchings and debauchery in his chapters on what he calls "the tyranny of the majority." According to the French thinker journeying through America, the prototypical expression of majority rule is the rioting mob.[26]

From Burke onward, this will now be the primary function of the rhetoric on the masses: it ensures that the political influence of collective movements automatically calls forth the specter of violence, and it ensures that all kinds of political violence automatically call forth proposals to restrict the political influence of collective movements. There emerges in the public mind an associative link that makes democracy look dangerous.

This somber interpretation prevailed. Not only Burke and Tocqueville, but also most political philosophers of the Enlightenment, claimed that democracy entailed a society in which law and state were subordinated to the explosive passions of the majority. The rule of the people was arbitrary and unpredictable. The founders of the republican governments in the United States and France therefore invented an alternative to democracy: "the representative system." In theory, this system meant that political power was delegated to society's most able and far-sighted groups. In practice, it licensed political rule to a limited circle of tax-paying male citizens who chose public officials and delegates among themselves by casting votes at regular intervals. With the introduction of "universal" suffrage and women's suffrage, this system was gradually extended to the adult population as a whole. So it is that the representative system today identified as democracy, and commonly celebrated as the only legitimate form of democracy, is rooted in a political system that was invented in explicit rejection of democracy.

In today's cultural and political environment, we have scarcely retained the ability to imagine what democracy would have meant two hundred years ago: the rule of all by all in a community where the relations of representatives to represented are direct. Embracing the safer and more predictable alternative of the representational system, the founding fathers of the French and American republics made no excuses for their preference. Democracy was a dangerous thing and had to be avoided by all means.

[5] Social Depths

Masses don't write memoirs. Who stormed the Bastille? What made them act? What did they think? Who are "the masses"? Those who are indicated by that word, or are concealed behind it, have left few declarations behind. Little documentary evidence testifies to their motives. By excavating the archives, historians have still managed to catch a glimpse of the anonymous agents of the revolution, and they have identified some of the men and women who were part of the revolutionary crowds. By studying court proceedings, police records, and documents from other authorities that concerned themselves with the lower classes, historians have also been able to establish that the popular uprisings during the revolution follow the usual patterns of human action. Like human affairs in general, they are determined by multiple pressures and concerns. As soon as historians zoom in on the mass, it loses its presumed homogeneity, dissolves into a maze of contradictory motivations and plans, until it finally stands revealed as the great simplification it always was.[27]

The British writer Thomas Carlyle was conscious of this dilemma. How to discern a meaningful pattern in the historical processes that transformed France within the span of a few brief years, without reducing the real historical agents to mere representatives of the collective forces that were set in motion? In *The French Revolution*, published in 1837, Carlyle stressed the poor fit of the crude categories of political philosophy to history's raw material:

> With the working people, again, it is not so well. Unlucky! For there are from twenty to twenty-five millions of them. Whom, however, we lump together into a kind of dim compendious unity, monstrous but dim, far off, as the *canaille*; or, more humanely, as 'the masses.' Masses indeed:

and yet, singular to say, if, with an effort of imagination, thou follow them, over broad France, into their clay hovels, into their garrets and hutches, the masses consist all of units. Every unit of whom has his own heart and sorrows; stands covered there with his own skin, and if you prick him, he will bleed. . . .—what a thought: that every unit of these masses is a miraculous Man.[28]

In its original version, Carlyle's book carried the subtitle "A History of Sansculottism," an indication of the author's plan to let the common people, *les sans-culottes*, play the leading role in his narrative. True enough, the oppressed classes occupy a central place in Carlyle's account, but this is not because of their own virtues or political strivings. Rather, the sans-culottes appear as a tool in the hands of an ideological force that has all the attributes of a metaphysical power. For *The French Revolution* is not historical writing of the ordinary kind. It is an allegorical epic in which the revolution provides the occasion for developing a cosmogonical vision of history as a struggle between superhuman elements. In Carlyle's view, it is these elements, not human action per se, that determine the fate of humankind from creation to the last day.

We know that Hegel saw the revolution as an expression of the World Spirit, which used the people as its tool. In a similar way Carlyle transforms the laboring millions of France into a collective force called "Sansculottism." He draws a straight line from the bare fact of Number, or demographic conditions, to fantasmatic powers such as the Uncontrollable, the Immeasurable, and the Anarchic. Flesh-and-blood humans are toys in the hands of these anonymous forces, preventing the real historical actors from coming into view.

Carlyle sees the political actions of the masses as a force of destruction, dissolving all social hierarchies and institutions in a whirlwind of numbers. But in contrast to Burke and Tocqueville, who judged the destructive force of the people as a blunt violation of the natural rights of property and inheritance, Carlyle interprets the "destructive wrath" of Sansculottism as a divine and primordial force, the results of which he rendered in passionate prose typical of European romanticism:

[The] French Revolution means here the open violent Rebellion, and Victory, of disimprisoned Anarchy against corrupt worn-out Authority: how Anarchy breaks prison; bursts up from the infinite Deep, and rages uncontrollable, immeasurable, enveloping a world; in phasis after phasis of fever-frenzy;—till the frenzy burning itself out, and what elements

of new Order it held (since all Force holds such) developing themselves, the Uncontrollable be got, if not reimprisoned, yet harnessed, and its mad forces made to work towards their object as sane regulated ones.[29]

Carlyle also likened the revolutionary French people to a "World-Phoenix." He characterizes Sansculottism as "many-headed" and "fire-breathing." Rising in the fire of the netherworld and consummating itself in the same fire, it takes the ancien régime with it into the flames: "skyward lashes the funeral flame, enveloping all things: it is the Death-Bird of a World."[30] Which is to say that it brings another world into life. In the flames of the revolution, Carlyle the romanticist saw Aurora, the morning star, shining. After the assault of the masses, history would begin anew.

[6] The Hydra

In Jacques-Louis David's image of the revolution, the figures are ordered along a horizontal axis that stretches from one edge of the canvas to the other. Let's call it the axis of equality. No one rises above the rest—no one except for Bailly, the chair of the Assembly, who dictates the oath. By pressing as many people as possible into the visual plane, David suggests that the emerging democratic system is based on numeric might. By rendering the precise moment when everybody's attention is turned toward Bailly, the artist furthermore transforms the multitude of heads and figures into one body, thereby inventing a visual equivalent of the concept of democratic sovereignty, which stipulates that the many be made into one single constituting power. *The Tennis Court Oath* is an altarpiece devoted to society's new sovereign.[31]

How does David create the impression of a boundless quantity manifesting itself as a magnanimous union? If we take a closer look at the painting, we may identify some of the aesthetic oppositions and political contradictions that he keeps in equilibrium. Art historians have pointed out that David apparently was motivated by two different aims.[32] He wanted to record a real historical event, including portraits of the some six hundred people present. At the same time, he wanted to eternalize the assembly by transforming it into a timeless ideal, that is, into a work of art, as can be seen in the neoclassical composition of the gestures and postures of the various delegates. This stylistic tension between an idealist principle of composition and a realist intention is amplified by an opposition that appears in the manifest content of the image. The painting seems to portray the common will as a contractual matter that the delegates affirm in a spirit of sober and rational deliberation, yet at the same time it renders a spontaneous outburst of patriotism rooted in deep political

passions. This combination of rationalism and irrational passions, in its turn, is connected to a structural opposition in the formal construction of the image. The hall in which the persons are placed is firmly divided by distinct lines of perspective, a clear separation of back- and foreground, and a marked segmentation of the visual space in the foreground. The image appears to be organized by a geometric matrix that ties each figure to a certain place and role in the great drama. Yet, the figures' physiognomies indicate that this is a collective about to explode in a moment of immense passion: cries of enthusiasm, gaping mouths, eyes brimming with tears, bodies embracing and hands holding hands, faces possessed by epiphanies and revelations. Just to the right of Bailly in the middle, a figure beats his breast with his fists, his gaze fixed at a distant point in the sky, as though seeing something in the clouds outside the windows. It is Maximilien-Marie-Isadore de Robespierre, apparently carried away by his private vision. No, this assembly is not ruled by reason alone.

David produces a crossing between a well-ordered parliamentary assembly and a raging mob. This opposition reveals an ultimate contradiction that discloses the real nature of the painting's historical charge. The French critic Antoine de Baecque has argued that the image can be traced back to two distinct iconographic conventions.[33] First, *The Tennis Court Oath* is influenced by a representative tradition of painting, in which the artist was commissioned to glorify the political ruler: hence all the portraits of righteous individuals and groups of important men that hang in our museums. These dignitaries are always figured as harmonious and concentrated, gracefully resting in movement; they are symbolically dressed and carefully positioned on the image's surface, so as to make a striking impression on the viewer. Power is transformed into an ideal body, at once potent and beautiful, according to the principles of neoclassicist doctrine.

But David's image also inscribes itself in a lower, if not plebeian tradition. In David's time, popular prints often caricatured the aristocracy and the royal court as a many-headed hydra. The monarch and his closest allies, usually the royal family, the cabinet, and members of the aristocracy, were pictured as so many rattling heads on the wild beast. At the time when David prepared *The Tennis Court Oath*, he was also projecting a painting for the city of Nantes that was to include "the hydra of despotism." De Baecque convincingly argues that the image of the National Assembly has absorbed the figure of the many-headed hydra. Behind the rendition of calm and enduring fraternity, the viewer senses the shadow of a threatening and uncontrollable lust to revolt. The hydra is resting inside the newborn body of France's democracy, like an intestinal worm.

De Baecque's observations help explain why the image has retained its symbolic allure and today stands out as an icon of the revolution. Incorporating the ideal political body *and* the hydra of despotism into one and the same image, David managed to produce a visual equivalent of the dialectical revolutionary process itself, as it veers from enlightened rationalism to terror, from popular egalitarianism to the dictatorship of the Jacobin elite, and from the scientists' belief in the dry fact of numbers to the regime's foundation of a political cult in which the nation would worship itself as "the Supreme Being." The same ambiguity marks David's visualization of the idea of the people. As he paints it, the figure of the people is composed according to strict symmetrical laws, yet it is also a messy aggregation of heads, bodies, and body parts. The people is sovereign reason; the people is also a contest of passions.

French historian Pierre Rosanvallon writes that the people has two bodies. As he explains, this is because "the people" always refers to two distinct concepts. In political theory and constitutional law, "the people" denotes a unified agent in which sovereignty is invested. In the social sciences, however, "the people" denotes a heterogeneous population, numbers unlimited, that can only be grasped as figures and statistical averages. The people-as-sovereign *is* well defined—a popular vote, a parliament, or a house of representatives, which at once expresses and confirms the principal unity of the people. The people-as-society, by contrast, *are* evasive, abstract, and formless, pure seriality.[34]

Strangely, however, David manages to fuse both concepts of the people into one image. His portrait of the National Assembly renders the people both as ideal and as reality, both as sovereign principle and as a documentary record of a historical event. Herein lies the revolutionary accomplishment of the image. For the French revolution itself is characterized precisely by the fact that the two bodies of the people merge into one. Unifying itself, the heterogeneous and many-headed people are transformed into one political agency that constitutes itself as the sovereign power. To use Pierre Rosanvallon's terms, the people-as-society and the people-as-sovereign fuse into the people-as-event.[35]

Such is the ultimate horizon of David's image—the reason for its immediate success and its enduring value as a visual representation of the revolution, but it is also the reason why the painting just as quickly came to be regarded as a hollow idealization.

An immediate success—in the sense that *The Tennis Court Oath* is in fact one of the few existing images of the people-as-event. David catches a transient historical moment in which the people is identical with itself, its

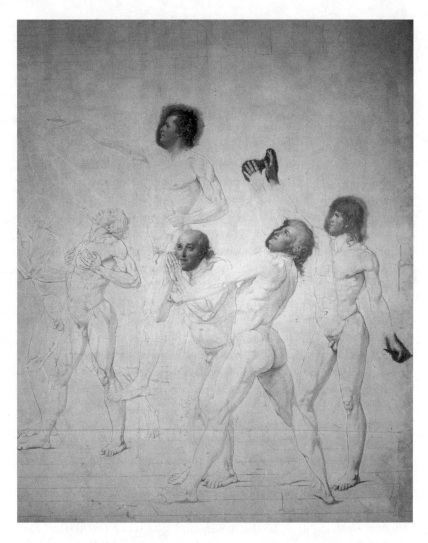

Figure 6.1. Jacques-Louis David, *The Tennis Court Oath* (*Le Serment du Jeu de Paume à Versailles le 20 juin 1789, fond d'architecture de Charles Moreau*), 1791–, sketch. Versailles, châteaux de Versailles et de Trianon. Photo RMN / © rights restricted.

reality embodying its ideal, its multitude fusing into union, and its political passions confirming the principle of democratic sovereignty.

But also a failure—in the sense that the image hides the historical truth, the fact that the two bodies of the people will inevitably separate as soon as the revolutionary moment has passed. The people-as-society will again disintegrate into countless men and women, all of them busy with their own concerns, and it will therefore be impossible to portray them as a unity. At the same time, the idea of the people-as-sovereign turns into an abstraction that is almost impossible to grasp, since the idea no longer corresponds to that concrete human reality from which it once originated.

The people-as-event is transient. Possibly, the primal scene of democracy resists representation altogether. We get a sense of the difficulty that David sought to master once we realize that *The Tennis Court Oath* actually gives us a visual representation of something for which there can be no visual record. The painting renders an oath, a spoken object, a speech act that institutes a new social order. We thus have to imagine David's image as a visual translation into pictorial form of a collective enunciation: we are the people, we hold power.

Needless to say, the sound of these words had vanished long before David had even begun to paint. The divorce between the two bodies of the people, and between representatives and represented, was soon irreparable. *The Tennis Court Oath* remained an enormous swath of empty canvas. The canvas has been preserved, along with some of David's preparatory sketches, which allow us to follow the painter's work process. On the unfinished canvas, he has laid out the interior of the tennis hall and the contours of the delegates' bodies with clear lines in ink and crayon. The only areas that have been painted in oil are four faces in the foreground (see figure 6.1). These four heads hover like flying saucers above an empty, sepia-colored surface. They seem to have lost their connection to the now absent body of democracy. They are cut off from the revolutionary community, which existed on that day in June 1789 but which then scattered so fast that David never had the time to dress it for eternity.

[7] Marianne

The summer of revolution is short. Few writers and artists have had time to step out of their studies or studios to participate as society is celebrating its unity and claiming that unity as a portent of a coming age of justice. Those who have managed to record their impressions of such events are even fewer. Long before their time-demanding work is completed, the revolutionary momentum has stalled, and power has again congealed in new molds.

People who at young age have experienced the spontaneous outburst of the popular will have often reported that the trembling stays with them forever. Sometimes they spend the rest of their lives working through that unsettling encounter with the democracy of the street, and comrades who once walked arm in arm may some decades later draw conclusions about that encounter that are diametrically opposed to each other.

In the history of art and literature, the best attempts to represent popular sovereignty emerge in such historical periods, when society, as though resetting itself, turns back to zero. This is to say that aesthetic representations of society follow roughly the same historical cycles as constitutional representations of society do. In political history, we read about crises of legitimacy and crises of representation, that is, times of indecision and uncertainty concerning the ways in which society should be represented and its representatives appointed. Such are the times of revolution, when political leaders sit down with philosophers and legal experts to draft new constitutions and constitutional amendments, remaking the political outfit of the democratic community.

The arts, too, undergo crises of representation. Aesthetic traditions sometimes crumble as suddenly as states, and artists and writers are forced to rethink the aesthetic devices, narrative forms, and symbols

through which they have portrayed society. This is why we sometimes speak of cultural revolutions. It is often said that the arts are politicized by such events. But the arts are always politically charged, they are always *in* politics. Rather, we should perhaps say that cultural revolutions are great moments of aesthetic reflexivity. The arts turn back on themselves, interrogating how their modes of representation and their artistic institutions relate to the surrounding history—much in the same way as politicians and citizens are forced to assess whether existing political institutions really correspond to the general will.

In times of greater stability, when the citizens voluntarily allow themselves to be represented by a national assembly, a parliament, or a head of state, the people also disappear from images, books, and newspapers. But not quite. Their presence is often asked for to confer legitimacy upon the power of their leaders. Hence the faceless ranks of soldiers and the sea of onlookers in the great historical paintings; hence the common men and women walking in and out of the realist novels as secondary characters. They have a small but a necessary duty to fulfill: posing as a cheering audience, they affirm the deeds of the heroes—much in the same way as the people at regular intervals are called to the voting booths, in order to confirm the existing government or transfer power to a new one. For all other purposes, the people disappear behind the mechanisms of representation that were set in place to manifest their presence.

Why was Jacques-Louis David unable to complete his great celebration of the revolution? He was at it for a full fifteen months, in 1791 and 1792. But he never got beyond that empty canvas, with its lines in ink and crayon and the four free-floating heads in oil. "The sports of the revolution turned all my ideas upside down," David noted retrospectively in 1798. "Public opinion, which for some years was fleeting and unpredictable, my own misfortunes, as well as other circumstances made my brushes stiff."[36]

What's left of the project today is not only the large empty canvas but also a small oil painting hanging in the city museum of Paris, Musée Carnavalet, in addition to a number of preparatory sketches and drawings kept in an attic of the Versailles Palace. The most significant piece of this material is a large etching exhibited in the Paris salon of 1791 (figure 1.1). It was produced to serve as a master copy for a printed edition to be offered on subscription. The revenue from the sales would pay for the production of the main oil painting, David calculated.

Already at that point, however, the union between power and people shown in *The Tennis Court Oath* was torn to pieces. This was partly due to the internal fragmentation within the political class. The ties between

the sworn delegates of the third estate in the miraculous summer of 1789 soon dissolved, and many of the individuals that David planned to incorporate into the revolutionary assembly fell into disrepute or were retired, detained, or executed.

The disuniting of the assembly was linked to the general instability of revolutionary France. Different fractions and individuals made competing claims to act as custodians of the public interest. The decision to abolish monarchy and proclaim a republic, passed by the national convent in August 1792, polarized the country. Half a year later, the conflict escalated as the convent decided, by a tiny majority, to condemn Louis XVI to death for having conspired against the French people. The guillotining of the king, or the regicide, as Edmund Burke called it, sent shock waves throughout Europe, giving the young republic additional enemies both domestic and foreign. In the state of emergency that ensued, the governing Jacobins went to extremes, relying as much on repression as on propaganda to consolidate what the revolution had accomplished. The period has gone down in history as the Terror. Looking for support for their often draconic measures against royalists and counterrevolutionaries, the Jacobins no longer trusted the bourgeoisie, long the vanguard of the third estate, but relied on the grudging and insurrectionary urban majority. The delegates of 1789, including wealthy men like Bailly, Mirabeau, and Sieyès, were no longer credited as loyal spokespersons of the people but appeared as a privileged circle, too far removed from the suffering majority. The Tennis Court Assembly was thus stripped of its aura of popularity. To make matters worse, many of the delegates of 1789 had in fact sided with the king, supporting as they did a reformed system of monarchic rule. Four years later, the governing cabinet looked upon these delegates as traitors.

David was himself a leading member of the Jacobin party. In 1792 and 1793, it would have been ideologically foolish of him, if not plainly suicidal, to glorify the delegates of the 1789 National Assembly as the incarnation of the French people.[37] The will of the people was no longer personified by the delegates on the floor but by the onlookers of common men and women standing in the upper wings of the image: shop owners, clerks, chamber maids, conscripted soldiers, servants, artisans, or, in short, the *sans-culottes*.

Among the audience in the windows, David placed a historical person who is easily recognizable because of his facial traits and his tools. On the balcony at the top right is a man with pen and paper (figure 7.1). At first sight, it looks like he is taking notes or reading the newspaper. The man

is Jean-Paul Marat, publisher of *L'Ami du peuple*, one of the most radical organs of the revolution. David situated Marat in a symbolic position. The writer is quite literally standing on the border. He does not belong to the delegates on the floor but has his place in the periphery of the political arena, reporting to the people outside about the events taking place inside. More than any revolutionary leader, Marat was hailed as the voice of the people. When he was assassinated in July 1793, he immediately became the martyr of the revolution. In fact, he may be the first in a long row of modern political martyrs whose deaths have given rise to instant cults—Abraham Lincoln, Emiliano Zapata, Mahatma Gandhi, Che Guevara, John F. Kennedy, Salvador Allende, Olof Palme.

The martyrdom of Marat was in part the work of David. In the summer of 1793, he had interrupted work on *The Tennis Court Oath*. The shocking assassination of Marat reignited his calling as the chronicler of the revolution, and he set out to eternalize the popular leader. *Death of Marat* (*Marat assassiné*; figure 7.2) was soon completed, and just as soon it became David's most famous revolutionary painting. It is one of the most enigmatic images in the history of modern art.[38] The dying Marat is sitting in his bath tub, clasping his pen. Seconds before, young Charlotte Corday, devoted royalist, has sneaked into his apartment and up behind his back to stab him in the chest. The blood-stained knife is exhibited on the floor, its handle made of shining ivory. The pen as the weapon of the people, the knife as the weapon of the reaction: David's painting was exhibited on a great podium outdoors as a cult object for the mourning crowds.

In his effort to visualize the popular will, David thus went from picturing the collective (*The Tennis Court Oath*) to picturing the individual (*Death of Marat*). This transformation reflects a historical process in which democracy ceases to be associated with any established political institution, such as the National Assembly. Instead, democracy is now described as intangible and invisible: an atmosphere, a collective passion, a spirit, perhaps even a holy spirit, but above all a popular spirit that spins a secular halo around the head of every devoted *citoyen* and *citoyenne*. As a consequence, capturing democracy in visual form becomes deeply problematic because from now on it is spread across the entire territory of the French nation, as amorphous as social life itself.

In his quest for the true figure of the people, David invented new modes of visual composition and affect. He ventured in two different directions, the first one being the pictorial hagiography, the image of the saint or martyr charged with religious overtones, the second one being conventional allegory, that is, visual personifications of abstract ideals like

Figure 7.1. Jacques-Louis David, *The Tennis Court Oath* (*Le Serment du Jeu de Paume à Versailles le 20 juin 1789*), 1791–, detail with Jean-Paul Marat. Versailles, châteaux de Versailles et de Trianon. Photo RMN / © rights restricted. Also see color plates.

Liberté, Egalité, Fraternité, Patrie, Nation, and Peuple. Indeed, in 1793, David made not only *Death of Marat*. He also painted two more political martyrs, Michel Lepeletier and Joseph Barra, both of them staunch defenders of the revolution, and, just like Marat, victims of counterrevolutionary assassinations. Without any knowledge of the historical context, however, it is difficult to see how these three images differ from artistic representations of Christ's Passion.

David executed these three works outside of his ordinary duties as member of government. His main political responsibility was to organize revolutionary festivals in which hundreds of thousands of people participated as both actors and audience. As director of these festivities, David explored the allegorical method for visually performing democracy. The people was generally represented as a secular divinity, most often as Hercules, a god of Greek antiquity. In one of the sketches produced for these revolutionary feasts, David has the People personified as a Herculean figure enthroned on a chariot pulled by two oxen, Egalité and Fraternité, crushing *l'ancien régime* under their massive hooves. It is an ambiguous image for the same reason that David's paintings of Marat, Lepeletier, and

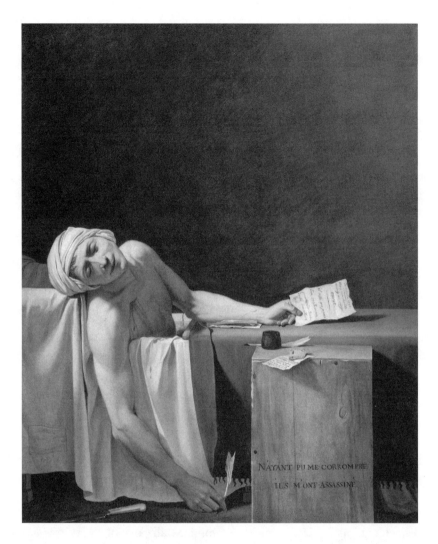

Figure 7.2. Jacques-Louis David (studio), *Death of Marat* (*Marat assassiné*), 1793. Oil on canvas, 165 x 128 cm. Paris, Musée du Louvre. Photo RMN / © Gérard Blot / Christian Jean.

Barra are hard to decipher: when popular sovereignty is personified by a single allegorical body or by a human individual, it becomes difficult to distinguish it from any other leader or form of sovereignty. It is easy to imagine the exact same image of the chariot—but with Caligula or Louis XVI on the throne.

Or Napoleon Bonaparte, why not? When Napoleon seized power and dissolved what remained of the National Assembly, David had no difficulty adapting himself to the new regime. He crowned his artistic career with a series of monumental oil paintings glorifying the rule of the Emperor Napoleon. These paintings—the culmination and fusion of three great traditions of European art, court painting, religious painting, and history painting—remain mounted in their original positions in the Versailles Palace, inviting every visitor to imagine the dazzling complexity and majestic dignity that would have characterized *The Tennis Court Oath* had it ever been completed. Few artists have come as close to the secrets of political power as did Jacques-Louis David. This is true not only of his relationship to Napoleon's regime but even more so of his fruitful collaboration with the revolutionary government. David was intimately familiar with the power of the people, so much so, in fact, that it often seemed as though he was executing that power by the strokes of his brush.

In the following decades, artists struggling with the same task—how to visually represent the sovereign people?—often resolved the problem by placing a female symbol on the throne where David had seated Hercules. Her name could be Germania, Svea, or Brittania, and she served as the personification of the people. It was a smooth solution to an irresolvable problem. The solution was a bit too smooth, perhaps. As woman, the allegorized people posed no threat to power-holding male citizens. As fantasy, she made no intrusion on the bloody realities of statecraft. As symbol, she was nonetheless a rallying point, a unifying force. In Susanne Falkenhausen's concise terms, the feminized allegory of the people appeared as a *corpus mysticum*, sanctioning the male citizens' *corpus politicum*.[39] By the mid-nineteenth century, this visualization of the people had already settled into a firm convention. I'm thinking of Marianne, the woman with the Phrygian cap, flying the tricolor, the political icon of the French republic to this day.[40]

[8] *Les Misérables*

Yes, the summer of revolution is short, and it gradually shifts into the fall of restoration. During the first half of the nineteenth century, David's horizontal representation of the French people as a community of equals will turn into its opposite as French culture becomes saturated with narratives and images that depict the social world as a firm hierarchy in which the classes are layered on top of one another. As the palaces rise above the apartment buildings, as the apartment buildings rise above the workshops, as the workshops rise above the streets and squares of the city, and as these streets rest on soil concealing a dark network of sewers and catacombs—so also is the population of the French capital divided, and in the political life of Paris a similar structure is reproduced.

The melodramatic tales and realist narratives about the Paris of that time still convey a sense of adventure. The restoration period, from the abdication of Napoleon in 1815 to the June revolution of 1830, is typically seen as a period of political backlash, in which the monarchy and the landowning nobility reestablish their positions. In the same period, however, Paris expands enormously, and the growth of the economy accelerates under the reign of Louis-Philippe (1830–1848). The writers of the period compete with one another in mapping the new urban landscape, often describing themselves as daring explorers journeying through unknown territories, which the era of modernity—the factory, the steam engine, the money economy—has populated with a new human race. In this spirit, Balzac establishes an encyclopedia of "Parisian physiognomies," Victor Hugo investigates "the Parisian race," Eugène Sue delves into "the mysteries of Paris." Novels and newspapers sound the depths of society, elaborating a sophisticated array of metaphors in order to render the intricate construction of the social pyramid.[41]

"It is the same with nationality as with geology," writes the historian Jules Michelet. "The heat is below. Descend, and you will find it increases. In the lower strata it is burning hot."[42] In *The History of the Thirteen*, Balzac's narrator spirals downward through Paris until he reaches the blasting furnaces of the netherworld, operated by workers who worship the God of fire and lightning: "Is not Vulcan, with his ugliness and strength, the emblem of this strong and ugly race of men, superb in its mechanical skill, patient so long as it chooses to be so, terrible one day in every century, as explosive as gunpowder, primed with brandy to the point of revolutionary incendiarism." The population living in this underworld, Balzac approximates, "amounts to three hundred thousand souls. Would not the government be overturned every Tuesday were it not for the taverns?"[43]

Energy, numbers unlimited, crime and insurrection: these characteristics are tied together by Balzac as he describes the basement of Paris. The same phenomena structure Eugène Sue's *Les Mystères de Paris* (1842–1843), and they are further magnified in Victor Hugo's *Les Misérables*, published in 1862. The novel is set during the restoration period and culminates with the republican insurrection of 1832. As Hugo attempts to sum up the current state of society, he chooses the underworld as his comparison:

> All human societies have what is known to the theatre as an 'understage'. The social earth is everywhere mined and tunneled, for better or for worse. There are higher and lower galleries, upper and lower strata in that subsoil which sometimes collapse under the weight of civilization, and which in our ignorance and indifference we thread underfoot. The Encyclopedia, in the last century, was a mine very near the surface. The catacombs, that dark cradle of primitive Christianity, lay waiting for the chance to explode under the Caesars and flood the world with light. For in the deepest shadow there is latent light. The volcano is filled with darkness capable of bursting into flame; lava at the start is black. . . . The deeper one goes the more unpredictable are the workers. At the level which social philosophy can recognize, good work is done; at a lower level it becomes doubtful, of questionable value; at the lowest level it is fearsome. There are depths to which the spirit of civilization cannot penetrate, a limit beyond which the air is not breathable by men; and it is here that monsters may be born.[44]

Victor Hugo continues his descent, until he has reached "the lowest level of all, the ultimate underworld." It is a pit of darkness, he explains. It is "the stronghold of the blind. *Inferi*":

Anarchy lurks in that void. The wild figures, half-animal, almost ghosts, that prowl in the darkness have no concern with universal progress, neither the thought nor the word is known to them, nothing is known to them but the fulfillment of their individual cravings. They are scarcely conscious, having within them a terrifying emptiness. They have two mothers, two foster-mothers, ignorance and poverty [*l'ignorance et la misère*], a single guiding principle, that of necessity, and a single appetite, for all the satisfactions of the flesh. They are brutishly and fiercely voracious, not in the manner of a tyrant but of a tiger. By an inevitable process, by the fateful logic of darkness, the child nurtured in misery grows up to be a criminal, and what arises out of that lowest level of society is not the confused search for an Absolute but an affirmation of matter itself.[45]

Hugo's social allegory is elaborated with such fantasmatic creativity that it takes precedence over reality. The reader soon forgets that the reason for this cave expedition was to provide a sociological survey of Paris in the 1830s. Like Thomas Carlyle's history of the French Revolution, Hugo's novel is ultimately a myth. Carlyle described how Sansculottism "bursts up from the infinite Deep." Hugo, for his part, strings all social conflicts to a pillar footed in a dark void, and he situates all his characters somewhere on an evolutionary ladder stretching from the monstrous underworld to the peaks of human civilization.

The key word in the passage above is "*misère*." The term is difficult to translate, because the English "misery" is a mute word compared to its French counterpart. Words like poverty, affliction, distress, suffering, deprivation, or misfortune also do not fully correspond to the meaning of the French word. Evoking an entire human predicament, "*misère*" activates a range of connotations that spread in many different directions. Hugo wanted to comprehend and summarize this predicament in his novel—its first, tentative title was *Les Misères*—and the task was so immense that he needed thousands of pages in order to do justice to his topic.

When Hugo renders *la misère*, his metaphors are drawn toward an imagery of violence and darkness. This condition has a particular feature: Hugo speaks of a "fateful logic of darkness" that transforms misery into criminality. "By an inevitable process . . . the child nurtured in misery grows up to be a criminal."

The historian Louis Chevalier states that during the 1820s and 1830s, "*misère*" was primarily used to explain the allegedly criminal inclinations of certain parts of the population. The dangerous classes, *les classes dangereuses*, were a major obsession of the period. They kept the police busy,

spread fear among the bourgeoisie, aroused the curiosity of many novelists, and provided an inexhaustible supply of material for early crime journalism and sociology alike. Since it was difficult to demonstrate any difference between the background of criminals and the condition of the working people in general, "the dangerous classes" were increasingly identified with "the working classes." The common denominator of both was *la misère*.

"*La misère*" was soon used as an umbrella term, according to Chevalier. It signified crime, poverty, unemployment, homelessness, hunger, suicide, infanticide, prostitution, alcoholism, illiteracy, street children, begging, and all other conceivable symptoms of the material and mental destitution suffered by the Paris majority. "*Misère*" did not denote any one of these phenomena in particular but suggested that they were all connected. For instance, the fact of starvation or poor housing conditions was often seen as causing moral dysfunctions, such as dishonesty and criminality. And conversely: the vile character of the lower classes served to explain why they starved or could not find proper housing.[46]

The problems discussed under the rubric *misère* were roughly the same ones as the organized labor movement would later bring up as *la question sociale*, the social question. During the first half of the nineteenth century, however, misery was rarely seen as a *social* question. More often, working-class misery was attributed to moral degeneration, or it was seen as an inevitable fact of nature. Thomas Malthus's population theory, predicting a ruthless social struggle for diminishing resources, was a constant reference in this milieu. Equally popular were the ideas of Pierre Cabanis, Johann Caspar Lavater, and Franz Joseph Gall, who argued that the class divide had its root in biologically determined and physiognomically detectable differences between various people.

Though most social observers of the era pitied the masses and expressed compassion with their wretched condition, this did not prevent them from asserting that the masses were either undeserving of political rights or incapable of executing them. Honoré-Antoine Frégier provides an illustration of this argument in his influential book of 1840, *Des Classes dangereuses de la population des grandes villes* (The dangerous classes in the population of great cities): "The poor and criminal classes have always been and will always be the most productive nursery for all sorts of wrongdoers: we will designate them more particularly as the dangerous classes, for even when vice is not accompanied by perversity, by the simple fact that it is allied with poverty in the same individual, society should rightly fear him; he is dangerous."[47]

Why are certain classes dangerous? Frégier: "society" has reason to fear them. Why does "society" have reason to fear them? Fregiér: because the combination of vice and poverty makes them dangerous. Such circular arguments are the rule in mainstream political discourse of mid-nineteenth-century France. Hidden inside the rhetorical cover—the bowing before the general will, the honoring of social harmony, the reference to the interests of the poor, the appeal to superior moral principles—is a brutal message, which is revealed in Frégier's terminology: the working classes are not part of "society".

In early-nineteenth-century France, the novel was a step ahead of the press and the social sciences in investigating politics and social life.[48] The novel of that period blended historical overviews, scientific analyses, statistical data, and individual case studies; the universal narrative thus produced was often capped by a clear moral lesson or even by direct proposals for social reform. Victor Hugo had similar ambitions when, in the 1840s, he began to write the novel that would summarize the conditions of French society during the first half of the century. The title that Hugo chose for his novel—the working title was *Les Misères* but he then changed it to *Les Misérables*—indicates that he shared the general opinion about the causes of the social and political problems in his country: the unlimited numbers of poor people who arrived in the capital to find work and who, once they arrived, were swallowed by the faceless majority, begging, laboring, homeless—*les misérables*. Yet, Hugo objected to the predominant view that the working classes were fated to remain outside society forever. The children of misery are wretched, unhappy, defiant, dangerous, criminal, and rebellious—and yet, they are the people of the future, Hugo believed.

> It is above all in the back streets, let us be clear about this, that the real Parisian race is to be found, the pure stock, the true face; in the places where men work and suffer, for work and suffering are the two faces of man. There, in that ant-heap of the humble and unknown, the strangest types exist, from the stevedore of La Rapée to the horse-butcher of Montfaucon. *Fex Urbis*, 'the lees of the city', Cicero called them, and 'mob' was the word. Burke used mob, masses, crowd, public . . . the words are easily said. But what does that matter? What does it matter if they go barefoot, or if they cannot read? . . . Cannot light penetrate to the masses? Light! Let us repeat it again and again—Light and more Light . . . And then, who knows, opacity may be found to be transparent. Are not revolutions transformations? Let the philosophers continue

to teach and enlighten, to think high and speak loud, . . . dispense the alphabet, assert men's rights, sing the Marseillaise. . . . The crowd can be made sublime.[49]

For Hugo, the masses constitute the raw material of humanity, not yet refined by education and literacy. If the ideal is injected into the masses, they cease being masses and become the sublime entity called the people, the ultimate sovereign of France. The French Revolution encapsulates this transfiguration. The legacy of the revolution to later generations is a primordial formula that, if followed, may execute this magical transubstantiation, Hugo argues. And he is firmly convinced that he is the custodian of this legacy.

Using the formula of 1789, Hugo reads the history of France as the march of the people toward its predetermined position as the nation's sovereign. He classifies each insurrection, each upheaval, and each transformation of the past by deciding whether the rebellious masses measure up to the ideals of 1789 or are merely following their own blind self-interest. Using the same criterion, Hugo resolves the question concerning the legitimacy of violence as a political tool. There is sacred and righteous political violence, by which the masses transform themselves into a people, as they did in 1789. There is also criminal political violence, which erupts when the masses betray popular sovereignty:

> In any matter affecting the collective sovereignty, the war of the whole against the part is an insurrection, and the war of the part against the whole is a form of mutiny: the Tuileries may be justly or unjustly assailed according to whether they harbor the King or the Assembly. The guns turned on the mob were wrong on 10 August and right on 14 Vendémiaire. It looks the same, but the basis is different: the Swiss guards were defending an unrighteous cause, Bonaparte a righteous one. What has been done in the free exercise of its sovereign powers by universal suffrage cannot be undone by an uprising in the street. The same is true of matters of pure civilization: the instinct of the crowd, which yesterday was clear-sighted, may tomorrow be befogged.[50]

This dense passage contains the quintessence of Hugo's philosophy of history. An "insurrection", he states, emerges when the majority, or "the whole," rises against a repressive "part", or "fraction." If on the other hand "the part", or "fraction," rebels against "the whole," this should be designated as a "mutiny" (*émeute*).

How can we tell whether the insurrectionary masses consist of *a whole* or *a fraction*, whether they act in the long-term interest of the people or as a blind mob? The decisive factor is the nature of the regime under attack, Hugo answers. If the multitude rises against absolutist rule, it acts in the name of the people. Such was the case on August 10, 1792: challenging Louis XVI, the inhabitants of Paris were thrown back by the king's private troops, the Swiss guard, which committed the bloodiest carnage of the revolution. The event caused furor and eventually led to the fall of the monarchy. But if the masses revolt against a government that has been confirmed through popular election, they are always in the wrong and thus deserve having the canons turned against them. Such was the case on 13–14 Vendémiaire in year III (October 5–6, 1795) when Napoleon Bonaparte, at that time a young general, managed to bring his artillery to the Tuileries to strike down a royalist insurrection that threatened the revolutionary government. The masses were clear-sighted on August 10 but befogged on 14 Vendémiaire.

That there were two entirely different masses behind these two revolts is a fact that doesn't seem to bother Hugo. He remained the benevolent custodian of the masses, seeing them all, regardless of the situation, as expressions of one and the same force, raw and undifferentiated, and he graded hunger revolts, wild strikes, and uprisings as though they were consciously planned attempts to realize the political ideal of the people. He paid less attention to the material side of these conflicts, what he himself had called the "affirmation of matter," that is, the fact that rebellions are rarely born from the conscious struggle for political ideals but more often from situations of desperation and depredation.

Hugo's taxonomy of various species of collective violence therefore tells us little about the historical realities of France. Yet, for all his pedantry, his analyses has the advantage of indicating the exact function of "the masses" in the social discourse of his era. "The mob [*la foule*] betrays the people," he states.[51] "The war of the part against the whole is a form of mutiny," he also says. In Hugo's discourse, "the mass," or "*la foule*," is always "the part." It either betrays "the whole" and so remains a blind mob, or else "the mass" supports the whole and is then ennobled, the insurrection and the revolution being the rite of passage by which the laboring masses fuse with the people as sovereign. In Hugo, then, "the masses" names precisely that *part* of the population that has yet to realize the people as ideal and that hence is excluded from the polity that presents itself as the embodiment of that ideal.

We here reach the core of the debate that at the dawn of industrialism

sought to circumscribe the nature and future of *les misérables,* and we begin to sense the political logic behind the use of "*la misère*" as a sweeping description of the condition of the working classes. As we have seen, "*misère*" means both a material and a spiritual deprivation. Those slumped together as *les misérables* are poor, implying that they do not pay taxes and hence, according to general nineteenth-century opinion, do not contribute to the wealth of the nation. The *misérables* also lack schooling, literacy, and discipline. It is therefore believed that they are guided by their instinctual drives. They do not understand their own true interests, let alone the general interest.

"*Misère*" thus signals the absence of the two properties that at this time were used as criteria to qualify someone for political rights. The first criterion was motivated by the liberal idea that political order is constituted by a social contract: only individuals who fulfilled their duties toward society, that is, only those who contributed to society by paying taxes or serving in the military, were entitled to participate in the political life of the state. The French constitution of 1831 stated that only men who paid more than 200 francs in taxes had the right to vote. To run for office, one had to pay at least 500 francs in taxes. This statute was a great improvement compared to the previous constitution of 1814, where the limits were set at 300 and 1000 francs, respectively. Still, even under the more generous rules of 1831 less then one percent of the population had the right to vote—some 200,000 in a population of thirty million. For the leading circles, it was self-evident that the laboring people were so preoccupied with survival and bread winning that they, as John Locke once maintained, had "neither time nor ability to direct their thoughts at anything else." In this view, those who lived in poverty and misery were disqualified from political rights. Private income and wealth were the criteria separating citizens from the masses.

The second criterion that decided the distribution of political rights had to do with the educational level. In writing about the laboring classes, Hugo echoes Immanuel Kant's firm belief in the emancipatory force of Enlightenment: "Light! Let us repeat it again and again—Light and more Light." According to Kant, Man's emancipation "from his self-incurred tutelage" demands that he cultivate his reason, refine his senses, and form his personality in accord with the Ideal. Unlike Hugo, however, Kant doubted that the majority would ever be able to cross the threshold toward Enlightenment. They were so bent on immediate needs that they must remain in tutelage. The masses occupied a lower stage of evolution, comparable to that of savages who seek instant gratification of every desire,

Kant argued. Only people who had learned to suppress their passions, or who had channeled them into profitable economic activity, deserved the rights of citizens.[52] The distinction between those guided by reason and those misguided by passions thus justified the distinction between those pretending to represent the general will and those who were excluded from the public arena. In novels, newspaper articles, theater plays, and the social sciences of the nineteenth century, certain groups are repeatedly described as being enslaved by their passions. Among these unhappy ones were, first, women and children, followed by drunkards, insane individuals, perverts, and criminals, in addition to all non-European peoples, and finally the laboring classes. They were all portrayed as irresponsible, unable to act in the interest of the whole, and always inclined to sacrifice their future well-being for the transient pleasures of the present.

Throughout the nineteenth century, these two discourses mutually reinforce each other. Together, they form a system of representation that decides which part of any given population is excluded and subsumed under the category of "the mass." There is a political side to the system, determining who has the right to be a citizen with voting rights and to be appointed to public office. In this context, "the masses" emerge as those who are deprived of such rights. The system also has an ideological and cultural aspect, determining who may represent or personify the values, symbols, and ideals that unify the political community. Here, "the masses" emerge as a social phenomenon governed by irrational passions that threaten to destroy communal norms.

The mass is thus all the instincts that the human being must repress in order to become a rational subject. The mass is also the social agents that the political institutions must exclude in order to function as a unified and rational political organization. In these two forms, the mass constitutes the haunting shadow of both the bourgeois individual and of bourgeois society as such.[53]

Did civilization decline? Did political order crumble under the weight of the working classes? Were alcohol consumption and prostitution on the rise? Did great poetry cease to be written? Had someone been robbed in the park? Did factory production decrease? Were the streets getting noisier at night?

The specter of the masses loomed large.

[9] The Barricade

The seeds from which the new hierarchies grow are sowed already at the outset of the revolution. In his 1789 pamphlet *What Is the Third Estate?*, Emmanuel Sieyès claims that the people as a whole is represented by the third estate. The third estate, in its turn, is represented by the bourgeoisie, Sieyès argues, for this group demonstrates greater political and administrative skill than any other. Since the bourgeoisie makes common cause with the whole people in the struggle against monarchy and feudal privileges, it appears as the universal class of France.

No sooner had the democratic idea been formulated, however, than objections were raised against the universal claim of the bourgeoisie. In June 1789, the delegates of the third estate take the fate of the nation into their own hands, proclaiming themselves as the constituting power of France. But what should their newly founded power call itself? Who are the delegates? For whom do they speak? What is the true identity of the men gathered in the tennis court? An impassioned debate breaks out on the floor. Delegate Mounier suggests that they call themselves "The Representatives of the Nation's *Majority*." Delegate Mirabeau objects that this splits the nation in two parts, a minority (nobility and clergy) and a majority (third estate), and he suggests that they instead call themselves "The Representatives of the French *People*," a designation that he prefers also because "the people" is a flexible term that can signify both the few and the many. Delegates Target and Thouret frown at his argument, asking whether in that case "people" would refer to the "*plebs*," the Roman word for the lower classes, or the "*populus*," which refers to all citizens. Delegate Sieyès, for his part, repeats a proposition he has introduced earlier. Wanting to quell the antagonisms between estates and classes, he suggests that the assembly simply call itself the National Assembly (Assemblé

nationale). The delegates proceed to vote: 491 votes are in favor of Sieyès proposition, while 90 oppose it.[54]

At the very moment when the third estate constitutes itself as the voice of the nation, a new distinction thus emerges. On the one hand, the most dynamic elements of the bourgeoisie step forward as universal citizens acting in the interest of the people as a whole. On the other hand, there is now the majority of the people, the *plebs*, or *le menu peuple*, who because of their poverty and ignorance can't conceivably participate in the political decisions that are made in their name.

The majority again remains anonymous and invisible in the new system of representation that is instituted after Napoleon's imprisonment in 1815. France now becomes a constitutional monarchy, with a parliament chosen by the powerful and the wealthy. But the republican opposition grows stronger. It is victorious first in the July Revolution of 1830 and then again in the February Revolution of 1848, and it accomplishes a broader distribution of political rights. In both cases, however, democratization is abruptly halted—in 1830 as the bourgeois monarch Louis-Philippe is brought to the throne, and then again in 1851, as Louis-Napoléon Bonaparte, nephew of the emperor, seizes power in a coup and reintroduces imperial rule.

Throughout this historical process, with its rapid succession of regimes and constitutional frameworks and with people conquering political rights only to see them lost the next morning, all political actors steadfastly insist that they work in accord with the general will and represent the true interest of the people. Political institutions claim the people as their legitimizing foundation. Politicians present themselves as the voice of the people. The political class as a whole professes its loyalty to the will of the people. But since the majority of the people cannot express its will—they are not allowed to vote, after all—the truth is that any political decision may be rubberstamped in the people's name. It is not uncommon to find members of parliament justifying severe restrictions of voting rights by appealing to the best interest of the majority. Throughout the nineteenth century, the pattern is repeated: elected delegates will argue that their own ideas and initiatives axiomatically promote the well-being of the people; ideas held by peasants, artisans, workers, or seamstresses, by contrast, are seen as expressions of immaturity and base instincts: not the will of the people but its perversion.

In 1789, Jacques-Louis David had represented the fusion of the people-as-ideal and the people-as-society. A few decades later, these two conceptions of the people have turned into opposites of one another. The voice

of the people speaking in parliament is pure and finely tuned, the radical opposite of the vulgar argot and brute voices heard in fields and factories. In a work from 1846, the historian Jules Michelet describes the lenses through which the custodians of the general interest view society: "You go hunting in the gutters with a magnifying glass, and when you find some dirty, filthy thing, you bring it to us exclaiming, 'Triumph! Triumph! We have found the people!'"[55]

Michelet writes at a time when the term "people" is undergoing a crisis of signification. Behind the confusion are political antagonisms that divide French society. What does "*le peuple*" really mean? The word refers to the ideal of 1789, in the light of which the French bourgeoisie understands its past and its future as the universal class of the nation. At the same time, strangely, the word signifies the opposite of that ideal: "this people so brutish, so ignorant, so vain, so disagreeable to brush against, so disgusting to see close up," as Flora Tristan writes in 1843.[56] It is against this horizon that the meaning of "the masses" further consolidates itself. The word will evoke the disgust and fear expressed by Tristan when she writes about the people, but the word will also serve to exclude and control those who are seen as the source of that fear. In this context "the masses" will thus designate that part of the actually existing people that does not conform to the ideal people, and these "masses" will constitute not just a fraction but more often the vast majority of the real people.

In his famous painting of 1831, *Liberty Guiding the People* (*La Liberté guidant le peuple*, figure 9.1), Eugène Delacroix visualized the 1830 revolution. In the picture, we see a worker and a bourgeois marching in step across the barricade with Marianne—the spirit of liberty, the goddess of the revolution, the symbol of the republic—spurring them forward. The worker and the bourgeois are the two halves of the real people; through their fraternal unity in the struggle they embody the people as ideal, a principle of democratic sovereignty more powerful than the king.

But once they have defeated monarchy and disappear outside the frame, the two march off in opposite directions. Lining up behind Louis-Philippe, the bourgeoisie argues that popular sovereignty may be represented by a new form of enlightened monarchy. The working classes, on the contrary, deliver new blows against the crown in the insurrection of 1832, this time without the support of the bourgeoisie, and they are struck down. After 1830, then, worker and bourgeois are never again to appear as the two halves of a people dreaming of some ultimate wholeness under Marianne's tricolor. They now appear as two distinct peoples, with conflicting interests.

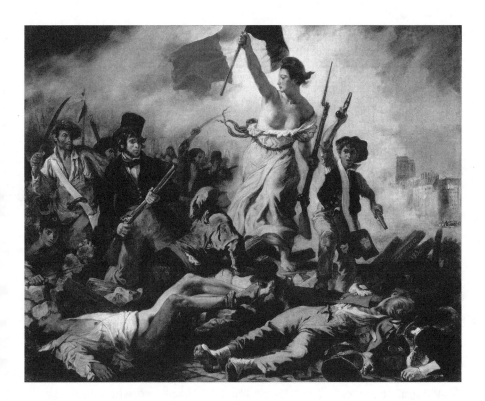

Figure 9.1. Eugène Délacroix, *Liberty Guiding the People* (*Le 28 juillet 1830: La Liberté guidant le peuple*), 1830. Oil on canvas. Paris, Musée du Louvre. Photo RMN / © Hervé Lewandowski.

"They form a nation within the nation," Daniel Stern says about the working classes after the insurrections of 1848.[57] They are the barbarians, Eugène Sue writes in the first chapter of *Les Mystères de Paris*—"just as much outside civilization as the savage tribes so well depicted by Cooper. But the barbarians of whom we speak are in the midst of us."[58] Each factory owner, Saint-Marc Girardin states already in 1831, "lives in his factory as the plantation owner in the colonies surrounded by slaves, one against one hundred."[59]

Victor Hugo and Jules Michelet belong to the tiny minority of intellectuals who keep stressing that *les misérables* are part of the people. They even suggest that these are the most significant part: would the suffering children only join forces to pull themselves out of their misery, this would serve as a true confirmation that the ideals of 1789 remain valid.

The bourgeoisie shuns such a scenario as either threatening or unrealistic. Daniel Stern clarifies the bourgeois attitude: "Since they have not dared to get close enough to the people . . . they mix up socialism with terrorism," and she goes on to explain: "they see the laboring classes as a different people, which they call masses."[60]

"What if they attack us?" Eugène Buret warns in his book from 1840, *De la Misère des classes laborieuses en Angleterre et en France* (On the misery of the laboring classes in England and in France):

> The workers are just as free of obligations toward their masters as the latter ones are toward them; they consider them as men of a different class, opposed and even hostile. Isolated from the nation, placed outside the social and political community, alone with their concerns and their misery, they are acting in order to leave that terrible solitude, and, just like the barbarians with whom they are often compared, they perhaps contemplate an invasion.[61]

In June 1848, these barbarians tried to take Paris. It was "the biggest street war in history," wrote Hugo.[62] The 1848 revolution in France had two major phases. The first one was successful. In February 1848, the people of Paris, including large parts of the bourgeoisie, forced Louis-Philippe to abdicate. The country was radicalized, and within a month the temporary assembly had instituted universal suffrage for men and made laws that granted everyone's right to work. In the countrywide democratic elections held in May, however, the conservatives were victorious, extinguishing all hopes among the Paris workers for further democratization and socialist reforms.

The second revolt was a failure. In June 1848, the new government decided to close the public workshops that had been set up to provide work for all. One hundred thousand workers or more had relied on the workshops as their source of livelihood, and they were now pressed to sign up for the army—the colonization of Algeria was in full sway—or else face deportation from the capital to various public works in the provinces. Heavy piecework, like digging roads and ditching swamps, was what the government offered. The working classes of Paris rose against the draconic measures, erected barricades, occupied parts of the city, and called on the conservative government to step down.

Writing about the June insurrection, Victor Hugo admits that the spirit of democracy was partly on the side of the rebels. The harsh reforms introduced by the government and the brutality it used against the

Paris population demonstrated that its claim to protect the well-being of the people was but a fig leaf for crass class interests. The insurrectionary workers, for their part, unselfishly sacrificed their lives for the future of the French people, according to Hugo. Yet, the fact remains that the government against which the people revolted was elected by the very same people, Hugo continues. If the rebels embodied democracy in spirit, the government embodied democracy in principle. The revolt therefore "had to be combated," Hugo concludes.

What was June 1848, in the final analysis? Hugo answers: "mobocracy rebelling against *demos*." He confesses that he is just barely able to conceive of such an event. His vision of society is founded on the ideal of 1789. A unified French nation without fundamental antagonisms between classes and estates, a unified French people where all are citizens and equal representatives of the whole—such is the norm against which he judges the political events of his time. Historical events are meaningful only to the extent that they can be measured as confirmations of that norm or as deviations from it.

What is at stake in 1848, however, is the norm itself. This challenges Hugo's understanding of the history of France as well as his definition of France as a political community. Is the history of France the history of a nation and of a people being gradually unified by the ideals of 1789— liberty, equality, fraternity? Or is the history of France taken hostage by the country's bourgeoisie, whose members have learnt to bend the ideals to their own favor? May it not even be the case, then, that the socialists of 1848 had a point, arguing that the history of France is the history of class struggle?

Victor Hugo is of two minds. The June insurrection appears incomprehensible to him, and his descriptions become ever more twisted: June 1848 was "a revolt of the populace against itself," he writes in *Les Misérables*.[63] "On the one hand the desperation of the people, on the other the desperation of society," he notes in his journal.[64] "Those who are against the people are against me," he states during the May election campaign.[65] A month later, the people are fighting among themselves, and what side should Hugo then support? France seems irrevocably divided between two incompatible ideas of "the people." Hugo makes an effort to distinguish between "the red republic" and "the ideal republic."[66] But if the republic is now split all the way down to the ground, it is no longer possible to assess the legitimacy of political violence. Or rather, from now on, one's judgment on the legitimacy of violent action may be decided only by taking sides. Faced with a political process that is not open to judgment

according to the impartial standards of reason or the universal ideals of 1789, Hugo is forced to admit that June 1848 is an event *àpart*, "an event which history finds it almost impossible to classify."[67]

What resists classification may still be invoked or pointed out. The plot in Hugo's *Les Misérables* culminates with the revolution of 1832, and the insurrection of June 1848 has no logical place in the story. Even so, 1848 casts a shadow on Hugo's narrative. The heart of the novel's social commentary and the driving force behind its pathos are buried in a long digression on 1848. As so often in his long story, Hugo sidetracks. Leaving the storyline about his hero Jean Valjean and the 1832 uprising, he lures the reader down a one-way alley that ends abruptly in front of the enormous barricade raised by the inhabitants of Faubourg Saint-Antoine in June 1848. At the foot of the edifice, Hugo takes a pause, as if he needed to inhale, and then goes on to offer the most spellbinding description of urban architecture in all world literature. The barricade in Saint-Antoine stands squarely at the center of *Les Misérables*. It is a great monument to Western modernity. It is also an allegorical representation of the history of France. It is a world worn out and smashed, and yet spectacular, sparkling with life:

> Of what was it built? Of the material of three six-storey houses demolished for the purpose, some people said. Of the phenomenon of overwhelming anger, said others. It bore the lamentable aspect of all things built by hatred—a look of destruction. One might ask, "Who built all that?"; but one might equally ask, "Who destroyed all that?" Everything had gone into it, doors, grilles, screens, bedroom furniture, wrecked cooking-stoves and pots and pans, piled up haphazard, the whole a composite of paving-stones and rubble, timbers, iron bars, broken window-panes, seatless chairs, rags, odds and ends of every kind—and curses. It was great and it was trivial, a chaotic parody of emptiness, a mingling of debris. Sisyphus had cast his rock upon it and Job his potsherd. In short it was terrible, an Acropolis of the destitute.[68]

Hugo continues his description of the barricade over several pages and seems unable to bring it to completion. An assembly of all the broken pieces of French society, the barricade, like the society it reflects, is inexhaustible. Objects are lined up, pressed together, spread out, and piled on top of one another, giving an overall impression of sheer quantity, of masses.

One seemed to hear, buzzing over that barricade as though it were their hive, the gigantic dark-bodied bees of violent progress. Was it a cluster of thickets, a bacchanalian orgy, or a fortress? Delirium seemed to have built it with the beating of its wings. There was something of the cloaca about it, and something of Olympus. One might see, in that hugger-mugger of desperation, roofing-ridges, fragments from garrets with their coloured wall-paper, window frames with panes intact set upright and defying cannon fire amid the rubble, uprooted fireplaces, wardrobes, tables, benches piled in clamouring disorder, a thousand beggarly objects disdained even by beggars, the expression of fury and nothingness. One might have said that it was the tattered clothing of the people—a clothing of wood, stone and iron—which the Faubourg Saint-Antoine had swept out of doors with a huge stroke of the broom, making of its poverty its protective barrier. Hunks of wood like chopping-blocks, brackets attached to wooden frames that looked like gibbets, wheels lying flat upon the rubble—all these lent to the anarchic edifice a recollection of tortures once suffered by the people. The Saint-Antoine barricade used everything as a weapon, everything that the civil war can hurl at the head of society. It was not a battle but a paroxysm. The fire-arms defending the stronghold, among which were a number of blunderbusses, poured out fragments of pottery, knuckle-bones, coat buttons, and even castors, dangerous missiles because of their metalwork. The barricade was a mad thing, flinging an inexpressible clamour into the sky. At moments when it defied the army, it was covered with bodies and with tempest, surmounted by a dense array of flaming heads. It was a thing of swarming activity, with a bristling fringe of muskets, sabres, cudgels, axes, pikes and bayonets. A huge red flag flapped in the wind. The shouting of orders was to be heard, warlike song, the roll of drums, the sobbing of women, and the dark raucous laughter of the half-starved. It was beyond reason and it was alive; and, as though from the back of some electric-coated animal, lightning crackled over it. The spirit of revolution cast its shadow over that mound, resonant with the voice of the people, which resembles the voice of God: a strange nobility emanated from it. It was a pile of garbage, and it was Sinai.[69]

Oscillating between disgust and awe, Hugo confesses his inability to understand what he views. The huge mass resists comparison with past events. Hugo states that the barricade had been raised in the name of the revolution, but what was it fighting? "It was fighting the Revolution. That

barricade, which was chance, disorder, terror, misunderstanding and the unknown, was at war with the Constituent Assembly, the sovereignty of the people, universal suffrage, the nation and the Republic. It was the 'Caramagnole' defying the 'Marseillaise.'"[70]

The barricade in Saint-Antoine may be understood as a burial mound thrown on top of the corpse of the people after the defeat of 1848. A mountain of garbage serves as monument for a perished democracy. The barricade is also a symbol for a French nation that has disposed of all its symbols. All is ruined, all ideals are consumed, and from now on, the country will have to do without unifying images and bonds of patriotism.

Yet, the edifice is a also bastion of resistance, the patchwork result of collective efforts, a bricolage of the people. Hugo invokes that primordial power that Carlyle called the wrath of Sansculottism. Behind the barricade, we sense the shadow of a people refusing to be unified, evading all words or images that seek to capture its essence, and rejecting those who want to speak on its behalf. It is a people representing its own interest. It speaks for itself, and in voices that fail to harmonize with the political order: "the shouting of commands . . . , warlike song, the roll of drums, the sobbing of women, and the dark raucous laughter of the half-starved"—"an inexpressible clamour . . . beyond reason." Which symbols can register such voices of the people? Which institutions can faithfully express popular aspirations of this kind? And which form of state fits this body—"beyond reason and . . . alive"—sparkling and crackling at the first touch of the observer? An inconceivable creature, the people is primitive yet technically minded, absolutely archaic yet fully modern: "an electric animal," says Hugo. In the chaos of the barricade, the ruins of an old society form the foundation for a new one under construction. The pile of old scrap has an absolute newness to it, for which words have yet to been invented.

Finally, what emerges from Hugo's account of the barricade is an encounter between the author's interpreting gaze and a social composite holding out against every interpretation. Having already declared that June 1848 was an event that cannot be digested by history, he now concludes that the barricade in Saint-Antoine is also beyond reason. We are faced with a phenomenon of the kind that aesthetic theory typically approaches under the category of the sublime. Refusing to enter language, evading the grip of rational concepts, the barricade, like all things sublime, allows only for a contemplative viewing, as it instills in the spectator a sense of fear and admiration related to religious experience.

"The crowd can be made sublime," Hugo exclaimed earlier in the novel,

meaning that it is the task of the intellectual to approach the masses in order to enlighten them.[71] The barricade situates him and his reader in front of masses made sublime by their own powers, without philosophical guidance and through actions inconceivable to intellectuals like Hugo. The barricade shows up the people as sphinx, tight-lipped, secretive, enigmatic, exalted. Not even Hugo, the great friend of the people, is able to solve its riddle, but he remains planted, petrified, gaping in awe, staring at the mass of refuse.

[10] Making Monkey

The barricade in Saint-Antoine is also mentioned in Gustave Flaubert's *L'Education sentimentale* (*Sentimental Education*) from 1869. Victor Hugo's high-pitched symbolism appears a bit pathetic when compared to Flaubert's sober description of the stronghold. Flaubert makes us see nothing, not even the barricade—the commotion has stirred up too much dust. But the rifle shots from the army's final clearing operations in Saint-Antoine resound all the more clearly in his text.

Flaubert's narrative lacks the dramatic nerve that characterizes other accounts of the violence of 1848. Whereas other writers and observers report having seen the wheels of history rolling down the streets of Paris, Flaubert deciphers a cheap fight between deceit and pretentiousness. Frédéric Moreau, the main character, toys with the idea of writing a comedy— "*une grande comédie*"—based on the signature events of the French Revolution.[72] It is tempting to read *Sentimental Education* as Flaubert's attempt to write a farce about the revolution of 1848.

In Flaubert's view, 1848 demonstrated the same poor fit between reality and ideal that one finds in the genre of comedy. We laugh at the idealist who, while shaking his fists against the gods, stumbles on the pavement of reality. Flaubert's novel generates endless laughter of this kind by letting high and low clash over and again. The novel makes a point of belittling the revolutionary crowds, depicting them as a mass of drunkards, street children, careerists, and idealists. The stupid and childish behavior of the Paris people is then contrasted with the solemn ideals—democracy, republicanism, universal suffrage—put forth in their name. At the triumphant moment of the February Revolution, as the popular crowds force their way into the royal apartments of the Tuileries, Frédéric Moreau and his friend Hussonnet are swept along by the flood and come to witnesses a

spectacle that turns all social hierarchies upside down. "The rabble draped themselves mockingly in lace and cashmere. Gold fringes were twined round the sleeves of smocks, hats with ostrich plumes adorned the heads of blacksmiths, and ribbons of the Legion of Honour served as sashes for prostitutes."[73] The event gives Flaubert an opportunity to portray the new sovereign of the era, "His Majesty the People":

> Pushed along in spite of themselves, they entered a room in which a red velvet canopy was stretched across the ceiling. On the throne underneath sat a worker with a black beard, his shirt half-open, grinning like a stupid ape. Others clambered on to the platform to sit in his place.
>
> "What a myth!" said Hussonnet. "There's the sovereign people for you!"
>
> The throne was picked up and passed unsteadily from hand to hand across the room.
>
> "Good Lord! Look how it's pitching! The ship of state is being tossed on a stormy sea! It's dancing a can-can! It's dancing a can-can!"
>
> It was taken to a window and thrown out, to the accompaniment of hisses and boos.
>
> "Poor old thing!" Hussonnet said, as he watched it fall into the garden, where it was quickly picked up to be taken to the Bastille and then burnt.[74]

So much for democracy, republicanism, and popular sovereignty. The people are pathetically unable to represent the elevated ideals promoted in their name. Worse still, the people turn these ideals into their opposites. Flaubert renders the victory of democracy as a farce and a pillage—and sometimes as sheer madness: "In the entrance-hall, standing on a pile of clothes, a prostitute was posing as a statue of Liberty, motionless and terrifying, with her eyes wide open."[75]

Condescendingly, but not without a dose of redemptive irony, Flaubert observes how the working classes take advantage of their moment to pose as nobility for a day. Toward intellectuals and members of the bourgeoisie, who hasten to remake themselves into good republicans overnight, he is merciless, showing how they pay just enough lip service to popular sovereignty to retain their offices under the new majoritarian regime.

In short, *Sentimental Education* is a magnificent liquidation of democracy and a frontal assault on "the people" as a credible political ideal. Other observers, such as Victor Hugo, Daniel Stern, Jules Michelet, Pierre-Joseph Proudhon, Karl Marx, and Heinrich Heine described the revolutions of

1848 as a decisive step on the path of progress. The people moved forward. Those anonymous masses now became the subject of history. For Flaubert, on the contrary, there was no subject of history, and strictly speaking no people either. The people exist neither as a constitutive political power, nor as an embodiment of the nation, but only as a cover-up for the pursuit of private ambitions and collective delusions. What we call history is the sum total of various individual and collective desires for recognition and influence. Society consists of numbers unlimited, of crowds driven to and fro, of masses in motion:

> The drums beat the charge. Shrill cries arose, and shouts of triumph. The crowd surged backwards and forwards. Frédéric, caught between two dense masses, did not budge; in any case, he was fascinated and enjoying himself tremendously. The wounded falling to the ground, and the dead lying stretched out, did not look as if they were really wounded or dead. He felt as if he were watching a play.[76]

In the chaos of the revolt, there is no sense of unity or commonality. Slipping on clothes and weapons, people fall into the mud. Frédéric steps on something soft that turns out to be the hand of a killed sergeant lying face down in the gutter. The firing is fierce, but people take breaks to smoke a pipe or have a beer at the wine-merchant's shop, which remains open throughout the battle. A stray dog howls. "This raised a laugh," concludes Flaubert about the spectacle.[77]

Gisèle Séginger has observed that Flaubert's mass is the opposite of any emancipatory historical force. No collective idea or common rationality is manifested through the actions of Flaubert's crowds, which always act blindly and become increasingly alienated. The reason the masses are alienated is that they form a collective life form, Flaubert argues. Groups and collectives are the seedbeds for prejudices and stereotypes. The human being is prevented from thinking independently, and his or her head is loaded with delusions, half-truths, and stupidities, what Flaubert termed "*idées reçues*"—received ideas—which he abhorred more than anything else.[78]

To Flaubert, the masses are therefore no cause for alarm. Needless to say, they also do not ignite any hopes. *Les misérables* leave him cold. A letter to his colleague and friend George Sand speaks for itself: "I believe that the crowd, the mass, the herd, will always be detestable."[79]

As Flaubert closes his story about 1848, he has disclaimed not only the political fanaticism of his era, but everything that smells of politics.

He has emptied history of its meaning and shown that the category of the people lacks political substance. The ideal people doesn't exist, and the real people are the antithesis of political ideals, that is to say, they are masses, lacking qualities, convictions, and capacities for growth and maturation.

However, because of the masses' formlessness and malleability, they are all the better suited for a different purpose. The narration in *Sentimental Education* is governed by an authorial gaze that turns the variegated multitudes into a whole, much in the same way as a painter forms trees, hills, fields, and streams into an appealing vista. Flaubert is the first writer to systematically turn the masses into an aesthetic object. Of course, many before him—David, Balzac, Hugo, Délacroix, to name only those mentioned above—had already started to see the representation of the people or the masses as a serious aesthetic task. In their cases, however, the aesthetic expression was always a means toward a higher social or political end. They served as court painters to the new sovereign, helping "the people" and "democracy" to make a dignified visual impression. Flaubert refused such assignments. If he assumes a cold attitude toward the people, this is because he wants to put them at a distance in order to see them well, to register his sensual impressions of the people as exactly as possible, and to model these impressions into an aesthetic experience, which is its own goal and justification. "They spent the afternoon watching the people in the street from their window," the novel states at one point about the hero and his company.[80]

In this sense, *Sentimental Education* points forward. The novel takes a few first steps toward a way of representing the masses that is then fully realized in the great modernist accounts of the metropolis and the industrial collectives, culminating with the cinematic city symphonies of Dziga Vertov and Walther Ruttman in the late 1920s. In Flaubert, "people watching" becomes an activity in its own right. Indeed, what Siegfried Kracauer, in 1927, identified as the "mass ornament" is already half developed here. The crowd offers itself to a detached observer as an aesthetic adventure, an explosion of changing forms and shapes in swift movement: "from a distance the dense crowd looked like a field of black corn swaying to and fro"; "a vague mass of people swarming about below; here and there in its midst bayonets gleamed white against the dark background"; "a bewildering flood of bare heads, helmets, red caps, bayonets, and shoulders, surging forward so violently that people disappeared in the swarming mass as it went up and up, like a spring-tide pushing back a river, driven by an irresistible impulse and giving a continuous roar."[81]

In Flaubert's view, this is the only forgiving aspect of the revolutionary masses of 1848, their only value, as it were: they stimulate the senses and the production of literary style. The intellectual studying and describing the masses from afar has something in common with the political leader surveying the people from an elevated position and perceiving distant masses. The representation of the people as aesthetically fascinating masses requires a point of view that can only belong to someone who truly believes in his individuality. He is far removed from the violent events he is observing. Regardless of the outcome of the struggle, he is safe and secure. Flaubert is well aware that the aesthetic pleasure he takes in the insurgency presupposes an indifference as to its consequences. He finds it is a justified attitude, however, and he lets his hero speak in its support: "For there are situations in which the kindest of men is so detached from his fellows that he would watch the whole human race perish without batting an eyelid."[82]

[11] Smokescreens

In a debate in the National Assembly in 1850, Adolphe Thiers explained why it was necessary to restrict voting rights. He sharply distinquished between the people and the masses. "It is the masses [*la multitude*], not the people [*le peuple*], that we want to exclude; it is that disorganized mass [*cette multitude confuse*], that mass of vagabonds that one cannot locate anywhere, that could not create a substantial shelter for their family: it is that mass that the law intends to banish."[83]

According to Thiers, a person's rights as a citizen depends on whether that person has residency and a permanent address. In nineteenth-century Paris there was a severe shortage of housing. Tens of thousands of families and individuals lacked proper housing and were forced to stay on the streets or to sublease rooms or parts of rooms on temporary terms, as they went out each morning to find work that would pay for the evening supper and next week's rent. The demarcation between the homeless, who "could not create a substantial shelter for their family," and the laboring classes in general was fuzzy.

Definitions slide. People and masses are now synonyms, now opposites. Thiers sides with the people against the masses. He knows how to manipulate the political language in order to reinforce the boundary between those who have political rights and those who are without. Thiers, like many others, employs "the masses" to indicate a segment of the population that must be removed in order to enable the others to become a "people," united by shared values and political institutions.

Let's take a final look at *The Tennis Court Oath*. When preparing his painting, David divided his motif into a geometrical pattern, allotting a certain slot to each group and delegate. In the organizing matrix that governs the image, one line of division is stronger than the others. This

is the line that represents the walls of the building itself. At the historical moment rendered by David, the force of the unified people floods the walls. Waving and cheering through the large windows high on the walls, common men and women confirm the historical oath by their presence. Moments later, the stage is changed. The revolutionary instant has passed; the ordinary men and women have climbed down and disappeared behind the walls of the building. These walls divide not only the space in which the historical event takes place, and not just the visual plane of the painting, but also the political arena of society. David's projected painting unifies the body of the people, at the same time tearing it apart.[84]

Society is always divided. Some have access to its political institutions and appear as society's representatives; others don't. This boundary is never self-evident. If we study the history of political exclusion, we see that there are two kinds of banishment. In the first case, one group rejects another group because each considers the other to be an enemy. In the second case, a powerful group banishes a weaker group from political influence by referring precisely to the latter's weakness, which necessitates the intervention of some stronger authority—often the powerful group itself—to serve as custodian for the weaker ones. The paradox is a strange one: the weak group is not allowed to speak for itself because someone is already speaking for it, and speaking more efficiently; the weak group may be excluded because it is somehow already included through intermediaries.

The demarcation between people and masses also hinges on another distinction. Being a citizen means being registered as a voter and being listed in the tax records and the address directory. Once a person is included in such public records, he or she has a recognized identity; he or she becomes a citizen and an individual. To be a citizen and individual is, moreover, to be a recognized representative of a certain community and a certain people. Persons who belong to the masses, by contrast, are not individuals but beings with neither names nor rights.

As the nineteenth century wears on, the discourse on the masses is increasingly conducted from the standpoint of individualism. Writers like Gustave Flaubert and politicians like Adolphe Thiers can depict other humans as masses only on condition that they understand themselves as individuals. The history of France after 1848 is commonly described as a struggle between the working class and the bourgeoisie. But the relation between the classes is far from a symmetrical one. While the bourgeoisie is rendered as an agglomeration of recognizable individuals, reports concerning the other class speak of a collective being or, more simply, of

Figure 11.1. Edouard Manet. *The Barricade* (*La Barricade*), 1871. Ink, wash, and watercolor on paper. The William A. Whitaker Foundation Art Fund, Ackland Art Museum, the University of North Carolina at Chapel Hill.

the mass—*la foule, la multitude*. This seems natural enough, for almost all social observers of that era were members of the bourgeoisie, regarding themselves as the norm and center of society. They perceived the working classes' demands as an imminent threat against the social and political order that they represented. Of course, their perception was justified.

Delacroix's *Liberty Guiding the People* of 1830 is not just the last picture where worker and bourgeois fight side by side, standing united under Marianne's wings.[85] It is also the last picture where worker and bourgeois are drawn as individuals of the same species. In later images they face each other as enemies. But these enemies do not confront each other as two human beings on equal footing, nor do they fight man to man. Rather, they relate to each other as an individual citizen relates to the faceless masses—as in Baudelaire's prose poems, Flaubert's *Sentimental Education*, Hippolyte Taine's account of the French Revolution, Émile Zola's *Germinal*, and the vast majority of other novels, books, and poems about the working class, all the way through the early twentieth century.

The antagonists often clash with each other in street battles, with dust and gun smoke obliterating the individual traits of the combatants. In a drawing from 1871, Édouard Manet renders one of the clearing operations ordered by Adolphe Thiers after the fall of the Paris Commune (figure 11.1). The faces of the targeted communards are difficult to see, as they are concealed by the smoke from the rifles that are executing them.

[12] Mass Grave

Ernest Meissonier's painting *The Barricade* was made once the gun smoke had cleared out (figure 12.1). As a captain of artillery in the National Guard, Meissonier belonged to the troops that conquered the barricade in rue de la Mortellerie in June 1848: "I saw the defenders shot down, hurled out of windows, the ground strewn with corpses, the earth red with blood it had not yet drunk. 'Were all these men guilty?' said Marrast to the officer in command. . . . 'I can assure you, *M. le Maire*, that not more than a quarter of them were innocent.' "[86]

Meissonier's painting was completed in 1849. Today it hangs in the Louvre. It's a small picture. From a few feet away, the motif looks crammed, its colors pale and tarnished. It's hard to see anything but an abandoned street lined by houses.

Writing about *The Barricade*, art historian T. J. Clark explains that Meissonier intended it as a warning to future rebels: look, this is the way revolutionaries end up! Yet, like all true artists, Meissonier created a work that exceeds his intention. *The Barricade* is no simple object lesson. When the painting was first exhibited in 1851, one critic regretted that it lacked drama and artistic energy. In order to really see the painting, one must move close and scrutinize the fine details, but then it gives a much too agonizing impression. *The Barricade*, this critic complained, is nothing but an *omelette d'hommes*—a human omelet.[87]

As the viewer approaches the image, he or she discovers that the pavement consists of human corpses. Meissonier painted the bodies in the same nuance as the cobblestones from the razed barricade, and the heads have the shapes of the rocks that lie scattered around. The workers who held rue de la Mortellerie just a few hours ago are reduced to raw matter.

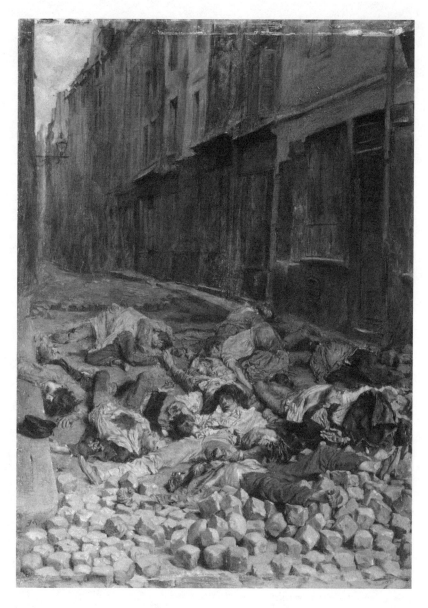

Figure 12.1. Ernest Meissonier, *The Barricade* (*La Barricade, rue de la Mortellerie, juin 1848*, also called: *Souvenir de guerre civile*), 1849. Oil on canvas, 20 x 15 cm. Paris, Musée du Louvre. Photo RMN / © rights restricted.

Some days later, when the bodies had been identified, they were packed on a cart, transported outside the city wall, and thrown into a mass grave.

With Flaubert's aestheticization of the masses, with Thiers's assertion of the need to exclude the multitude from political life, and with Meissonier's agonizing picture of the killed workers, a social divide is made complete. The excluded part of the population has been transformed into a mass and made invisible, turned into matter and made harmless. This process of social splitting is mirrored in the semantic transformation that "the masses" undergo between 1789 and 1848. At first, the word simply designates democracy, an emerging political system under majority rule, the empowerment of numbers unlimited. The word is then employed in descriptions of the destitute condition of the poor and the working classes, *les misérables*, particularly when the criminal and rebellious potential of these groups is at issue. The meaning of "the masses" then shifts once again, now evoking the workers' movement as such. Around 1889, as we shall see, "the masses" attains a fourth signification.

What remains constant throughout these semantic transformations is the discriminating function of the term. Most words in our hate-speech lexicon share this feature: the mere uttering of a word—"the masses"—is also a rejection of those denoted by it. By conjuring up fantasies of violence, burning passions, and barbaric instincts, "the masses" operates as a mechanism of exclusion, at the same time justifying the exclusion it performs. "The masses" is a scar on the political body. The scar reminds us of parts that have been cut off, in order to enable "the people" to become identical with itself. Or, to be more exact: in order to enable the dominant part of the population to constitute itself as a political and cultural community.

According to T. J. Clark, Meissonier's *The Barricade* renders the true anonymity of the people—an anonymity that cannot be traced back to the people themselves but only to the dehumanizing violence they are exposed to.[88] To look at the people as a mass, or to depict it as a mass, is the first step toward transforming it into a mass. Once we scrutinize Meissonier's image and peer into the faces of the dead rebels, we notice that each face has its own attitude to death. If the men all look the same, this is due not to any natural similarity but to the way they were treated.

1889

James Ensor, *Christ's Entry Into Brussels in 1889*

So you're challenging everything that exists today?

—HERVÉ BORUGES

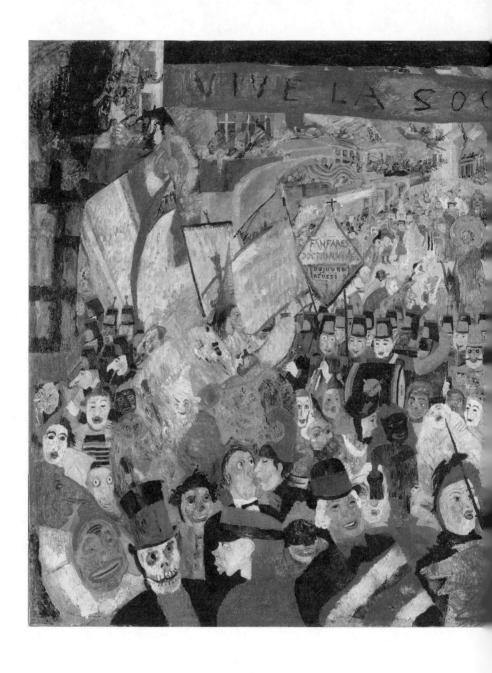

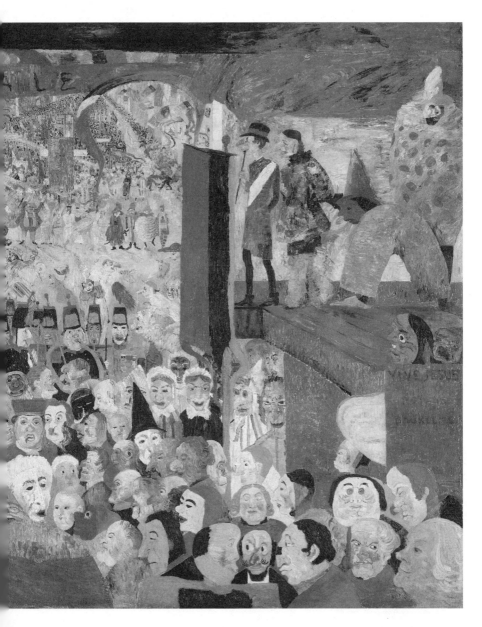

Figure 13.1. James Ensor, *Christ's Entry Into Brussels in 1889* (*L'Entrée du Christ à Bruxelles en 1889*), 1888. Oil on canvas, 252 x 430 cm. The J. Paul Getty Museum, Los Angeles. © Estate of James Ensor/Artists Rights Society (ARS), New York. Also see color plates.

[13] The Crucified

"I want to be mad, I want to be mad," wrote August Strindberg to Friedrich Nietzsche on New Year's Day 1889. A few days earlier, Strindberg had received a puzzling letter signed "Nietzsche Caesar." The letter made him sad and worried, because it confirmed his suspicion that the German philosopher was losing his mind. Strindberg made an effort to reach out to his comrade one last time, hailing him in the Epicurean idiom of immoderation and intoxication that the ancients had cherished as a path to higher wisdom. Let us revel, Strindberg exclaimed, in "the joy of insanity."[1]

Nietzsche's reply to Strindberg sealed their friendship with another signature of madness; now it read, "The Crucified."[2] Nietzsche then withdrew to another reality. His last report recounts the discovery of a world that is indeed one of joy. In a letter of January 3 to Meta von Salis, Nietzsche is enraptured: "The world is enlightened, because God is on earth. Don't you see how the heavens rejoice?" This letter, too, was signed "The Crucified."[3]

Even experiences that seem uniquely private and noncommunicable—the pains of the ill or injured, the revelations of the believer, the delusions of the madman—are often marked by conventions and fashion trends. Nietzsche's identification with Christ was by no standards original. Many mentally ill people of the time mirrored themselves in the fate of Christ, artists and writers in particular. Another one was James Ensor. Already in 1886, he painted himself nailed to the cross: "Ensor crucified."

Did Strindberg recognize Nietzsche's fate in the visionary images of the Belgian painter? Did he perhaps even recognize his own? A decade or so after Nietzsche's collapse, Strindberg describes how Ensor helped him recognize the face of madness. In a key episode in the 1903 novella *Alone (Ensam)*, Strindberg relates his confrontation with the underclass

of Stockholm, a layer of the population that he, the son of a servant, both identified with and abhorred:

> As I observed these creatures I noticed an overwhelming number of cripples; crutches and canes mingled with crooked legs and broken backs; dwarfs with giant backs, and giants with the foundations of dwarfs; faces without noses, and feet that had no toes and ended in lumps. An assembly of all the misery that had been hiding during the winter and that now had crawled out in the sunshine to move out to the country. I had encountered such human-like creatures in Ensor's occult mask-scenes and at the theater in Gluck's Orpheus in the Netherworld, at that time believing they were fantasies and exaggerations.[4]

Looking down on the masses from his carriage, Strindberg's narrator is first filled with compassion. Next he realizes that he is the focal point of their envy and hatred, as he is comfortably cruising forward elevated above them. If he wished to express his sympathy, he would have to step down to the miserable ones and rub his body against theirs. The mere thought makes him so terrified that he tells the driver to rush back home. Once at his doorstep, "I was liberated as from a terrible dream."[5]

What we have here is a modernist primal scene. The solitary individual confronts a society of faceless masses threatening his sense of autonomy. In a 1926 essay on Ensor, the German art historian Wilhelm Fraenger argues that the same scene often returns in the work of the Belgian painter.[6] Ensor proves his individuality by depicting humanity as a mad mob, with himself, the only voice of truth, as a victim or a savior in its midst.

Like Nietzsche, Ensor depicted himself as the crucified Christ. Like Strindberg, he transformed his interactions with society and his fellow human beings into mental conflicts which he enacted in a phantasmagoric theater of combat. Both Ensor and Strindberg had a psychic constitution that bordered on insanity, but the same constitution also motored sharp social critique and a remarkable aesthetic creativity. Their work restructures society according to a new logic, at once fantasmatic and political, which tears out social events, persons, and groups from the ideological and historical contexts in which they are normally embedded. The social universe is cut up and refashioned, as in Ensor's major work, a great oil entitled *Christ's Entry Into Brussels in 1889* (*L'Entrée du Christ à Bruxelles en 1889*, figure 13.1).

James Ensor was only twenty-eight when he made it. It has been regarded as the summa of his career, and the artist himself always consid-

ered it his greatest achievement. He refused to sell the painting; in fact, he was reluctant to show it at all. At first he kept it in his studio, then in his home, where it hung like a huge tapestry covering the entire wall behind his organ. Compared to other paintings of the period, *Christ's Entry* strikes the viewer as stunningly original. It is one of a handful of modernist works that have played a decisive role in the evolution of painting, including Georges Seurat's *Sunday Afternoon on the Island of La Grande Jatte*, Paul Gauguin's *Where Do We Come From? What Are We? Where Are We Going?* and Pablo Picasso's *Les Demoiselles d'Avignon*. Ensor's image encapsulates a cultural moment, at the same time launching a new way of viewing the world. A modernist landmark, *Christ's Entry Into Brussels in 1889* is a revolution in the history of art.

[14] The Belgian's Glory

Strindberg must have encountered Ensor's work in the special issues that the French journal *La Plume* devoted to the painter in 1898.[7] On the initiative of Eugène Demolder, a close friend of the artist, all the major figures of the Belgian avant-garde paid tribute to Ensor's genius. The contributors signposted three features of Ensor's work: his treatment of light; his depiction of crowds; and the mad nature of his images, a visual outrage they explained by linking it to the wacky character of the artist himself.

These three features were ingrained in European culture of the period. In the 1880s, art claimed autonomy as a means to explore the nature and perception of light. The bourgeoisie was obsessed with the presence of the so-called masses. And medical science redefined madness as a pathological condition caused by the absence of reason.

Although the three issues seem unrelated, Ensor's images fuse them into a solid unity. In Ensor scholarship, however, the only element that has been examined in depth is the first one, light; the other two—masses and madness—have been treated as though they were self-evident: the madness as an aspect of the artist's biography and the masses as one of his motifs. This is understandable. Art history is written by people trained to decipher the smallest nuance in an aesthetic object, while lacking knowledge about the history of madness and the history of the masses. Generally speaking, art historians argue that *Christ's Entry Into Brussels in 1889* delivers a message. They tell us that Ensor's masterpiece deplores the fate of Christ. Arriving in the city to announce the promise of salvation, the Messiah falls prey to the insane masses on the street. This depiction is then taken as a statement about the human condition in modern society: mass movements blinded by ideologies corrupt individual virtues, assaulting everyone who breaks the customs of the tribe.

What makes this interpretation credible is that it finds support in Ensor's biography. We know that Ensor willingly played the role of the suffering Messiah, in an act of rebellion against a cultural establishment and a Belgian society from which he felt excluded. What makes the interpretation questionable, however, is that it tells us nothing about Ensor's picture itself. Other paintings of the period depict the encounter of the individual and the masses much in the same way as Strindberg did in *Alone*. The reader or viewer is asked to identify with an individual hero whose fragile sense of autonomy and self-esteem is challenged by the delirious crowd. This is how the confrontation between individual and masses has been depicted from Flaubert until our day and time, and in the previous part we have seen where these images stem from. What's so strange with *Christ's Entry Into Brussels in 1889* is that it explicitly rejects the paradigmatic way of rendering the encounter between individual and masses.

Ensor stood at the heart of the intensive nineteenth-century discussion about the conditions of the working class. He broke his own path, using his visual means of representation to articulate an idea of society and democracy that was diametrically opposed to the widely disseminated postulate about the eternal conflict between the individual and the masses. In Ensor's painting, we see neither individuals nor masses but a more fundamental substance of social life. It is the substance that Jacques-Louis David sought to represent during his years as the painter of the revolution. In Belgium of the 1880s—it, too, a society on the brink of revolution—many awaited the advent of democracy. Reveling in the joys of alternative worlds, Ensor painted the event before it occurred. On the centennial of the French Revolution, Christ enters Brussels. The Messiah remains his biblical self, at the same time being someone else in disguise who arrives to fulfill the very meaning of the words crowning Brussels' main boulevard: "Vive la sociale."

[15] Divorce

Among the insurgent workers of June 1848 there was a man called Boissy. He called on his comrades to separate themselves from society: "Leave, leave this society for which you do everything and which does nothing for you, this society where those who do everything have nothing and those who do nothing have everything."[8] The 1848 revolutions are often described as the breakthrough of the organized labor movement in Europe. The corpses strewn on the Paris barricades made Emmanuel Sieyès's conviction of the third estate as a universal class of equals look like a bad joke. From within the third estate, and as its main political competitor, "the fourth estate" gradually distinguished itself as a separate political force. An increasing number of workers and artisans founded their own societies, which were gradually transformed into parties and labor unions.

Boissy's exhortation is an early instance of what Pierre Rosanvallon calls the period of working-class secession, "le temps de la séparation ouvrière." There was more to come. In 1864, sixty workers published a manifesto that immediately caught wide attention because it apparently confirmed the working classes' secession from the ideals of 1789: "It has been repeated over and again that there are no longer any classes and that since 1789 all the French are equal before the law. But for us who have no property other than our arms, who are subject every day to the legitimate or arbitrary conditions of capital . . . it is very difficult to believe the statement."[9] "The Sixty's Manifesto" is one of the founding documents of the French labor movement. The manifesto explicitly rejected the existing political system, in which someone's right to represent the people depended on that person's property and education. The party system was at this time just barely emerging. It was commonly

argued that the will of the people was best represented by impartial advocates—usually lawyers by profession—who would service the public interest as faithful deputies.

The workers behind "The Sixty's Manifesto" demanded to be represented in parliament by people from their own ranks. The proposal caused outrage among liberal and conservative commentators. Was it not selfish and narrow-minded, they asked, to call for politicians and political movements who would support the social cause of the proletariat only, without any concern for the common wealth of the nation? These commentators dismissed the proposal as undemocratic, even dictatorial.

In this conflict, two ideas of political representation clashed. According to one view, the people ought to be represented by certain qualified citizens who could serve as incorruptible custodians of the general interest. According to the other view, an advocate who would speak for the people as a whole simply did not exist, and it was therefore best if each class selected its own representatives.

But this was also a clash between two different notions of the people. In the first view, the people was an organic unity, with different classes fulfilling different functions and with a political elite, consisting of those in charge of the state, acting for the well-being of the whole. In the second view, the people was irremediably divided into classes with contradictory demands, and the class in control of the state would inevitably use its power to further its own interests.

These antagonisms characterized the political landscape in the second half of the nineteenth century. Those favoring a return to monarchy and feudal privileges aside, the main conflict persisted between liberal parliamentarism, a restricted democracy in which political rights depended on the tax record, and socialism, which demanded universal suffrage and a resolution of the social question: higher wages, shorter working days, security of employment, and workplace safety.

Since the workers' movement lacked efficient political representation, it resorted to extraparliamentary actions to promote its demands. There was a steady increase in marches, strikes, and workplace sabotage, not excluding acts of violence that the authorities swiftly classified as acts of terrorism. Predictably, this aggravated the upper-class fear of the masses. In speaking of the masses, they now rarely alluded to "*les misérables.*" The word no longer elicited compassion with the suffering poor; it warned against militant unions, wild strikes, socialist agitation, and the destruction of valuable property.[10] After 1871, "the mass" still carried these meanings,

but it also evoked something even worse that made the former threat pale in comparison. The Paris Commune of 1871 confirmed the black omens that the members of the bourgeoisie had so vividly painted for many years. It proved that the masses were capable of seizing power in the second largest city of the world.

Like all revolutions, the reign of the Commune was brief. In the fall of 1870, Bismarck's German troops besieged Paris, causing the emperor to flee the city along with his government and military command. The majority of the population and the National Guard refused to give in, however, and slowly stepped in to take charge of the city. After a winter of political disorder and desperate shortage of food and fuel, a different Paris emerged. The capital was now ruled by elected councils of socialist-minded workers, intellectuals, civil servants, and shop owners who managed, within a few spring weeks, to reorganize life in the city, distributing work tasks, political influence, services, food, and other necessities according to communal principles.

The reaction to the Paris Commune among intellectuals was one of shock and disbelief.[11] The well-bred Frenchman heaped scorn on the lower-class communards and the National Guard. Gustave Flaubert, for one, argued that the Commune proved how governance had become too lax. Ignoring the fact that the adherents of the Commune had resisted Germany's siege and defended Paris, while the emperor and the government had chosen to abandon the capital, Flaubert asserted that the majority of the French people were biologically unfit to take charge of public affairs. "The *people* never come of age, and they will always be the bottom rung of the social scale because they represent number, mass, the limitless," Flaubert wrote of the Commune on April 30, 1871.[12]

In the same spirit, other French writers denounced the Commune as the deluge or the apocalypse. They evoked heinous scenes, depicting how the elements of the netherworld had come crawling from the sewers to hold orgies on the streets of Paris. In their opinion, the masses were now directly challenging the existing political order, and it seemed as though democracy would usher in chaos.

Eighteen years later, in 1889, the ruling classes were still troubled by their trauma. Marc Angenot has charted the cultural climate of 1889 in great detail. He describes the predominant sentiment among the members of the French bourgeoisie: "their memory of 1871, an outburst of collective insanity including stranglers, cannibals, and arsonists, remained vividly present."[13] By this time, the dominant interpretation was set in

place: the Paris Commune proved that the masses were agitated by an inherited inclination toward vice and violence.

Such, in short, was the prevailing view of the masses when James Ensor made his enigmatic masterpiece, in which we see Christ, surrounded by thousands, entering Brussels on the back of a mule.

[16] Hallucinations

A year after the fall of the Commune, in 1872, a young physician named Gustave Le Bon published a book called *La Vie: Physiologie humaine appliqué à l'hygiène et à la médicine* (Life: Human physiology and its application to hygiene and medicine). Le Bon thus launched a career as a writer that would turn him into one of the most influential public intellectuals of France. The arid, scientific ring of the title masks a content of enormous pretensions. Not only is *La Vie* a physician's attempt to diagnose society, it also seeks to cure a disease afflicting the political body of the people.

In this book, Le Bon repeated what many had said before him. The masses have a dangerous impact on social development. What made his work original or even pioneering, however, was its claim to explain crowd behavior in rigorously scientific terms. Le Bon asserted that mass behavior is caused by a psychic pathology: "Hallucination is a phenomenon which, by imitation or under the influence of identical excitations acting simultaneously on a great number of individuals in the same state of mind, is able to become collective. These collective hallucinations are veritable mental epidemics very common in history."[14]

According to Le Bon, the Paris Commune was an example of such an epidemic, a pathological manifestation comparable to other medical and biological abnormalities. In his subsequent writings, Le Bon refined his diagnosis of the disease by adding a host of other symptoms: the democratization of the access to education, the institution of the lay jury, urban congestion, the decreasing authority of the church, the behavior of audiences at cheap spectacles, and workers' strikes. In modern society, the human being is increasingly influenced by large groups and collectives, Le Bon explained. This was reason for alarm, he added, because in such

situations the human being loses his or her ability to think independently. He or she instead becomes ruled by primitive instincts.

Gustave Le Bon held the scientistic convictions of his age. He agreed with those who argued that the study of history, culture, and society should follow the positivistic model of the natural sciences.[15] Ideally, historians and social scientists should apply the same methods in their examination of social phenomena as natural scientists did when studying chemical and physical processes. Moreover, the theories of Charles Darwin and Herbert Spencer had paved the way for an understanding that saw human behavior as primarily guided by hereditary dispositions, and this idea became an overshadowing concern in turn-of-the-century European culture. Heredity theory stamped its mark on the works of many influential writers, from Henrik Ibsen, Hippolyte Taine, Émile Zola, and August Strindberg to Otto Weininger and Sigmund Freud. They all argued that "inherited qualities" make up a substratum of unconscious instincts that the human race has developed in the struggle for survival and recognition. Higher mental qualities such as deliberation, conscious will, and active memory, by contrast, form a thin layer of civilization that has developed fairly recently in the course of human evolution. Such qualities are therefore unevenly distributed among different peoples and among individuals of the same people. The inherited disposition is ineluctable and dominate over the conscious personality, these thinkers maintained. It is wishful thinking to try to reform and improve individuals whose brutal behavior reveals that they stand under the influence of their subconscious instincts. The majority of humankind must instead be soberly and scientifically disciplined.

The masses were a privileged field of research for many of the new branches of knowledge that arose in this intellectual paradigm. Sociologists, criminologists, and anthropologists sought to explain the growing tendency of humans to congregate in crowds, the laws governing crowd behavior, and what possible consequences all this held for society's future.

Le Bon's contribution to this theoretical inquiry was his affirmation of the existence of a crowd consciousness, a collective soul, or a mass soul— he variously referred to *"une âme collective"* and *"une âme des foules."*[16] This idea he picked up from the anthropological science of his era, which commonly argued that the differences obtaining among the various peoples of the world could be derived from a racial soul or a racial consciousness that determined each people's qualities. In similar vein, Le Bon now submitted that there is a crowd soul, consisting of inherited dispositions, which finds expression whenever people gather in crowds.

In order to explain the function of the crowd soul, Le Bon turned to his colleagues in the medical sciences. He relied on recent discoveries in clinical psychology that, in his view, could explain why large numbers of people were eager to join collective movements that voiced dissatisfaction and pressed for social change. Le Bon's attempt to apply the methods of empirical psychology to the analysis of social processes led to *Psychologie des foules* (1895, *The Crowd: A Study of the Popular Mind*), usually regarded as the great summation and popularization of end-of-the-nineteenth-century French mass psychology.

French psychology of this period was entirely based on the study of mental pathologies. The core of Le Bon's description of collective human behavior consists of three concepts: suggestibility, hypnosis, and mental contagion. Le Bon appropriated all three from studies of insanity developed by Charcot, Esquirol, Bichat, and other physicians at the asylums of Salpétrière and Bicêtre in Paris.

Le Bon's account of "mental contagion" is a good illustration of how he went about constructing his theory. Le Bon was here influenced by Herbert Spencer's conception of primitive learning as an act of *imitation*, an idea later developed by the sociologists Gabriel Tarde and Emile Durkheim to account for similarities of behavior that make societies cohere.[17] Le Bon connected this theory of imitation to psychologist Prosper Despiné's theory of contagion, which served to explain how somebody may unconsciously *imitate* the symptoms of his or her mentally disturbed partner. The phenomenon was known as *"folie à deux,"* madness for two. It was usually seen in loving couples: a deranged person seemed to incite his or her healthy spouse to commit criminal or pathological acts. Despiné placed such behavior under the rubric of *contagion*.

In his theory of mass psychology, Le Bon compressed these two distinct scientific ideas into one. Sociology offered him a general theory of society as being founded on the human drive to learn by imitating others; psychology offered him a theory of how a mentally ill person encourages a companion to imitate his or her behavior. By eclectically (con)fusing the two, Le Bon was able to pretend that the universal scope attributed to the sociological theory of imitation could be claimed for the rather particular case of mental contagion of madness, and he went on to conclude that humans were susceptible to brain disturbances whenever they gathered in groups: "ideas, sentiments, emotions and beliefs possess in crowds a contagious power as intense as that of microbes. . . . Cerebral disorders, like madness, are contagious (the classical folie à deux)."[18]

Like other researchers devoting themselves to the study of mass psy-

chology in the 1880s and 1890s—Gabriel Tarde, Scipio Sighele, Pasquale Rossi, Ernest Dupré, Auguste Marie, and Charles Blondel—Le Bon also relied on clinical psychology for his theory of hypnotic suggestion. Since all of them readily ignored that the theory of hypnotic suggestibility applied only to a small number of neurotic patients, they could portray all social relations involving a leader and a group as hypnotic acts.[19] Hallucinations induced in a mad patient by the hypnotizing physician were thus seen as analogous to the alleged collective hallucinations induced by the agitator of the crowd.

The combination of these psychological notions of mental contagion, hypnosis, and suggestibility provided the mass psychologists with a powerful diagnostic system, with which they sought to explain how hallucinations induced by the hypnotic powers of a political leader could easily spread to all members of a crowd. At the end of the day, the mass psychologists were thus prone to conclude that collective behavior was actually a case of "*folie à deux*," but on an epidemic scale. In *Psychologie des foules*, Le Bon sums up the principal characteristics of a person who joins the masses: "the disappearance of the conscious personality, the predominance of the unconscious personality, the turning by means of suggestion and contagion of feelings and ideas in an identical direction, the tendency to immediately transform the suggested ideas into acts. . . . He is no longer himself, but has become an automaton who has ceased to be guided by his will."[20] The individual who becomes part of a mass thus relinquishes his or her individuality and becomes an organ stirred by the passions circulating in the larger social body. Together, these passions form what Le Bon called a crowd consciousness or a mass soul.[21]

When Le Bon and other mass psychologists described crowd behavior as collective hypnosis, they assumed that someone was playing the role of the hypnotist. This actor was the leader; with his suggestive powers he fused individuals into a mass. "A crowd is at the mercy of all external exciting causes," Le Bon stated. The mass is "the slave of the impulses it receives."[22] Put differently, we may say that mass psychology construes the masses as a political problem, to which the leader constitutes the solution. Once effected, this solution implies that the formless matter of "the masses" is transformed into an organized group: a party, an organization, even a people.

The scientists who developed the theory of mass psychology often compared themselves to chemists and physicists studying molecules and physical forces. Were not social groups and individuals subject to the same inexorable laws of nature? "Vice and virtue are products like

vitriol and sugar," wrote Hippolyte Taine.[23] These social scientists gave a view of the mass that borrowed many features from the view of a physical mass presented in the natural sciences. Inert and undifferentiated, the mass was raw matter waiting to be kneaded into form by firm hands. Like all matter, the mass was bound energy, social and political passions that, under normal circumstances, were tied up and directed toward constructive purposes, the result being what social scientists called "civilization" or "social order." But the passions could also destructively explode, the result being a "riot," or even a "revolution."[24] To accomplish the former and avoid the latter, there was a need for a strong leader who could tame the people's volatile passions and guide them toward purposeful labor—a strong leader like Athena, the goddess of law, who by suppressing the Furies instituted the civilized polis.

As codified in the 1880s and refined in the following decades, mass psychology thus explains how leaders mobilize masses to further certain political or social goals. The theory offers no judgment on the goals as such. Hitler whipping up enthusiasm for the annihilation of Jews or Gandhi exhorting India's poor to rise against British injustice or Revlon promoting a new eyeliner—these are, in mass psychology, comparable phenomena. In all three cases, a leader directs the masses' desire toward a certain objective; that the objective can vary between such extremes only confirms another basic assumption of the mass psychologist: the masses are incapable of thinking and may be led to do anything. It is no coincidence that Le Bon's *Psychologie des foules* was preferred reading for chiefs of state around the world, from Theodore Roosevelt to Adolf Hitler and Benito Mussolini.[25] "I have read all his works," Mussolini confessed once. "And I don't know how many times I have re-read his *Psychologie des Foules*."[26]

Mass psychology did not seek to explain only *how* power is exercised—through the hypnotic ability of the charismatic leader. It also sought to prove *that* power *must* be exercised—for otherwise the dangerous classes would be led astray by their passions. This hints of the ambiguity of mass psychology: it is at once a lesson in domination and a lesson about domination. It provides a manual in the art of manipulation, at the same time offering a critical analysis of that art.[27]

What is the ultimate meaning of the view of the masses that, in or around 1889, was promoted to a scientific discipline called mass psychology? In his book about the history of madness, Michel Foucault writes about the "the Great Internment" at the middle of the seventeenth century, a clean-up operation that sought to discipline idle or rebellious seg-

ments of the French population.[28] Those considered mad—idiots, village fools, and mentally disturbed—were picked up from streets and squares and hoarded into correctional institutions, where they were lumped together with idlers, unemployed, homeless, beggars, poor elderly, cripples, petty thieves, criminals, vagabonds, and other kinds of loose people. As Foucault emphasizes, the mad ones were not detained because of their *mental* disability. They were excluded on account of their *moral* inferiority and *social* irresponsibility, qualities they presumably shared with the other targeted groups.

With the emergence of mass psychology at the end of the nineteenth century, the scenario is reversed. Now, those who are seen as morally inferior and socially irresponsible, that is, the impoverished and laboring classes, are grouped with the insane and excluded on account of their *mental* disability. With the theory of mass psychology, all grounds for defending collective action were cut away from mainstream cultural and political vocabulary, argues the historian Robert Nye. From now on, acting collectively was clinically defined as insane.

Meanwhile, mass psychology also invited a particular kind of historical revisionism. The physician Lucien Nass, for one, described the Paris Commune as a "revolutionary neurosis," manifesting an underlying "morbid psychology."[29] Another ambitious application of mass psychology was made by neurologist Alexandre Calerre, who classified all the major revolutions and rebellions in the history of France—David's 1789, Hugo's 1832, Meissonier's and Flaubert's 1848—according to the nature of the contagion and the degree of suggestibility that characterized these events. Calerre also claimed discovery of some mass-psychological diseases that in his view had been unduly neglected: "contagious hystero-demonopathy" and "hallucinatory psychosis of a depressive order."[30]

Gustave Le Bon, for his part, applied his theory in *La Psychologie du socialisme* of 1898, a book that clarifies the deeper political rationale of mass psychology. The problem at stake for Gustave Le Bon in 1898 is the same problem that was at stake for Edmund Burke in 1790: Who are best suited to represent the general will, the interests of society? Le Bon dismissed the labor movement's struggle for universal suffrage and social justice as a pathological delusion. "We must not forget," he wrote, "that the exact hour that definite decadence began in the Roman Empire was when Rome gave the rights of citizens to the barbarians."[31]

[17] Society Degree Zero

Mass psychology is the most doctrinaire version of a view of society that has taught us to perceive human collectives as crowds or masses. It has taught us to analyze theses masses as unified blocks, ruled by emotions and acting impulsively. It has made us understand these unified and impulsively acting masses as disorderly and dangerous. And so it has convinced us that masses are a species to be held under surveillance and in confinement.

Mass psychology has also trained us in the art of interpreting visual representations of human crowds. The analytical tools that art historians and critics use in approaching images of collectives seem like Stone Age axes when compared with the advanced instruments applied in their interpretations of artistic portraits of individuals.[32] According to Hanna Deinhard, art history and art theory have yet to develop an iconology of the crowd.[33] She asks why no one has cared to seriously investigate how human collectives have been represented in Western painting.[34]

A moment ago, I mentioned that interpretations of James Ensor's *Christ's Entry* are marked by social views derived from mass psychology.[35] Describing the painting in 1947, Jean Stevo writes: "The mass, the brutal and barbarian mass pushes forward in closed ranks. The mass oppresses us through its presence."[36] Twenty years later, Georg Heard Hamilton writes: "In depicting the event as a socialist holiday, Ensor expressed his disgust with what Mallarmé had called the 'ordinary enemy,' the people."[37] In a book from 1970, Patrik Reuterswärd describes the painting in similar terms: "Judged by the way this cheering mass has been depicted, there is no other way to see it than as a thousand-headed hydra made up of all sorts of reckless indulgence and promiscuity."[38] Stephen McGough, who in 1985 published the most comprehensive analysis of *Christ's Entry*, as-

serts that "Ensor's message" in the painting "was that society was systematically excluding the person who was truly an individual. . . . For Ensor the mass in *The Entry* is the metaphor for this willful alienation of the self so that it may be lent to collective purposes."[39] Joachim Heusinger von Waldegg apparently is of the same opinion, stating in 1991 that "Ensor's pessimistic analysis is in many ways related to Gustave Le Bon's *Psychologie des foules*. . . . Ensor's painting . . . makes manifest the irrational moment of the masses in their inability to communicate with anything else than gestures. At the same time it shows their susceptibility to slogans and doctrines."[40] Finally, here's Michel Draguet in his 1999 survey of Ensor's life and work: "The crowd threatens to devour anyone who tries to distinguish himself from it. The malleable crowd evolves through hypnotic contagion and suggestion. Ensor's vision renders such a collective hallucination."[41]

It is true that Ensor was submerged in the same cultural atmosphere as the French mass psychologists and that he struggled to represent social situations of a similar kind. Yet, a closer look at *Christ's Entry* makes clear that the painting contests their view of society. Indeed, even the elementary formal features of *Christ's Entry* undermine mass psychology's assumption that society is constituted by individuals and masses. As Waldemar George has emphasized, *Christ's Entry* obeys no known laws of perspective that aid the viewer to organize the visual plane.[42] This is because the painting is structured by three conflicting perspectives that, taken together, turn the image into a play of oppositions, suggesting alternative ways of organizing the same social space. The first perspective is, of course, that which follows the boulevard itself, its end dissolving into infinity under the great red banner. But the eye is at the same time led along a vertical axis running straight up the middle of the canvas and connecting a series of key figures, from the conspicuously massive body of the bishop up front, through the red-nosed drum major that heads the marching band, to the geometrical center of the framed rectangle, where we make out the tiny figure of Christ on the back of a mule. This perspective is further marked by a slanting diagonal movement of light and people that emerges from the side street just above Christ's halo.

On a first viewing, however, the observer is not invited to explore either of these axes, both of which pull the gaze into the depth and background. A virtual mural or tapestry of oil, *Christ's Entry*—its width exceeding four meters—instead calls for a horizontal scanning of the panorama, and the viewer will typically stroll in front of it as along a mural, watching the masks and faces that are compressed into the front plane. The third

perspective thus consists of a web of horizontal exchanges, gestures, and glances within the collective closest to the viewer. For instance, the gaze of the man in the lower right corner has his eyes fixed on the clowns and blank banners to the left. Their elevated position, in turn, is mirrored by the four figures on the green podium to the right. The horizontal lines suggested by these glances and positions delimit a rectangular area separating the crowd in the foreground, in front of the military band, from the rest of the street.

Each perspective thus brings a different crowd into focus. The one gathering around Christ is a religious procession, a fools' parade, or a band of circus clowns and artists. The crowd that occupies the foreground suggests a spectacle of power, a pantomime of authoritative positions enclosing a horde of people whose attention is suspended between left and right. The perspective that travels down the boulevard brings serried ranks and flying red banners into view: a workers' demonstration. In this way, *Christ's Entry Into Brussels* mirrors different aspects of a social drama—and this not only by presenting it through three different perspectives but also by alluding to at least four distinct pictorial conventions. Ensor evokes traditional images of military parades, press images of workers' demonstrations, depictions of carnival processions, and, of course, also popular prints representing Christ's Passion.

Why insist on seeing all this as *one* mass? Ensor's painting shows not one crowd but an aggregation of many. They come toward us from different directions and for different purposes. They move at cross currents and block one another's way, until they reach the front and line up as a series of faces detached from the collective body they once belonged to, constituting a new kind of collective without identity or agenda, their swollen heads as self-assured and evasive as the burghers in any seventeenth-century Dutch group portrait—a genre, incidentally, that Ensor often caricatured, as in *The Good Judges* (1891), or in his many group portraits with masks, such as *The Intrigue* (1890; figure 17.1) and *Masks Observing a Turtle* (1894).

In everything, from the sheer dimensions of the canvas to the juxtaposition of various crowds, to the stark contrasts of colors and the different ways in which the paint is applied—by brush, knife, fingertips, drippings, cloth, or tube opening—Ensor maximizes the contrasts and oppositions of the visual plane, as though exploring how much heterogeneity a limited piece of two-dimensional space can tolerate before it disintegrates.

This is to say that *Christ's Entry* lacks a unifying structure. The absence of a dominant organizing pattern corresponds to the absence of any au-

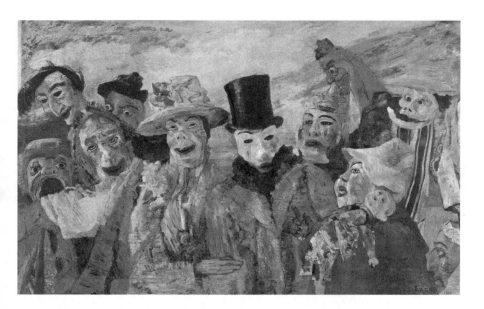

Figure 17.1. James Ensor, *The Intrigue* (*L'Intrigue*), 1890. Oil on canvas, 90 x 150 cm. Royal Museum of Fine Arts, Antwerp. Image courtesy of Reproductiefonds.

thority in the social drama itself. What the Lacanians would call the big Other—the phallic signifier imposing unity and identity on the members of the collective—is absent from the painting. Where is the leader of this crowd? Well, there are a few figures on the tribune or podium at the right. But they are apparently clowns and jesters, and they seem reluctant to issue any commands. The Christ figure at the center catches the attention of no one except his most immediate entourage. All the others are seeking in vain for a point of identification, for someone to identify with—for as long as this authoritative point of identification is missing, they will have to make do without identity.

"In political struggles men do not appear in their natural guises; each of them is dressed in a mask," wrote Georges Sorel, the anarchist and theoretician of mass action, in his review of Le Bon's *Psychologie des foules*.[43] Sorel believed, like Le Bon, that people involved in political struggles mime roles that corrupt their inborn identities.

Ensor was more radical. In his work, men and women fail to appear in their natural guises, for they have none. One's very identity is a mask, fabricated, wrinkled, and scarred through countless encounters with others.

In Ensor, human identity appears as a thin crust of ice covering the

fluid masses of social life. His work stresses this idea by foregrounding the mask. It's not just in his visual works that Ensor views humanity as a masquerade; in the odd speeches that constitute the bulk of his writings, he typically greets his audience as "Dear friends, ministers, consuls, mayors, and masks."[44]

True, the mask is a standard theme in late-nineteenth-century European culture. Deep uncertainty about the essence of the human being led many to the solution we call symbolism: human life hides another reality that can be accessed only through symbols. The masks populating Ensor's universe are in this sense the symbolic appearances through which a hidden social reality—shapeless and daemonic—expresses itself. But Ensor resolved the symbolist problem in a unique way. As André de Ridder states, he effaced the difference between the face and the mask.[45] The result were masklike humans and humanlike masks, creatures that are neither masks nor humans but belong to a third species without definite qualities. Human faces are loaded with exaggerated detail, surcharged by the monstrous and the ridiculous. Related to caricature, Ensor's vision effects a doubling or *dédoublement* that superimposes the anonymous mask of the type on the recognizable face of the individual or magnifies human traits to animal proportions. The unity of the person is split open, its unique personality impressed by the mark of the stereotype and suspended midway between identity and anonymity, humanity and bestiality. Neither autonomous individuals nor faceless elements of the crowd, Ensor's figures are at once themselves and others.

In his works of the late 1880s, these Ensorian creatures multiply and begin to engage in theatrical exchanges. It is impossible to say whether these scenes are psychological projections or mimetic descriptions of some external reality; the humanlike appearances are so fluid and fragile as to dissolve the walls between inner and outer world, between the dead skeleton and the pulsating body, and between individual and collective, to the effect that the interacting group of masks becomes an objective correlative of the deep and undifferentiated matter of social life as such. It is at this point that Ensor's symbolism turns expressionistic or even surrealistic, as it discloses a level of reality anterior to those cultural and conceptual systems of representation that organize the social field into distinct entities, fixed meanings, and stable identities.

James Ensor spent the larger part of his life in Ostende, a Belgian town well known for its annual carnival. His mother and sisters ran a souvenir store in which they sold carnival masks and costumes. In other words, there is a very concrete explanation why Ensor liked to

dress up the human being in masks and to render the world as a struggle between jesters and monsters.[46] In Ensor's work, the carnival is the moment of equality on earth.[47] It cancels all hierarchies. The carnival is a procession of signs without firm reference in reality, an endless process of semiosis. Because the carnival operates with mechanisms of reversal that cancel the distinction between imitation and original, the mask is placed on the same level of reality as the face. The connection between inside and outside is broken. External appearances no longer manifest any underlying identity. The meaning of the face, mask, or gesture will consequently depend only on its similarity to and difference from surrounding faces, masks, and gestures. The carnival is thus an a-psychological event. In this train of comic or ghostly figures, there is no appearance that can be led back to underlying interests or inner motivations.

Christ's Entry Into Brussels in 1889 undoubtedly conforms to the carnivalistic scenario. The heads in the painting seem disembodied, and some figures are literally decapitated. The obscure meanings of the faces or masks depend only on their relations to the surrounding ones, not on the fact that they are connected to separate organisms or psyches. Lacking any internal source of energy, their motions are determined only by the collective circuit in which they are inserted, like beads strung onto a tangled thread.

Christ's Entry thus operates on the same level as mass psychology, staging a conflict between reason and madness, order and revolt. In Le Bon's staging, this conflict is resolved by organizing society in two homogeneous blocs; the mad masses are tamed by the suggestive power of individual leaders. Ensor, by contrast, eradicates this division altogether. His figures drift in some new social medium where the conceptions of hypnosis, mental contagion, and suggestibility find no anchorage. For Le Bon, the crowd is structured by one collective soul; for Ensor, it is structured by countless lateral relations of difference and similarity. For Le Bon, the crowd is homogeneous; for Ensor, it is heterogeneous. Where Le Bon turns all the faces in the crowd toward the leader, Ensor has them fan out in a space without center. Where Le Bon sees the member of the crowd as an automaton, Ensor sees him or her as an ensemble of social tensions. If we want a definition of the visual grammar of *Christ's Entry*, we can say that the painting removes vertical relations of subordination and replaces them with horizontal relations of juxtaposition.

All this means that *Christ's Entry* suggests a social worldview that is the radical opposite to that of mass psychology. Ensor's figures all move

through a social field not yet divided into leader and people. The painting subverts hierarchies, tears down authorities, dissolves identities, violates order, breaks decorum, and laughs at dignitaries. Indeed, Ensor's depiction short-circuits the entire system of representation and power, not only the aesthetic system that determines *how* society should be represented but also the political system that decides *by whom* it should be represented. Through this work of destruction, Ensor delivers his figures to the ambiguous freedom of a world without fixed positions of power and hence without distinct social identities.

Consider, for example, the man and the woman kissing each other in the foreground of *Christ's Entry* (figure 17.2). Who is the woman? The red Phrygian cap betrays her as Marianne, symbol of the People and the Republic.[48] In Ensor scholarship, her embrace of the baffled burgher has been interpreted in Le Bon's terms, that is, as a denunciation of the contagious power of popular passions. Seduced by egalitarian ideals, the mob corrupts morality and invites vice.[49] If we remove Le Bon's lens, a different interpretation becomes possible. The good bourgeois is kissed in public by the heroine of the Commune herself. Is there a better way to rob him of authority and show him up for what he is? Interestingly, Ensor inserted this motif into many other works (*The Baths at Ostende*, 1890; *The Multiplication of the Fish*, 1891; *Masquerade*, 1891; *The Gendarmes*, 1892; and *Red Cabbage and Masks*, 1925–1930). He apparently used it as an emblem or a signature. Judge, bishop, minister, mayor, chief of police, general, doctor, and intellectual are resolutely forced into the howling crowd. As Ensor paints it, this crowd tells the agents of law and order: "Yes, we are just like you say, dangerous and insane—and we kiss you, because you're one of us!"

As the representatives of order are thrown into the gutter, so are the very principles of reason and civilization on which their authority is founded. The ruler of reason is broken. The painting destroys each normative position that would enable us to assess what is happening in the Brussels street. Hence, it is impossible to determine whether the social happening is normal or pathological. The distinction made by medical science between reason and insanity loses its applicability in Ensor's fantasy. His madness does not manifest itself as the opposite of reason but as a reason of a different order.

As in Strindberg and Nietzsche, we are faced with a madness in which there is method. It is not the method of science but of myth. *Christ's Entry* seems to tap its energy from the collective memory of a buried past when the categories of power and knowledge had not yet fully structured social

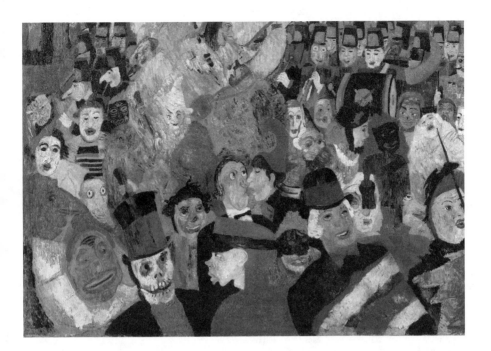

Figure 17.2. James Ensor, *Christ's Entry Into Brussels in 1889* (*L'Entrée du Christ à Bruxelles en 1889*), 1888. Detail with Marianne at center. Oil on canvas, 252 x 430 cm. The J. Paul Getty

life. It is in relation to this remote past that the peculiar *métissage* between human and animal that we see in Ensor's parade attains its ultimate meaning. The juridical systems of medieval Europe frequently designated someone who stood outside the law—the bandit or the outlaw—as a wolf-man. When a person was excommunicated from the polity of citizens, it was ruled that he could be hunted like the wolf, or he was said to carry a wolf's head and had to dwell in a no-man's-land between the human order and the animal order, the city and the forest, civilization and wilderness.[50] Popular imagination gradually transformed these outlawed wolf-men into werewolves and other hybrids of human and animal that came to populate European folktales and still are found everywhere in popular culture. The carnival, too, contains the echoes of distant times when a person could escape the law of his city by joining the free, outlawed community of the animal kingdom. The old master painters that were closest to Ensor were Pieter Brueghel the elder and Hieronymus Bosch. An extended family of

half-human creatures are swarming in their paintings. They also appear in *Christ's Entry Into Brussels in 1889*, once again conquering the city from which they were once expelled: a human face on the body of a bear; a human body with a monkey's face; a figure that is half-human, half-rhinoceroid; others bearing heads of wolves, horses, and hares; yet others with beaks of crows and parrots. The symbolic father of all these beings is the figure that is banned from the city and that threatens to return from the forest to undo the constituted social order. An echo of the same notion is preserved in Hobbes's account of the state of nature as a condition in which "man is a wolf to men." *Christ's Entry* reenacts this prepolitical state. As the order of the city is dissolved, its population no longer consists of distinct human individuals. We cannot even tell whether it consists of men or beasts.

But if there are no autonomous individuals in this painting, there cannot be any masses either, for, as suggested above, "the masses" is but a projection produced by people who regard themselves as individuals. What we see, then, is neither individuals nor masses. We see, rather, what a social community looks like before it is interrupted by systems of representation that divide the social field into individuals and masses. Society is here frozen in a state of becoming, constituted solely by horizontal connections and antagonisms, suspended between the nothingness of human desire and the always inadequate forms of being in which that desire seeks satisfaction.

Ensor renders the same condition of social transformation even more graphically in another remarkable work, *The Cathedral* (1886; figure 17.3). In this etching, the fluid collectivity at the bottom passes through a series of transmutations, ascending to ever-higher forms of social organization, until it seamlessly passes over into the petrified nature of the cathedral, a symbol of the authority and power of past generations, now weighing like a nightmare on the shoulders of the people. It is only in relation to these symbols of authority that the people appear as a mass. Remove these representatives, and the people will constitute itself in a different form. Remove the weight of the state, the church, and the rest of the ideological apparatus, and society will look like *Christ's Entry*.

In a little-known article on Ensor, Walter Benjamin remarks that the painter dissolved the seemingly solid masses of bourgeois society. Like someone who rolls away a stone to see what is concealed beneath it, Ensor turns over social institutions, thus exposing "not the faces but the entrails of the ruling classes."[51] Benjamin invites a reading of *Christ's Entry* in sequential terms. In his view, the image compresses the slowly flowing process of history into one punctual event. Ensor interrupts the flow of

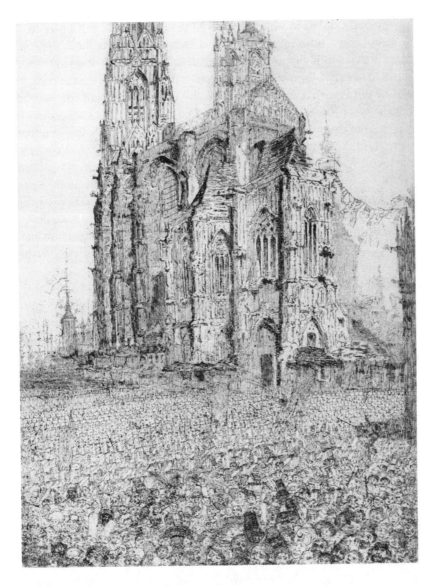

Figure 17.3. James Ensor, *The Cathedral* (*La Cathédrale*), 1886. Etching on paper, 24.7 x 18.8 cm. Museum Plantin-Moretus/Prentenkabinet, Antwerp: collection prentenkabinet.

history and exhibits a radical break, at the junction of a past order torn to pieces and a future not yet formed. Such an approach sheds light on some of the painting's most striking features. First, it elucidates why Ensor chose to antedate the event as taking place in 1889, that is, on the centennial of the French Revolution and in the inaugural year of the Second International—facts that most scholars pass over in silence. Second, it clarifies the meaning of the peculiar monochromatic fields in the upper margins of the canvas: the green and blue areas in the upper two corners, the broad stroke of dark green along the top edge, the checkered pattern of black stripes along the left edge. Critics have typically understood them as mere fill-ins of spaces that were left over when Ensor composed the image. But if *Christ's Entry* represents a historical break, these areas attain a crucial function. Comparable to the scaffolding on a construction site, these parts elicit the impression that the image represents a society in the process of rebuilding itself.

Moreover, to interpret *Christ's Entry* as a crystallization of a discontinuity is also to grasp the meaning of the three contradictory perspectives organizing the visual plane. I have already suggested that each perspective brings a different crowd into focus. This idea is both qualified and supported once we realize that each perspective, and the particular crowd it corresponds to, indicates a specific moment in the process that turns over the old order and institutes a new one. The main event is of course the "Entry" itself, evoked by the visual perspective centering on Christ. But if *Christ's Entry* inaugurates the coming of a new era, it also expels the old order. The caricatured clergy and bourgeoisie lined up in the foreground appear to embody this oppressive past; they are about to drop outside the frame, their exit heralded by the pompous bishop, the first to be dethroned by Messiah's arrival. Indeed, *Christ's Entry* could also be called *The Exit*.[52]

If the crowd in the foreground signifies the exit of the past and if, furthermore, the crowd around Christ in the middle represents the entry of the new, how are we to approach the crowd evoked by the third perspective that follows the boulevard to its vanishing point under the red banner? Legions of people, entire populations, line up in the street. They are too far away to be distinguished, the messages on their flying banners impossible to make out. They do not march but stand in wait behind Messiah, who seems to clear the way for them.

The infinitely extended perspective in this part of the painting is probably Ensor's way of paying tribute to the old Flemish master he admired most, Brueghel the elder. The principles of perspective governing the

composition of *Christ's Entry* is clearly related to the principles Brueghel applied in his *Children's Games*, in which the wide panorama of plays and games is spatially balanced by the depth perspective of the village street, which, like the boulevard in *Christ's Entry*, adds an almost transcendental thrust that immediately relativizes the activities in the foreground. In Ensor, similarly, the recognizable figures up front, Christ included, are temporalized, relativized, and eventually dissolved by the long perspective—a visual equivalent of the historians' *longue durée*—that is occupied and represented by the anonymous collective.

It is therefore inadequate to regard Christ as the main protagonist of *Christ's Entry*; his reduced size is enough to suggest the contrary. Ensor's Messiah is assigned the more modest role of path breaker. In that sense, he is similar to most other utopian figures: they are rarely authentic incarnations of the coming world of freedom but facilitators who enable that world to come into being.[53] Ensor's Christ is thus a mediatory figure that neutralizes the forces that block change. He marks the entry to a new order but is not himself of that order. *Christ's Entry* evokes the new order only as a possibility, represented by the anonymous multitude that covers the far section of the boulevard. Whoever they may be, they are about to enter the stage of history.

[18] The Nigger

The great symbolic event of the Paris Commune was the felling of the Vendôme Column on May 16, 1871. Forty-three meters tall, the column was erected by Napoleon to commemorate his triumphs in battle against his European rivals. According to the decree of the Commune, it was to be demolished because it commemorated warfare rather than universal solidarity; its very existence was thus "an assault on one of the three great principles of the republic—fraternity." It is easy to imagine the destruction of the column also as the revenge of a subjugated people, now shaking off the yoke of power.

The day before the demolition of the column, May 15, 1871, the young poet Arthur Rimbaud wrote to his friend and colleague Paul Demeny. The letter contains a couple of statements that have become historical. The first one, difficult to translate, is one of the most frequently quoted phrases in the history of literature: "Je est un autre." The sentence means not just "I is an other." Through its grammatical irregularity, it also enacts the estrangement of the "I" from itself. The sentence has come to codify a long tradition of critique of Cartesian individualism, that is, the idea of the "I" as a unified and autonomous agent.

The second statement is usually regarded as a key to the aesthetics of modernism: "A Poet makes himself a visionary through a long, boundless, and systematized *disorganization of all the senses.*"[54] Stated more crudely: Our everyday perception gives us a false idea of the world. To attain a true vision of reality, one must destroy one's habits of perception and ready-made views of the world.

However, the history of literature is silent on how Rimbaud opens his letter: "I have decided to give you an hour's worth of modern literature. I begin at once with a contemporary psalm." Rimbaud then inserts a poem he has

just finished, "Chant de guerre parisien" ("Parisian War Cry"). It is the song of a militant ("Never, never will we move back / From our barricades, our piles of stone") who has only one thing in mind: to crush the "bourgeois, bug-eyed on their balconies, shaking at the sound of breaking glass":

> The city's paving stones are hot
> Despite the gasoline you shower,
> And absolutely, now, we've got
> To find a way to break your power![55]

Rimbaud praises the Paris Commune, which in the very same days is being crushed by the French army. Reinstating the order of the sword, Adolphe Thiers has ordered the army to deny mercy for all supporters of the egalitarian regime. Thousands will be massacred.

A handful of explicitly anarchist writers aside, Jules Vallés being the most well known among them, Rimbaud is alone among French writers of the period to have spoken in support of the Commune. Why is his political commitment never mentioned in literary history? Perhaps for the same reasons that art historians tend to interpret James Ensor's work as depicting the struggle of the brave individual against the fickle masses. The posterior reception of Ensor is similar to that of Rimbaud. Their political commitments and activities go down as thrilling anecdotes or youthful delinquencies.

The alternative would be to see their militant spirit as part and parcel of the modernist thrust of their work. Theirs is apparently a modernism in which the aesthetic impulse is married to the political. Thus, in his letter to Demeny, Rimbaud delineates not only a new view of human life (*I is an other*) and a new aesthetic (*disorganization of the senses*), but a social revolution as well ("Parisian War Cry"). From his way of phrasing the matter in the letter, it is clear that these three are related aspects of a single and coherent program: the liberation of the sensuous human being through the affirmation of subjective and collective *jouissance*, that is, the very same liberation that Ensor enacts on the boulevard of Brussels.

Kristin Ross, in her book on Rimbaud and the Paris Commune, argues that the Commune during its brief period of existence came close to realizing a new form of social organization. She likens it to a swarm. Why? Because the swarm denotes the ideal conditions for democracy, Ross argues: a collective life-form in which nobody is elevated to the position of the others' representative. In this sense, the swarm deviates from our

common notions of the class, the proletariat, and the mass, all of which presuppose a firm demarcation between parties or political leaders, on the one hand, and the people or plebiscite, on the other. If we renounce the evolutionary vision of the swarm as something formless, utopian, primitive, or otherwise incompatible with the realities of a complex society, we can begin to see it, Ross states, "as that which escapes from any and all forms of sovereignty."[56] In the swarm, power is never delegated and put into the hands of a king, a government, or a leader. The social form of the swarm is horizontal and paratactic: it places each man and woman on equal level, eradicating social and political hierarchies, while also rejecting any system of representation that sets itself apart from the larger social fabric and seeks to constitute itself as an autonomous political body. Karl Marx described the Commune in similar terms, "as a resumption by the people for the people of its own social life."[57]

There is reason to ask, Can such a society exist? Evidently, yes, for this is what society was like during the Commune. How does such a society present itself? Ross points to the destruction of the Vendôme Column, which signified the leveling of those institutions that once represented society and its history from above. People instead represented themselves through a horizontal network of production and consumption in which each person satisfied the needs of others through his or her voluntary activity.

Above all, Ross points to the texts of Arthur Rimbaud, which, in her view, express the voice of the swarm. Less than twenty years old and fighting for the Commune, Rimbaud reinvented the art of poetry by transposing the leveling and allocentric form of the swarm into a lyric idiom that exploded meters and genres. Rimbaud's verse and prose are invaded by popular songs, citations, and slogans. As these idioms interrupt the poetic process, the poet becomes less an autonomous creator and more a medium through which the multiple voices of the collectivity speak. The central agency of literary representation, the authoritative first-person singular, is thus abolished. Exclaiming "Je est un autre," Rimbaud illuminates the radical democracy of the swarm, in which the individual is sustained only through the intervention of the other, of his fellow human beings. Rimbaud speaks for a centrifugal mental and social force that cancels the poetic authority, undoes each position of centrality, and throws everybody toward the barbarian margin.

Mixed in with the utopian vistas and frantic fantasies there are in Rimbaud's work also sentences that consist not so much of words as of screams and punches. Joining forces with the people of the gutters, or

even with the beasts, Rimbaud spontaneously identifies with the outcasts of human history. He shares in their hatred of the social order that keeps them down. It is the pitiful fate of the poet, he states in *A Season in Hell*, to have been born and raised in "these Western swamps," and the only way to escape is to make common cause with the barbarians.[58] "I have been of inferior race for ever and ever," Rimbaud claims.[59] "The best thing is to quit this continent where madness prowls, out to supply hostages for these wretches. I will enter the true kingdom of the sons of Ham."[60] Already in the 1870s, Rimbaud saw the connection between the religious discipline under which he suffered in school, the humiliation and exploitation of the laboring classes in mines and factories, and the colonialist subjugation of non-European peoples: "The white men are landing! Cannons! Now we must be baptized, get dressed, and go to work."[61]

The brief disruption of the system accomplished by the Paris Commune coincided with the emancipatory thrust of Rimbaud's own writing. Thus, while Alphonse Daudet warned that under the Commune Paris was in the hands of niggers ("*nègres*"), Rimbaud confirmed slyly that, yes, "I am an animal, a nigger." He then went on to enumerate the dignitaries of France, stating that they, too, are niggers: "maniacs, savages, misers, all of you. Businessman, you're a nigger; judge, you're a nigger; general, you're a nigger; emperor, old scratch-head, you're a nigger."[62] Celebrating a "race that sang on the scaffold," Rimbaud's paratactic prose stalks the heads of French society and throws them into a mad procession headed toward the slums. Authorities are dethroned, fools coroneted, the distinction between human and beast effaced.

Rimbaud's work thus calls not only for a "systematized disorganization of all the senses," but also for a systematic disorganization of all forms of power. The poet speaks about slaves and a future belonging to the many. The people's eternal dream of justice never seemed as compelling as in Rimbaud's work. Break camp! shouts the poet. Soon it's time to depart. "When will we go, over mountains and shores, to hail the birth of new labor, new wisdom, the flight of tyrants and demons, the end of superstition, to be the *first* to adore . . . Christmas on earth!"[63]

So it is that James Ensor's *Christ's Entry Into Brussels in 1889* encounters its textual sibling in Rimbaud's work. The correspondence between the worldviews and aesthetic attitudes of the poet and the painter is sometimes absolute. When the French writer evokes the spirit of the Commune in his prose poem "Parade," the text—including syntax, style, and rhythm—comes across as a detailed rendition of the drama that Ensor would visualize seventeen years later:

Chinamen, Hottentots, Gypsies, Morons, Hyenas, Molochs,
Ancient insanities, sinister demons,
They distort popular maternal scenes
With bestial positions and caresses.
They play new plays and they sing the songs
Of the spinsters and the knitters in the sun . . .
Marvelous jugglers, with magnetic acting
They transfigure places and people.
Eyes flame, blood sings, bones begin to swell,
Tears start, and networks of scarlet ripple and throb.
Their jibes and their terror endure for a moment
Or can last for months upon end.
ONLY I HAVE THE KEY TO THIS SAVAGE PARADE![64]

[19] The Modern Breakthrough

The best book on James Ensor is still the one published by his friend Emile Verhaeren in 1908. Verhaeren remarks that Ensor was often accused of inaugurating "a sort of Commune with his art and . . . inscrib[ing] his aesthetic doctrine in the folds of a red banner."[65] It is well known that Ensor's intellectual friends and acquaintances were socialists and anarchists, a few of them even veterans of the Commune, like the geographer Elisée Reclus. But it is difficult to prove any direct influence of their ideas on Ensor's life and work. He was an eccentric, a restless and stubborn person who regarded it as utterly senseless to imitate or illustrate the ideas of others. The elective affinities that he cultivated and the context that helped shape his work are detectable only in the rebellious expressivity of his images.

When Ensor executed *Christ's Entry* in 1888, the situation in Belgium resembled the one in France of 1871. It was a time of severe economic depression, with large parts of the working class unemployed and starving. In the spring of 1886, Belgium exploded in violent confrontations. The unrest began on March 18, when the anarchists in Liège marched to commemorate the fifteenth anniversary of the Commune and the military responded by killing several of the demonstrators. The event ignited a wave of rebellions that were eventually struck down by the army, leaving many more killed and the industrial centers under military command.[66] Following the rebellion was a legal maze of biased prosecutions of socialist leaders. The convicted included the head of the Flemish communists, Edouard Anseele who, incidentally, is saluted in the preparations for Ensor's *Christ's Entry* and also in the 1898 etching based on it (figure 19.1).

In his chronicle of that year, Louis Bertrand concluded "1886 is our *année terrible*, just like the year 1871 was in France." Yet, it was also, Bertrand added, the first time that "the popular masses forced everyone to

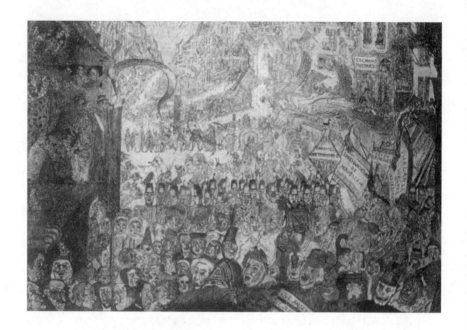

Figure 19.1. James Ensor, *Christ's Entry Into Brussels* (*L'Entrée du Christ à Bruxelles*), 1898, with the communist leader Anseele announced in the foreground. Etching on paper, 24 x 35.5 cm. Gift of Dr. and Mrs. Richard Simms. Research Library, The Getty Research Insititute, Los Angeles, California (2004.PR.58).

listen to their great voice."[67] The revolutionary ferment is now permanent, wrote Jules Brouez that same year: "a new element is today appearing on the social stage: the People, or, better, the Proletariat."[68] In 1886, this people awakened to the political reality: in a population of six million, 5,900,000 were excluded from the political system. One contemporary commentator remarked that Belgian society was split in two: "The people see in power nothing but an instrument of oppression, the bourgeois in the entire mass of workers nothing but an army of disorder."[69] In 1886, this system began to crumble; in 1893, it was replaced by universal suffrage for men.

The same year, 1886, was also when Edmond Picard, prolific writer, radical lawyer, socialist politician, and editor of the avant-garde journal *L'Art Moderne*, published his epochal article "Art and Revolution." The time had come, Picard said, for intellectuals "to dip their pens in red ink."[70] The artistic movement that Ensor spearheaded in the mid-1880s, Les XX (The Twenty), was identified with this political tendency. A critic

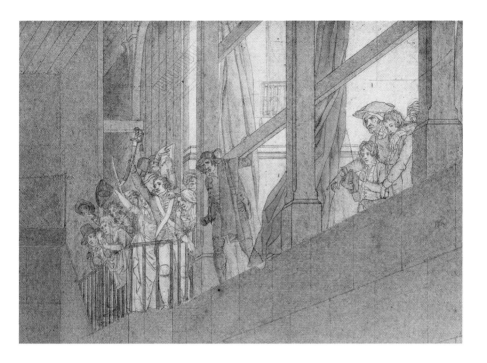

Jacques-Louis David, *The Tennis Court Oath* (*Le Serment du Jeu de Paume à Versailles le 20 juin 1789*), 1791–, detail with Jean-Paul Marat. Versailles, châteaux de Versailles et de Trianon. Photo RMN / © rights restricted.

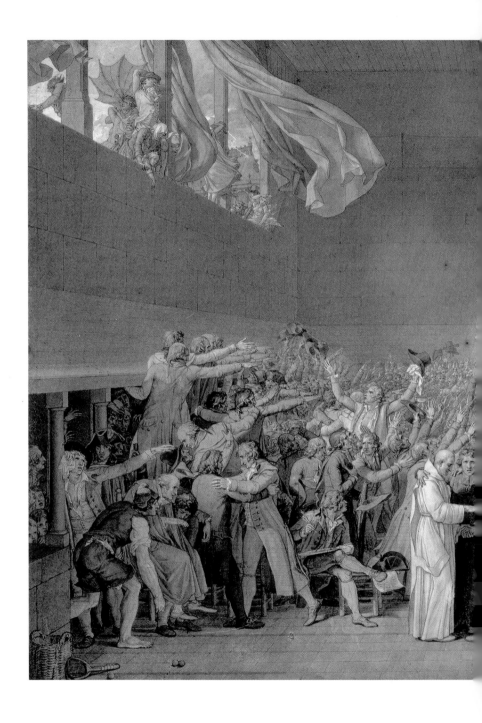

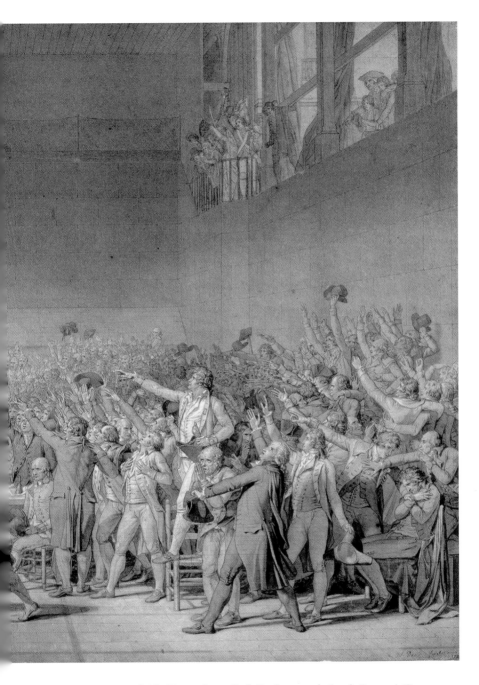

Jacques-Louis David, *The Tennis Court Oath* (*Le Serment du Jeu de Paume à V
ersailles le 20 juin 1789*), 1791–. Versailles, châteaux de Versailles et de Trianon.
Photo RMN / © Gérard Blot.

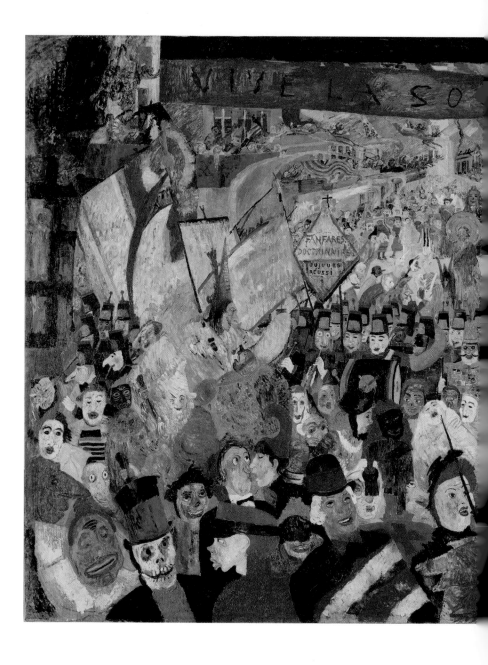

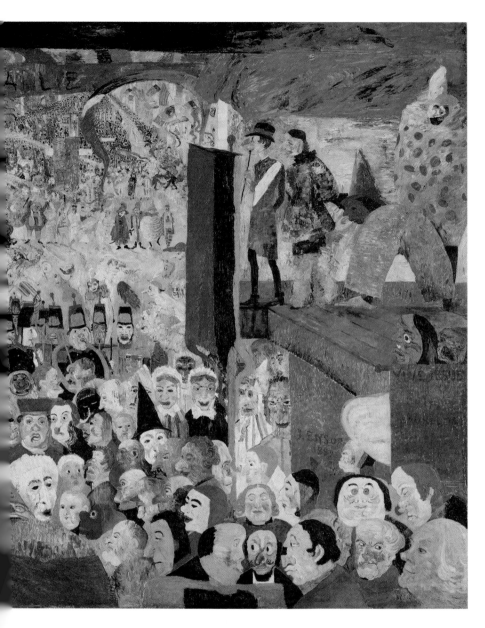

James Ensor, *Christ's Entry Into Brussels in 1889* (*L'Entrée du Christ à Bruxelles en 1889*), 1888. Oil on canvas, 252 x 430 cm. The J. Paul Getty Museum, Los Angeles. © Estate of James Ensor/Artists Rights Society (ARS), New York.

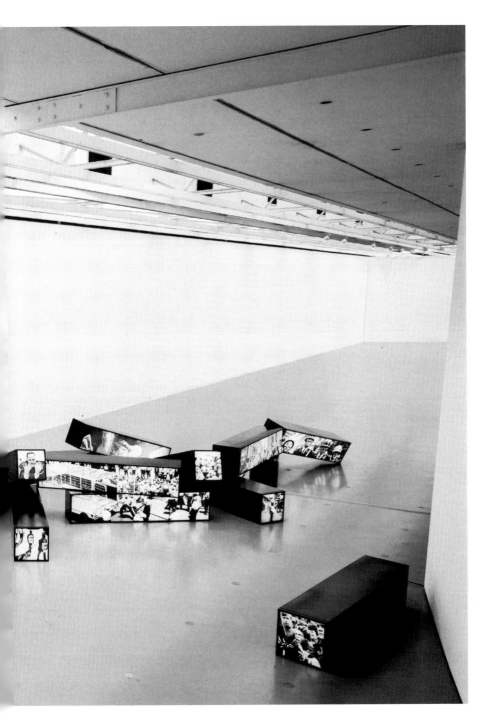

Alfredo Jaar, *They Loved It So Much, the Revolution* (*Ils l'ont tant aimée, la révolu-
tion*), 1989. Installation. Musée d'Art Moderne de la Ville de Paris. Published with the
permission of the artist.

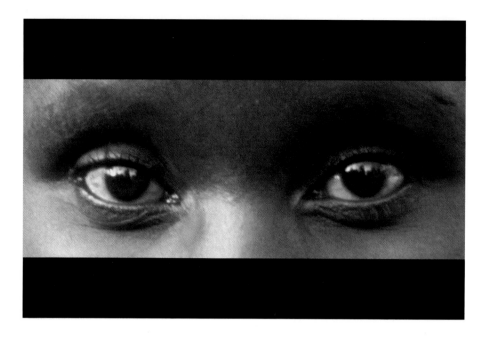

Alfredo Jaar, *The Eyes of Gutete Emerita*, 1996. Published with the permission of the artist.

Alfredo Jaar, *Gold in the Morning*, 1986. Detail. The Venice Biennale 1986. Museum of Contemporary Art San Diego. Published with the permission of the artist.

at *L'Etoile Belge* shivered at the sight of the exhibition catalog for the 1888 salon of Les XX: "the catalog is red, the red of blood, the red of combat and carnage."[71]

As contemporary chroniclers of Belgian art such as Camille Lemonnier and Richard Muther recognized, the political radicalism of the avant-garde allowed "the masses" to assert their presence in the nation's culture, thus changing the ways in which society was depicted aesthetically and at the same time calling for a new system of political representation.[72] Ensor's contribution to this tendency is most evident in a handful of militant and blasphemic images that frontally assault the pillars of society: *The Gendarmes* (1892) and *Doctrinal Nourishment* (1889). *The Strike* (1888; figure 19.2) renders police violence against striking fishermen in Ostende; while *Belgium in the Nineteenth Century* (1889; figure 19.3) shows king Leopold sitting amongst the clouds with a stupefied expression in his face, looking down through his monocle on a Belgium that is transformed into a battle field.[73]

The avant-garde had reasons to support socialism. Writers and artists did not share the experiences of the working classes, to be sure, but they struggled against common enemies: an authoritarian constitutional monarchy; a liberal industrial bourgeoisie notorious for its hostility to art and thinking; and a church that controlled the system of education all the way from kindergarten up through the university. Similar fronts of workers, intellectuals, and artists were found in many western European countries during the 1880s. The Danish critic Georg Brandes coined the expression the "modern breakthrough," arguing that the emergence of modernist manifestoes, the fight for secularism and freedom of expression, and the struggle for social justice were facets of one and the same historical process.[74] These movements shared a wish for new forms of representing society: new political institutions to articulate the common will and new cultural and artistic forms to capture social reality. At the same time, they sought to remove the mystifications of reality upheld by the aristocracy, the religious indoctrination of the church, the hypocrisy of the bourgeoisie, and the superstitions of the common people. The period between 1886 and 1893 was thus an era of sharp polarization. To depict Belgian society during these years was to take a stand in a number of social and cultural struggles. It was to choose sides in a contest that ultimately concerned what Cornelius Castoriadis has called "the imaginary institution of society."[75] Every time someone addressed the national situation, he or she inevitably had to answer the fundamental political question, how to represent society.

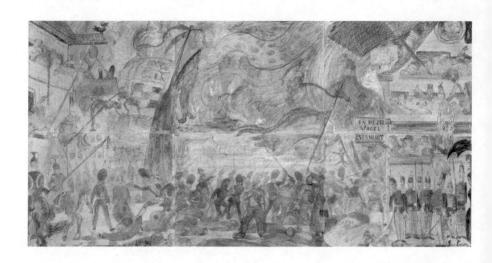

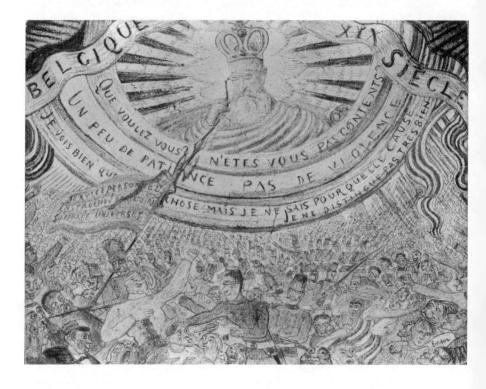

How should Belgian society best be represented? By whom? In which language? By which political institutions? Through which aesthetic methods? What makes *Christ's Entry* such a remarkable painting is that it condenses virtually all the lines of conflict that divided Belgian society and culture during the modern breakthrough. There is the struggle for universal suffrage and social justice, for the painting is partly modeled on newspaper illustrations depicting a huge socialist march that took place in Brussels on August 15, 1886.[76] In Ensor's image we also see the aesthetic fight between the avant-garde and the academy, as the union of young painters gathered in Les XX are shown throwing up on the academic establishment. Incorporated into the picture is also the cultural and linguistic struggle between the supporters of Flemishness and the adherents of Francophonie. We see the republicans fighting the monarchists and the movement for secularization assaulting the men of the church. Finally, there is, of course, the class struggle itself, which in 1886 brought Belgium to the brink of civil war. In Ensor's *Christ's Entry*, these conflicts, tensions, and struggles are all collapsed into one event.

Collapsed, but not ordered. For what is even more remarkable, and what makes *Christ's Entry* unique among crowd representations, is that it refuses to distinguish between these lines of conflicts. It does not sort out the ideological, political, social, cultural, and aesthetic aspects of the struggle that divided Belgian society around 1889. Unlike his colleagues Constantin Meunier, Léon Frédéric, Eugène Laermans, and Francois Maréchal, Ensor does not raise the masses to a level of dignity, so as to prove that the workers, too, are human beings. In Ensor, the conflicts are not aligned with class divisions, not argued according to the rules of political debate, not settled in line with the principles of reason, not organized according to aesthetic conventions. The conflicts are instead staged according to the principle of carnivalistic doubling and the visual grammar of juxtaposition I described a moment ago: social hierarchies are leveled while horizontal human relations are multiplied, to the effect that the event looks like a swarming multitude in which every being and

Figure 19.2. (top, opposite page) James Ensor, *The Strike*, or *The Massacre of the Ostende Fishermen* (*La Grève*, or *Le Massacre des pêcheurs ostendais*), 1888. Ink, crayon, and water color on paper, 34 x 67.5 cm. Royal Museum of Fine Arts, Antwerp. Image courtesy of Reproductiefonds.
Figure 19.3. (bottom, opposite page) James Ensor, *Belgium in the Nineteenth Century* (*La Belgique au XIXe siècle*), 1889. Etching on paper, 16.3 x 21.4 cm. Cabinet des Estampes, Bibliothèque Royale, Brussels.

every object are linked up in new social formations, or like a carnival in which the normal order disintegrates and all identities are doubled. This strategy enabled Ensor to bypass inherited ways of representing society and to go straight to the heart of the social matter: collectivity as such.

Christ's Entry captures the people on the threshold between disappearing and becoming. He also catches the people in the act—the act of tearing down old authorities and of constituting itself as the new sovereign subject of political power. "All social securities are voided, all social relations dissolved," said the politician and writer Jules Destrée about Belgium in 1886.[77] Between 1886 and 1889, the Belgian people made "a tabula rasa of the past," states Marcel Liebman in his history of Belgium's workers' movement.[78] Ensor seized this process in *Christ's Entry* and condensed it into one event by transforming it into a street festival of metaphysical dimensions. If there ever were a visual counterpart to that enigmatic phenomenon we call a revolution, this is it: society degree zero, as yet without meaning and direction. All possibilities are open, including the bad ones.

[20] Songs of the Fool

James Ensor's originality has commonly been explained as the positive side effect of the artist's neurotic constitution.[79] "Ensor was looked upon as an idiot," says Mabille de Poncheville.[80]

But be it not forgotten that we are here talking about the 1880s, a period in which the discipline of mass psychology and the culture of the bourgeoisie diagnosed the majority of the people as potentially insane. The idiot was a political figure, charged with insurrectionary capacities, while madness was seen as a force that rose from the lower depths of society. *Christ's Entry* should therefore be understood not only as an expression of Ensor's personal psychology. It makes more sense to see his painting as the result of a fusion of his personal fantasy narrative with the general narrative of Belgian history. The hero of the fantasy narrative is an insecure artist in the margins of society, who likes to see himself as a martyr—"the crucified"—and defends his integrity by attacking a cultural establishment that sees him as a fool. The subject of the political narrative is the Belgian people, asserting their humanity by striking back against political, economic, and religious institutions that construe them as subhuman and barbarian.

Such a view has the advantage of resolving the great enigma of Ensor's career. Why was his creative period so brief and explosive? Why, asks Roger van Gindertael, did he fail to do anything significant after 1893? "Even his most fervent admirer would admit that with very few exceptions he did nothing after 1893 but repeat himself more or less laboriously."[81] Ensor's creative period coincided exactly with the modern breakthrough in Belgium and with the struggling years of the nation's socialist movement, from the founding of the workers' party in 1885 to the institution of

universal suffrage in 1893.[82] During these years, the labor movement removed an oppressive system of political representation, and the intelligentsia undermined an authoritarian system that for long had determined how the people and the nation were exhibited, or concealed, in art, literature, and the general culture. In these struggles, which ultimately concerned the substance of society and its rightful representatives, the entrails of society were brought into view: the people as event, an entangled maze of passions and interests that block one another out and prevent every attempt at unification but that nonetheless appears as the constituting power of society. The zero-level of sociality that was exposed at this historical moment corresponded perfectly to the desired object in Ensor's own fantasy narrative: the moment when the columns of authority go down and people dance in the debris. Such is the year of 1889 in Brussels. Such is also 1789 and 1989 and, for James Ensor himself, every year.

Between 1885 and 1893, then, the political landscape provided Ensor with a set of antagonisms that allowed him to structure his own fantasy narrative. When he shouted at the bishop, the judge, or the art critic, "Yes, I am an animal, a beast—but so are you," his voice was also the people's. And when the people shouted, Ensor made their voice his own. The field of political conflicts became an allegory for his own struggle, and vice versa.

After 1893, the two narratives diverged. The conflicts that had seared Belgium were settled. Society returned to business as usual. The masks and myths that had animated Ensor's art lost their social resonance. His once powerful gestures were transformed into the compulsory ticks of the village fool and the tricks of the jester. Ensor disappeared along the same path as many other geniuses of his decade—Nietzsche, van Gogh, and Hill, though in his fading we do not sense the heroic and tragic overtones that characterized their descent into madness. Ensor lived well into his nineties and died only in 1949. He continued to paint, but without producing anything that is even comparable to his achievements during the brief summer of revolution, in the years of the modern breakthrough.

Senility struck him already at the age of forty, laments Michel Draguet.[83] In the early twentieth century, we encounter Ensor as the acrimonious baron, living off past victories, organizing carnivals, addressing the local Rotary Club, agitating against ugly buildings, defending animal rights, and crusading against the soullessness of the modern age. Draguet compares him to Don Quixote: just as Cervantes's hero followed through the moves of combat and the virtuous protocol of the knight in an era where

the institution of chivalry had lost its raison d'être, so did Ensor after 1893 repeat the moves of the anarchist, but in a sphere disconnected from both politics and the avant-garde. With the same intensity that he once scolded royalty and bourgeoisie, he now lashed out, not against windmills but, as the title of one of most pitiful pieces of writing makes clear, "Contre le swimming-pool."[84]

[21] Homo Sacer

But—for Christ's sake! Why read *Christ's Entry Into Brussels in 1889* as a political image? What about the religious message? Isn't it explicit enough? The powerful presence of Christ at the very center of the picture must surely be seen as an affirmation of the Christian message over against worldly matters and political struggles.

A glance at Ensor's cultural environment shows that matters are more complex. In 1886, the socialist Alfred Defuisseaux published a booklet called *Catechism of the People*. He used the format of the widely disseminated Lutheran catechism, usually the only book to be found in lower-class households, to disseminate socialist ideas, and the pamphlet went out in 250,000 copies. Some historians see it as the spark that ignited the protests of that year, which almost led to civil war. At the same time in Sweden, August Strindberg wrote a similar pamphlet, *Little Catechism for the Under Classes*, but his booklet was not printed until after his death.

A closer relative to Ensor's Gospel are the short stories that his friend Eugène Demolder began writing in the late 1880s.[85] In the collection *Contes d'Yperdamme* of 1891, Demolder transposed episodes of the Gospels to a Flemish setting. The son of God is a humble man, walking from hut to hut, performing his wonders to the benefit of people struck by poverty and misfortune, those whom Victor Hugo called "*les misérables.*" One critic remarked that Demolder's Jesus was a pagan character—"there is something barbarian and primitive in his religion."[86]

In the early 1890s, Ensor made a portrait of Demolder, depicting the socialist writer as a religious founder. The two also made a trip to the Netherlands together.[87] Ensor made a drawing of them that later became the etching *Fridolin and Gragapança of Yperdamme*, thus inserting him-

self and his comrade into the legendary landscape of Demolder's biblical tales. Demolder for his part had already inserted a character modeled on Ensor among the fictive characters of his tales, the flute-playing prophet Saint Fridolin.

In 1892, Demolder became the first one to publish a longer study of Ensor's art. He stressed the close affinity between Ensor's paintings and his own egalitarian Christianity. According to Demolder, Ensor's Christ wants to "step down into the crowd and slap the ridiculous bishop with his wounded hands."[88] Ensor's drawings of Christ are veritable illustrations of Demolder's tales, and these tales read like ekphrases on Ensor's art. In both, we encounter a Christ who is part holy sage, part village idiot, and part union organizer.

In the same year, 1892, Edmond Picard lectured on "The Life of Jesus and the *Contes d'Yperdamme*" in La Maison du Peuple in Brussels, the cultural center of the worker's party.[89] If there was one person who embodied the modern breakthrough in Belgium, this person was Picard. In a book from 1896, *Le Sermon sur la Montagne et le socialisme contemporain* (The Sermon on the Mount and contemporary socialism), he argued that socialism had inherited the ideals of Christ. Writing about the events of 1886, Picard extolled the killed workers as Christian martyrs.[90]

These examples from Ensor's closest circle form a pattern.[91] Socialism masks itself as Christendom and is itself transformed in the process, assuming some of the traits of its religious disguise. It is a case of what Oswald Spengler once called "*pseudomorphosis*": new content is slipped into old forms so as to gain acceptance and elude censorship. French socialists had used the same method in 1848.[92] In Belgium of the late 1880s, where the conservative Catholic party was in government and where the church controlled the educational system, the strategy was particularly germane. Against this background it may not have surprised anyone that the most intensely debated issue in the socialist journal *La Société Nouvelle* during the centennial year of the French Revolution was neither the relation of Marx to Bakunin, nor the class struggle, nor even the proletarian revolution, but the history of the church.

What enabled the socialist appropriation of the New Testament was a series of materialist interpretations of the Christian myth inaugurated by David Friedrich Strauss's *Das Leben Jesu* (1835–36). In France and Belgium, Strauss's work was translated and promoted by the philosopher and political reformist Emile Littré. Demolder noted early on that Ensor had smuggled a huge portrait of Littré into one of the large pencil drawings that he made in 1885. The drawing with the portrait of Littré is called *The*

Alive and Radiant. The Entry Into Jerusalem (figure 21.1), and it is the very model for *Christ's Entry.*

The messianic thrust of Belgium's socialism was so strong that Jules Destrée, another friend of Ensor, saw it necessary to warn against it. The confusion of "La grande Revolution Sociale" with "La sainte revolution d'un messie nouveau" invites everybody, he wrote, to just sit down and await the second coming, "le Grand Soir," when everything will be set right.[93] This did not prevent Destrée himself from using the Gospels in his polemics against church and capitalism, comparing the plight of the poor elderly to Jesus on Calvary, likening the workers' party to a church, or arguing that Belgium's legal system would surely detain and condemn Jesus again, should he appear among the vagabonds that were unjustly punished in the nation's courts.[94]

A socialist representative of Belgium's parliament exclaimed in 1899 that if Christ would return, he would seat himself on the far left.[95] In 1888, the same year that Ensor executed *Christ's Entry*, Georges Rodenbach, a major poet of the era, drafted an epic poem on industrial society, the working classes, and social justice. Its name? *Le Livre de Jesus* (The Book of Jesus).[96] The fusion of Christ and People even became institutionalized in the public space of Belgium's emerging socialist counterculture. In the new Maison du Peuple designed by Victor Horta and inaugurated in 1899, there was a great conference hall called "la salle blanche." As Paul Aron has shown, the workers' party commissioned Paul Signac to decorate this inner sanctuary of the socialist movement. Signac suggested his painting *Au temps d'harmonie*, which evokes the communist life of creativity and leisure (figure 21.2). The Belgian socialists rejected it, however, opting instead for a painting by Antoine Wiertz that depicted a great head of Christ (figure 21.3). Rebaptized *The Just*, Christ was evidently thought to be a more appropriate symbol for the movement than Signac's communist utopia.[97]

"Symbol" is the appropriate word here, for it allows us to distinguish the messianism of Belgium's socialists from Ensor's own peculiar christology. Ensor's Christ is no symbol, no metaphysical concept or idea that unites suffering humanity under one and the same divine sign. If this were the case, Ensor would just repeat the system where the sovereign individual speaks for the silent masses. What characterizes Ensor's art is precisely the *absence* of such authorities, an absence that leaves an opening for the individual and the masses to merge into some more elementary collective form. Ensor's Christ is central, to be sure, but he is also short, tiny, skinny, out of focus, and partly hidden behind the crowds. He enters the drama not so much as a sovereign individual but as part of the multitude.

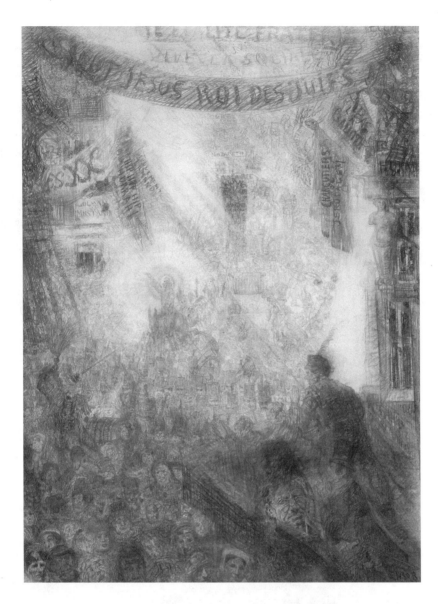

Figure 21.1. James Ensor, *The Alive and Radiant. The Entry Into Jerusalem* (*La Vive et rayonnante. L'Entrée à Jérusalem*), 1895, with the face of Emile Littré in the lower right corner. Drawing on paper, 206 x 150 cm. Royal Museum of Fine Arts, Antwerp. Image courtesy of Reproductiefonds.

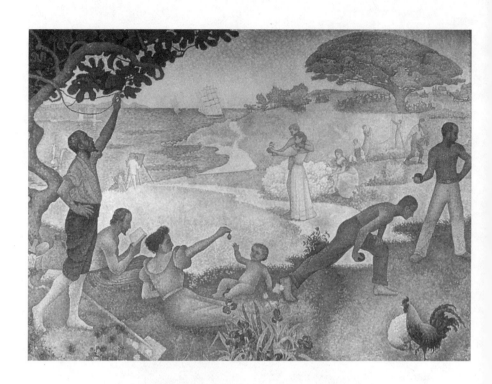

This feature also resonates with Brueghel. In his paintings, it is always difficult to distinguish Christ's deeds from the labors and festivities of the people around him. Christ performs supernatural miracles, but he remains embedded in the social world that benefits from his services. Contemporaneous with the chiliastic movements of the reformation, Brueghel's work is marked by similar heretic convictions: Christ is not primarily a worldly incarnation of the divine but rather an allegorical transfiguration of the real human condition. In Brueghel, as in Ensor, the figure of Jesus personifies the ethical substance of the popular collectivity.

This idea also returns in the work of Emile Verhaeren, Ensor's friend and interpreter, whose literary works seems to be cut from the same piece as Ensor's images. This applies especially to the trilogy that Verhaeren completed in the 1890s, consisting of the epic poems *Les Campagnes hallucinées* (1893; The hallucinated landscapes) and *Les Villes tentaculaires* (1895; The tentacular cities), and the play *Les Aubes* (1898; The dawns) which premiered in Brussels's Maison du Peuple.[98] Verhaeren's majestic trilogy—he was a perennial candidate for the Nobel Prize but lost the contest when his compatriot Maurice Maeterlinck received the award in 1911—alludes both to the Paris Commune and to the rebellions of 1886, and its main protagonist is not an individual but the masses themselves. The mass ("*la foule*") is mentioned first in the list of characters of *Les Aubes*, and the staging instructions for the play state, moreover, that the groups of the drama act as one "collective person" with multiple faces.[99] The characters of Verhaeren's drama are thus comparable to masks, transient emanations of a communal social entity. Like Ensor's work, Verhaeren's trilogy provides an inventory of the modes of action and forms of appearance of the crowd: "O these masses, these masses / and the misery and distress that move them."[100] In close proximity to these masses, Verhaeren's work situates two agents or roles who are infused with the great voice of the masses. The first agent is the fool, "*le fou*," whose very name establishes a relation with "*les foules*," the masses. A suite of poems called "Songs of the Fool" runs through the poetic cycle. At regular intervals, the idiot intervenes as a witness, testifying to the experience at the subaltern

Figure 21.2. (top, opposite page) Paul Signac, *Au Temps d'harmonie: L'Âge d'or n'est pas dans le passé, il est dans l'avenir*, 1895. Oil on canvas, 300 x 400 cm. With permission of Mairie de Montreuil 93100. Photo: Jean-Luc Tabuteau.
Figure 21.3. (bottom, opposite page) Antoine Wiertz, *The Just* (*Le Juste*). Late nineteenth century. Current owner and location unknown. Reproduced from Paul Aron, *Les Écrivains belges et le socialisme, 1880–1913* (Brussels: Labor, 1997).

margin of society: "I am the madman of the wide plains, / infinite, which the wind, like the eternal plagues, / strikes with the great beat of its wings; / the madman who wants to remain standing / with his head stretched toward the end / of coming times, when Jesus Christ / will come to judge the soul and the spirit. / Thus let it be."[101]

A madman, speaking with the voice of the people about the coming of Messiah—such is the formula of Verhaeren's mysticist socialism. For the second agent that here represents the masses in their misery and distress is Christ himself. "What do the evils and the demented hours matter," Verhaeren's poem asks—"If some day . . . a new Christ would come, in sculpted light, to raise humankind toward himself, and baptize it in the fire from new stars."[102] In another poem Verhaeren sketches a revolutionary eschatology in which the promise of the gospel is written over into Marxist categories: messianic power is first transubstantiated into the people, or rather into "the masses"—so that the masses and their fury ("*la foule et sa fureur*"), with their strong hands and without mercy, forge "the new universe of an insatiable utopia." An era of blood and darkness gives way to "an order gentle, generous, and mighty," revealing, at the break of dawn, "the pure essence of life."[103]

Consisting of the crowd, the madman, and Jesus, Verhaeren's trinity is the same as the one animating Ensor's art. In both, the history of the masses merges with the history of madness, jointly sustaining the hope for a just society. The trinity speaks with one voice and embodies the same social energy. The power it represents is the people's will to unify itself and institute a new universe, an insatiable utopia, or, as Ensor and his friends used to call it—communism.

The Christian subject matter is, in other words, the least original element in Ensor's work; it is as typical of its period as Friedrich Nietzsche's identification with the fate of the crucified. In Belgium at the end of the nineteenth century, Christ was everywhere in the workers' movement, and allusions to the Gospels saturated the radical culture that sustained Ensor's art. In the secular environment of today's humanities, it is too easily assumed that religious components found in artworks of an earlier era automatically elevate these works above the political struggles that were contemporary with them.[104] In the case of Ensor, however, it is precisely the religious imagery that places his works in the midst of a historical situation that enacted the originary drama of politics and power: how and by whom should society be represented? In Ensor's visionary interpretation of this drama, its outcome hinges on the transformative capacity of the social collective—a capacity entailing not just the redistribution of

political power but also the sublation of all identities, to the effect that all citizens and subjects are thrown back to the beginnings of society, a social stage without either masses or individuals, and where no acts, ideas, or beings have yet been marked according to norms of reason and unreason.

The light that radiates through this world is therefore akin to the clearsighted lunacy that Nietzsche expressed on New Year's Day 1889 and that has also been ascribed to Ensor himself. "One looked upon him as an idiot." What is exposed in this moment of illumination is the very meaning of that enigmatic word that crowns *Christ's Entry*, "*la sociale*," which in Ensor's culture was shorthand for "*la revolution sociale*." Having offered a visual interpretation of the meaning of these words, Ensor's canvas then turns that meaning into its own message: VIVE LA SOCIALE!

1989

Alfredo Jaar, *They Loved It So Much, the Revolution*

And some who have just returned from the border say
there are no barbarians any longer.
And now, what's going to happen to us without barbarians?

—CONSTANTINE PETROU CAVAFY

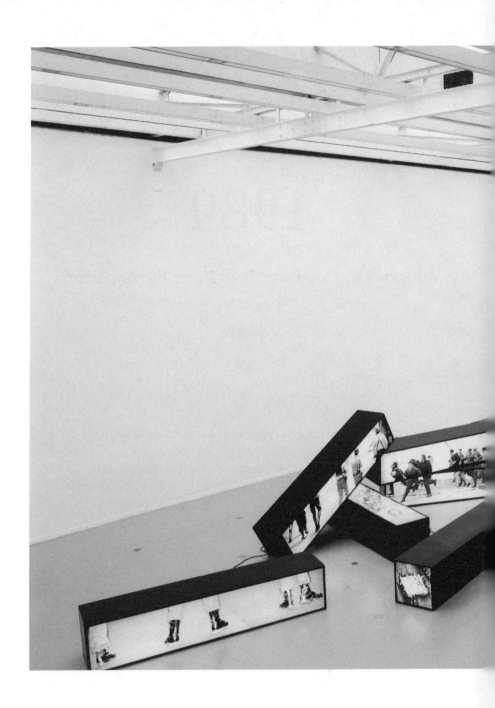

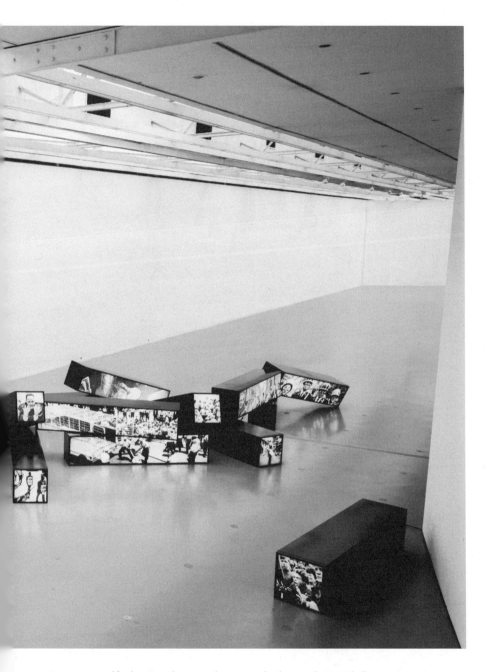

Figure 22.1. Alfredo Jaar, *They Loved It So Much, the Revolution* (*Ils l'ont tant aimée, la révolution*), 1989. Installation. Musée d'Art Moderne de la Ville de Paris. Published with the permission of the artist.

[22] The Beloved

So can we see the revolution? Who knows what mental images developed inside the visitors to the galleries as they circled Alfredo Jaar's installation *They Loved It So Much, the Revolution* (*Ils l'ont tant aimée, la révolution*, figures 22.1–22.3).[1] Some of the photographs had been shown before, others were unknown. The images railed against the title of the installation. They did not arouse feelings of love or joy but of violence and fury, oppression and riot. The pictures displayed protest marches, riot police, demonstrators on the run, violent gestures, batons smashing down. The execution of the installation—photographs displayed on large, oblong light boxes strewn across the exhibition floor—gave these familiar events a framework that made them manageable, almost ready to be sorted and stacked. At the same time, they were mysterious, even unintelligible, since it was impossible to work out how they could be stacked to create a meaningful whole.

They Loved It So Much, the Revolution was exhibited in the winter of 1989 at the ARC, the department for contemporary art in Paris's museum of modern art (Musée d'art moderne de la ville de Paris). Many of the images Jaar mounted in his light boxes depicted the events of May 1968 in the French capital. Visitors could have had no idea that a new revolution, in Eastern Europe, was just around the corner. Amid the turbulence of 1989, Jaar confronted the world of art with fragmentary images from the revolts of 1968. Could this world see the revolution?

Our interior is a developing liquid, writes Marcel Proust.[2] Most of our sensory impressions immediately sink below the surface and are stored in the unconscious. Then, memory drops a hook, catches an event from the past and reels it up into our consciousness, and we notice that the plate

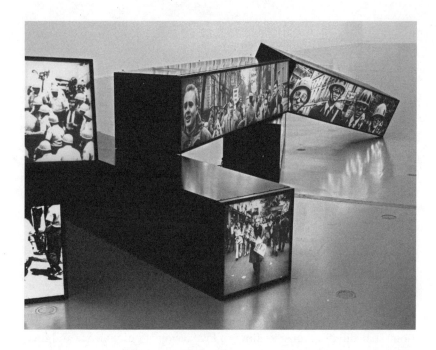

Figure 22.2. Alfredo Jaar, *They Loved It So Much, the Revolution* (*Ils l'ont tant aimée, la révolution*), 1989. Detail. Musée d'Art Moderne de la Ville de Paris. Published with the permission of the artist.

has been fixed; the event has taken on a meaning that was lacking when it took place.

Historical events only assume a meaning once they are over. This applies to revolutions in particular. The crowds gather and are dispersed, the tanks roll in, the leaders gesticulate, and the size of the newspaper headlines grows. But there is no pattern. The revolution is not a live transmission. As we see it, we cannot tell whether it really *is* a revolution. And when we know whether it really *was* a revolution, we can no longer see it.

How do we know whether it was a revolution? It all depends on what happens next. A revolution is a matter of the power to represent society—to lead society politically, to distribute its surpluses, to write its history, to display it in images. During a revolution, it's unclear who holds the power of attorney for society. Once the storm has passed, the structures of power are developed and the meaning of the recently concluded struggle is fixed.

"When is a revolution legal?" asks August Strindberg in his *Little Catechism for the Under Classes*.[3]

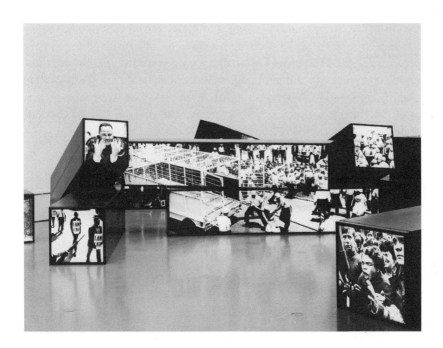

Figure 22.3. Alfredo Jaar, *They Loved It So Much, the Revolution* (*Ils l'ont tant aimée, la révolution*), 1989. Detail. Musée d'Art Moderne de la Ville de Paris. Published with the permission of the artist.

A: "When it's successful."
Q: "So how does it become legal then?"
A: "The revolutionaries draft a law that declares the revolution legal."
Q: "Is a revolution advisable?"
A: "That depends on its prospects of success."

Strictly speaking, then, there are no unsuccessful revolutions. An unsuccessful revolution is no revolution at all but a transgression: a criminal act, fanaticism unleashed, high treason against the security of the state—thank God that the barbarians were defeated. It is the privilege of the victors to write the history books. The vanquished—or at least those who survive—serve up testimonies to ensure the survival of their ideals or engage in self-criticism in an attempt to distance themselves from the misdeeds of their youths.

In Alfredo Jaar's installation, the summer of revolution has to share a moment in time with the fall of restoration. A conflict emerges between

the historical interpretation of 1968 and 1968 as lived experience, that is, the sequence of events whose consequences no one involved could have predicted at the time. If we are to understand Jaar's installation, we must examine it from two different angles. With one eye we are the historian, looking coldly and soberly on the past. With the other, we are the eyewitness, caught up in the flow of events. We see double, stereoscopically, dialectically: we see the revolution.

[23] The Backside of State

"The revolution devours its children," says Georges Jacques Danton, the hero of the people, before he is led to the guillotine.[4] His observation is remembered for its insight into the malevolent dynamic of the revolution. The transformation of society assumes such energy that it trundles on of its own momentum. This energy is always depicted as coming from below ("bursts up from the infinite deep," as Carlyle put it). It stems from the pent-up fury of the masses against all who have a better station in life. When they pick up the scent of justice, they will not rest until they have obliterated everything and everyone that reminds them of the injustices of the past, ultimately leaving nothing of society but ruins. The revolution is impossible to control; in its final stages, it destroys the achievements, the reforms, the beneficial forces, and the supporters that it had once generated. The revolution devours its children.

Danton's understanding was probably correct in the case of the French Revolution. More often, the course of events is the opposite: the children devour their revolution. This is a more prosaic observation: new generations consume the things that the revolutionary process uncovers and stirs up, so that ultimately the revolution is broken down into manageable forms that become established under law or even protected by copyright and marketed. In Alfredo Jaar's installation, the various events and leaders of the revolution are packed into boxes, like embalmed corpses, ready to fit into the categories that historians have defined for them, or like factory products ready for distribution.

The efforts of 1968 to democratize society through nonparliamentary action were crushed, across the world, from Prague to Mexico City. The remarkable thing about the rebellions is not that they failed in political terms. Historians seem to agree that the historical conditions were not

127

right for the seizure of power through the use of revolutionary violence.[5] The strange thing is that political defeat was combined with substantial cultural and social achievements. For this reason, the year 1968 stands out. The children eat their revolution—experience it, take part in it, love it—but, as it were, only before it has taken place. The year was marked by social movements that dreamed of revolution, practiced revolution, and planned for revolution, as if they were looking to create a humanity that was suited to the utopian world that would follow just as soon as the working class had issued the order. This did not happen. But that did not prevent the supporters of the revolution, through their experiments with different means of living, working, and thinking, from transforming all of the traditions and conventions that had long determined how people looked upon themselves existentially, sexually, culturally, and globally, and how they depicted themselves in art, cinema, literature, theater, and music.[6] If the political blows of 1968 were soon absorbed by state and capital, in cultural terms they led to significant democratization and, in some areas, to a transfer of power.

In 1965, the German philosopher Herbert Marcuse coined a term for the contradictory system that forbids citizens from becoming involved in politics but at the same time allows them free rein in cultural activities and in opinion forming. Marcuse referred to it as "repressive tolerance": the dissidents, the critics, and the independent thinkers are allocated a zone in which they are free to act as they like.[7] Because these free zones attract the like-minded, the rest of society is drained of critical substance. As long as they remain inside their reserves, these critical movements are tolerated. If they venture outside, they are put down in no uncertain manner. Marcuse argued that this is the way Western democracies are designed. He primarily had the United States in mind, where he had been living in exile since the 1930s. The inhabitants of advanced industrial countries thus enjoy a "comfortable, smooth, reasonable, and democratic unfreedom."[8] Everyone is free to say what he or she wants and may live the way he or she pleases, at the same time leaving "the real engines of repression in the society entirely intact."[9] This democracy, Marcuse maintained, appears to be "the most efficient system of domination."[10]

They Loved It So Much, the Revolution is, according to Alfredo Jaar's own notes, a *reconstitution* of 1968.[11] Not only was he aiming to reconstruct a past epoch, he also wanted to recreate the *constituent* forces that led the era to assume the form that it did. The constituent forces he refers to bear a striking similarity to repressive tolerance. From a distance, the installation seems to have come about in a spontaneous manner. The pho-

tographs look as if they have been mixed up, cut up, and stuck together randomly, and none seems more important than the others. The light boxes lie in a heap on the floor. There is no overall perspective calling on the visitor's eye. The installation offers an unlimited number of alternative interpretations and possible combinations.

But, on approaching, we discover that this spontaneity is an illusion. The installation is in an ordered disorder. Each light box is linked in a deliberate sequence, as is each photograph. We see an organized chaos. Is this a reflection of the year 1968? Together, the images present a pyrotechnic display of political idealism, crackling with defiance, flashing in every collision with the powers of law and order. But the energy is released within predefined limits, in public spaces bounded by shouldered rifles and framed by the boots of policemen. In its composition, the work is as fixed and strict as the planned chaos of repressive tolerance.

Still, the overall impression is fragile. The lines that bind together Jaar's three-dimensional montage are straight and brittle, and many of the angles are sharp. The construction does not look stable. The boxes do not rest firmly on the floor. It would only take a single person to walk up and nudge one of the boxes for the entire reconstruction of 1968 to collapse and the framed faces to shatter. The prepackaged protest marches and the violence conserved within would escape into 1989.

In fact, it is almost as if Jaar has shut the process of history into his boxes. If so, his structure is more than just a materialization of 1968; it is a crystal that has been formed under pressure over an extended historical process. At regular intervals from 1789 to 1989 we see burst forth the irrepressible desire of people to find a shape for their society, a representative, a sovereign leader who does not turn against them like a hostile power. Georg Büchner's 1835 drama *The Death of Danton* contains a monologue in which the revolutionary writer Camille Desmoulins describes the ideal political state in sensual terms. "The state should be a transparent dress that clings to the body of the people. The bulge of every vein, the tensing of every muscle and every sigh of longing must make its impression on it."[12]

But since each form of political representation tends in time to stiffen and become a straitjacket, rebellions will naturally succeed each other, like the pulse of history. The generation of 1968 read Leon Trotsky and spoke of the permanent revolution.

[24] The Empty Throne

The revolutions of 1989 in Eastern Europe have one thing in common with the Paris Commune of 1871: we have no visual representations that capture the historical tension and drama of the events.[13] There are, of course, countless television images and press photographs, but none of these documents comes close to the core of the revolution. Compare this with the revolt in Beijing's Tiananmen Square the same year! Here, we have a series of images that seems to say it all: the solitary student standing in the way of a column of tanks. But for Eastern Europe, there is no lasting symbol that says, "this was the revolution of 1989!"

The destruction of the deceptive and often bellicose representations of the nation and the people runs as a leitmotif through the brief history of the Paris Commune. The eradication of these images culminated in the demolition of the column in the Place Vendôme, the monument that glorified Napoleon's empire. Through the demolition of the column, the people of Paris invalidated the right of the state to determine how society should be symbolized.

Aside from this icon of iconoclasm, the Commune is remarkable only for its absence in the universe of imagery. No artist was able to strip bare its political essence and social pathos. How do you visualize democracy as a swarm? The Commune was unprepossessing, humble, teeming, and ineffectual. It was vulgar in the original sense of the word: it belonged to the people. But this vulgarity was of a different order than the robust, bucolic popularity that artists and authors had since ancient times classified into particular aesthetic genres, such as the idyll or the pastoral. The popularity of the Commune was urban and contemporary, therefore challenging every aesthetic convention. You might compare the difficulties faced by the artists of the time in capturing the essence of the Commune with

those encountered by modern-day artists trying to give aesthetic form to the lives of the lower classes in cities like Mexico City, Lagos, Calcutta, or Shanghai. There is a real danger of their work becoming infected by the stereotypes of misery and poverty, so common in mass-media representations of the Third World. Similarly, contemporary depictions of the Commune are dominated by caricatures that happily portrayed the communards and members of the national guard as a lower species of apelike barbarian. These demonizing images were distributed widely throughout Europe at the time. But otherwise the Commune has no place in the tapestry of art history. The revolution of 1871 was one that could not be framed.

The revolutions of 1989 were even more resistant to portrayal. The followers of the revolution had no interest in casting the many-headed being that was the revolution as bronze monuments or symbols. The point was rather the opposite: the people acted as a multitude, as an unlimited number; the very presence of the crowds in the public space implied the disenfranchisement of the communist state, which had cast itself as the face and voice of the people. While the leaders of East Germany had always spoken of "*das Volk*," the demonstrators blew this entity, the people, into as many pieces as there were inhabitants of the country. "*Wir* sind das Volk," they chanted—*We* are the people. In 1989, a plural sovereignty defeated the singular.[14]

Statues and monuments were pulled down, party symbols were chiseled away, and a funeral pyre was built of discarded images. In their humility, the leaders of the revolution were unsuitable to serve as cult figures. Even in their time on the throne, those who did show aspirations of achieving such a status—Václav Havel and Lech Wałesa—maintained their human vulnerability and took on a slightly ironic pose that made it difficult to dress them up as the personified will of the people.

In one phase of the revolt against Ceaușescu in Romania, the demonstrators waved flags that had holes cut out of the middle. They had removed the symbol of the Communist Party, the red star, to demonstrate their desire to eradicate the party from the fabric of the nation. The holes in these flags symbolized a demand for freedom and equality that was so radical in nature that it did not seem to accept any type of representation.[15]

The hand that cut the symbol from the flag in 1989 was the same that cast away the king's throne from the Tuileries in 1848. All of a sudden, the seat of power is missing. This absence is probably the most telling symbol of the state of democracy during the revolutions of 1989. It shows that the people have exercised their right to dispose of the king and have

demanded back the right to manage the general will. The hole means not only that the seat of the sovereign is empty but also that the people have a new opening.

Democracy has to manage without symbols, wrote John Adams, U.S. president from 1797 to 1801.[16] This is because democracy cannot, in essence, be represented as a picture, as an emblem, or as a ceremony. A symbolic emblem such as a picture must always emphasize a limited number of figures or qualities from the wide circle of citizens, which means that the majority is excluded, left outside the frame. And this soon brings us back to the symbolism of monarchy, Adams warned. The king and the emperor stand center stage against the background of their subjects. As Adams saw it, the newly independent American republic had to invent a different political iconography than the one that had glorified monarchic rule.

John Adams was not a democrat in today's sense of the term. He did not believe in giving equal political representation to all. But the point he made about the difficulty of tailoring a visual representation of the newly independent republic holds for democracy as well. To portray democracy in an image, to make a symbol of democracy, is to betray it.

Jacques-Louis David, James Ensor, and Alfredo Jaar are among the few artists who have enriched the portrayal of popular power rather than just simplifying it. Others who have attempted to depict the rule of the people have resorted to compact collectives, abstract symbols, flags, figures of the everyman, allegories, representations of key events in the past—the ideas have been many, but most have stumbled on the same problem: How do you turn the many into one? The founders and political philosophers of the early United States were aware of the dilemma and knew that no single symbol could represent the diversity of the country. But they found no better solution than to put George Washington on a pedestal, just as European countries had erected bronzes of their kings and emperors. At rapid speed, the United States also produced seals, figures, symbols, monuments, and buildings that strove to capture the essence and unity of the people of the republic.

Totalitarian states have generated a rich flora of similar images. In such visual propaganda, the leader of the people appears as a foreground to the background that is the stage of the nation. The leader and the led are generally clothed in the same uniform, and their gaze is directed at the same lodestar. The dictator and the subjects constitute a single, unified whole. Between them there is no conflict, or even any difference. The many become one. Several pictures are actually formed in such a way that the bodies of the people are colored dots or lines in a broader

mosaic representing the leader's countenance, as if to show that the ruler and his subjects constitute the same, sacred being. Art historian Horst Bredekamp has connected this totalitarian imagery with the seventeenth-century illustrations of the Leviathan, Thomas Hobbes's name for the supreme sovereign.[17] The body of the Leviathan consists of the bodies of his subjects.

Had Camille Desmoulins lived today, he might have compared the ideal democratic state to a sheer nylon body stocking. He believed that the structure of the state should be adapted to every curve and swelling of the body of the people. Hobbes, by contrast, preferred an absolutist representation in which the people were a soft material that could be cut up and trimmed like a piece of meat so as to follow the contours of the steel armor of the ruler. The contours of the tyrant mark a line around the people, and this line coincides with the frontiers of the political community. These frontiers, in their turn, correspond to a frame without which we would be unable to even imagine society and democracy as distinct entities. It is as if democracy must be framed as soon as it is to be represented (irrespective of whether it is represented in the form of a parliament or by oil on canvas). But to frame democracy is to define limits for the political community, and this in turn is to divide and partition humanity. And so every representation of society—political or visual—contains a trace of a selection of the human material that must be performed if society is to appear as a unified composition, and even perhaps if society is to come into being in the first place.

[25] Political Violence

In the introduction to her book *On Revolution*, Hannah Arendt poses an uncomfortable question concerning the origin of politics. Does politics originate in words, in debate? Or in violence, in the naked struggle for power?[18]

In the beginning was the Word, writes John the Evangelist, thus summoning up the idea of how Man brought order to his world by naming the things in it and reasoning with his fellows. Politics begins when people come together in gatherings or councils to make decisions on issues of common concern.

In the beginning was Violence, other myths would have it. Cain beat Abel to death, Romulus murdered Remus, the brothers in Freud's primeval horde killed their father. Whatever the type of community founded by humans, they have always been able to trace its origins back to the scene of a murder or a massacre.

Hannah Arendt returned to the essential problem of political philosophy, the mysterious transition from the "natural state" of humanity to social and political order. Such questions take on renewed urgency following the revolutions of 1989. The founders of modern political philosophy attract the interest of researchers and commentators as never before. Machiavelli has made a comeback, along with Thomas Hobbes and Baruch Spinoza, who, during the chaos of the seventeenth century, sought the key to a lasting social structure. Sources revisited also include the original theorists of democracy, from Burke and Condorcet to Tocqueville, Marx, and Geijer, who contemplated the consequences of the French Revolution and the implications of popular sovereignty.

And many have looked to those modern thinkers who have discussed the relationship between violence and politics: prominent figures such as

Hannah Arendt, Walter Benjamin, and Michel Foucault, in addition to others who in recent decades have found themselves quarantined, like Lenin or the even more controversial Carl Schmitt, who believed that the one constant of politics is the boundary between friend and foe.

What unites these thinkers, for all their differences, is their passionate interest in what we might call "the political," as opposed to "politics" in its usual sense. Politics is the concern of the prime minister. Politics chugs along in parliaments, governments, and newspaper editorials.

"The political," on the other hand, is a reference to the earliest development of society itself: how people come together by drawing up boundaries against the rest of the world; how this community then draws a boundary down its own middle, so that one or more people (a king, a council, or an assembly) are raised up as a representative of all; and how these boundaries are finally cemented in a constitution and are maintained through common consent or repression.[19] "The political" emerges at critical phases in history, those revolutionary moments when states are either created or collapsed. The fact that more and more people are taking an interest in the political as such suggests that the question of society is now seen as more important and more difficult than it has been for years.

The question of society? Yes, the question of what happens when people join together to form a community. What are the forces that bind them together? How is society even possible?

In referring to society, we usually mean the nation-state, the form of society that emerged in Europe after the Peace of Westphalia in 1648. Following the bourgeois revolutions of the nineteenth century and the First World War, this became the dominant social structure in Europe. The decolonization movements of the postwar period have rolled this model out globally. Many social scientists believe that in the wake of 1989, we are on the threshold of an era in which political, social, cultural, and economic realities are no longer governed primarily by either the nation or the state.[20] Global economic and technological changes have upset the assumption of the politically sovereign and culturally homogeneous nation-state, in which the inhabitants share a common history and in which they stake out their future without the intervention of outside forces. Over the past couple of decades, this nation-state has become a crucible for conflicting political projects and disorientated populations who feel they have lost control over their destiny and are quick to reorganize themselves along the lines of their ethnicity or religion.

The categorizations of "state," "nation," and "class," which once dominated the descriptions of reality proffered by historians and social scientists,

have consequently lost some of their value as analytical tools. "Society" is seen as an abstract and mysterious phenomenon: externally it is dragged in different directions by powerful global forces; internally it is dissolved as people organize themselves into new networks.

So what does "society" mean, if it no longer relates to the structures of the nation-state? Such questions have already transformed the humanities, the social sciences, and cultural debate. This change is especially noticeable in that today's intellectual agenda echoes a couple of discourses that last flourished during the interwar period. At that time, they were referred to as "geopolitics" and "mass psychology," respectively. Some of the matters once discussed under the rubric of geopolitics have today reemerged under the headline of globalization.[21] For although there are important differences between the past debate on geopolitics and the present debate on globalization, both amount to an effort to grasp the macrodynamics of world history and the global system. In the case of globalization, this is expressed in a particular interest in the economic and cultural processes that dissolve older social communities and eradicate the independence of states.

An interest in mass psychology, on the other hand, is characteristic of those who study the social and psychological consequences of this dissolution. How can people maintain some type of social community while their political authorities and social structures are collapsing around them?

Here, the interest is in the microdynamics of the interaction between people. A range of neglected categories has taken on new life in this context. One of these is "the passions," a subject that was actively debated among the philosophers of the seventeenth and eighteenth centuries. These passions—or emotional and impulsive instincts—offer a hypothetical answer to social theorists looking for answers to the basic problem of sociology: Why—and how—do people unify themselves in a collective? Examples of such theorists are the French philosophers Gilles Deleuze and Felix Guattari, who see desire as the driving force behind all social activity; the American philosopher Martha Nussbaum, who makes a political category of love; the "communitarians," who believe that society is held together by the ties of loyalty and family duty; and a whole range of studies of religious fundamentalism and ethnonationalism. Other thinkers, such as the German philosopher Peter Sloterdijk, explicitly align themselves with the mass psychologists Gabriel Tarde and Gustave Le Bon in offering an explanation of modernity as a consequence of the erosion of hierarchies and distinctions by the "masses."[22]

Whatever the differences among these theories, all try to identify the psychological mechanisms that bind people together into a collective fabric—class, nation, people, ethnicity, or community—from which each individual can then fashion his or her destiny. The French social psychologist Serge Moscovici goes so far as to assert that "society springs from within us, as passions arising from each of us." He continues:

> Under a society made up of institutions, so real and visible, in which we live, [the first sociologists] caught a glimpse of, and sought to explore, a society made up of the passions that flow through our lives. Who could doubt that these passions act as a stimulus to the great inventions of politics and religion, and are generally a sign of cultural innovation? . . . Our primal links between one another, much more than a blend of interests and thoughts, are the movements of the passions. These are what cause people to participate in that phenomenon, which in the end remains a mystery, called a collectivity.[23]

Moscovici's claim is radical in that it calls into question an array of prevailing theories about society. As he sees things, society does not depend on a "social contract" balancing individual interests (the liberal view), nor on laws created by a higher power (conservatism, monarchism, religion), nor on the common material production of humanity (Marxism), and not on the ability of mankind to communicate (structuralism). No, society is founded on a bottomless morass of passions and emotional needs. In every human subject, there is this indestructible psychosocial element driving him or her toward others: the passions.

But Moscovici is also radical in another sense. If we believe that society is founded on law, the social contract, common production, or a shared culture, we can also apply a theoretical description to it and find a political constitution to suit. But if laws, work, individuals, language, and culture, if all of these phenomena are just crystallizations of a more fundamental social reality consisting of "the passions that flow through our lives," how then to define this reality? How can the passions take on a political shape or voice? How to represent them in political organizations and institutions?

The mass psychologists of the nineteenth century had an answer: to give the passions political influence would be disastrous. We need strong leaders capable of disciplining the affectations of the masses. The passions were the raw material of society, they thought, and it must be processed, enriched, and refined in order to put it to some constructive purpose.

Because the masses are governed by their passions, they are unable to represent themselves in a sensible manner. The masses cannot speak; they shout. Individuals acting as their guardians and representatives must translate these cries into rational speech. Joseph Goebbels had no doubts on this matter: "leaders and the masses, it's no more complicated than painters and paint. To shape a mass into a people, and a people into a state, has always been the primary purpose of genuine politics."[24]

The name Goebbels also suggests the ultimate consequences of the theory of mass psychology: Gustave Le Bon's view of the masses suited the leaders of fascism down to the ground. And so the defeat of fascism in the Second World War also represented the end of doctrinaire mass psychology. The welfare states that came into being in the West after 1945 seemed to put an end to theories about the mad behavior of the masses and the base instincts of the working classes.

The nemesis of mass psychology was ultimately democracy. Behind the theories of Gustave Le Bon and other mass psychologists are the same impulses that governed large parts of the bourgeoisie at the time. Shrinking away from the peasants and the downtrodden workers, they kept their low speech, rough manners, and pungent odors at arm's length. The educated bourgeois was almost fit to swoon at the notion that the right to vote could place his fortunes in their horny hands. The achievement of Le Bon was to shore up this class instinct with easily comprehensible arguments. He explained that the masses always represented a dimming of common sense and therefore were the enemy of the well-ordered state. The obvious conclusion was that the majority of people must be kept outside the political process.

But even if the solution offered by mass psychology to the problems of democracy is no longer tenable, the question is as urgent as ever: How can the social passions that bind people together in a society be represented in the form of political institutions? The velvet revolutions in the Eastern Europe of 1989 represented a democratic breakthrough. But since that time there has also been profound uncertainty surrounding how democracy should function, while the power to influence the future is taken away from democratically elected parliaments to a diffuse international sphere governed by forces beyond democratic control. Older forms of society are rent asunder, the boundaries that have long governed the economy and the social order are dissolved, and where the new ones should be set up is the subject of controversy.

This is why social scientists have returned to the founding literature of political theory. They are hoping to shed light on the origin of the bound-

aries that decide who belongs to and speaks for the nation, the civilization, the general public, the citizens, the people, the world, the international community, or whatever we choose to call the groupings in whose name political power is exercised. It is not a coincidence that these theories surrounding the nature of the political have emerged as constitutional issues of various types are dominating the agendas of lawyers, political scientists, and politicians. Europe is to have a constitution. Several countries in Eastern Europe and in the Southern Hemisphere have in recent years produced new constitutions to determine the organizational structure of their societies.

There are three questions central to these theoretical discussions. The first is: Where does ultimate power—sovereignty—reside in modern society? There is at least some agreement. Power is hardly exercised by the people any longer, which means that if democracy is not exactly removed from the argument, it is certainly put to one side. This leads to the second question: Through which types of popular movements and institutions can the people reclaim power over society? But to answer this question, we must first deal with a third: What is "the people"? Those who wish to promote democracy (and who would claim otherwise?) have to identify the people, the *demos* that form the source of power and the body of society. Most people can visualize, say, "the Swedish people." But since Sweden's development is now influenced more by international forces than by the popular will, the Swedish people no longer constitute a sovereign democratic body. To master these international forces would require some type of "European people" with a common will, and in time, perhaps, a "planetary people." But there is no such thing. One of the challenges faced by contemporary social theorists is to identify the political subjects—the movements, the interests, the desires, and the passions—that could lay the foundations of a modern, transnational democracy.

This is a dizzying task. Few if any political thinkers have been able to devise a society not based on boundaries and exclusion. In the notion of a good society there is always a wall protecting us from those who do not belong. And often it has become clear that the outsiders have also had to toil away gathering wood, plowing the fields, and pressing the grapes to serve up the good life to those in the houses inside.

But didn't the French Revolution's philosophers of liberty solve a similarly dizzying challenge in their time? A France consisting of classes and elites divided by insurmountable boundaries was transformed into a France of equal citizens who represented themselves through the parliamentary process.

In theory, this is what happened, and it happened in Jacques-Louis David's *The Tennis Court Oath*. But things appear differently in Alfredo Jaar's installation on the revolution. Here, the police and army battle with the demonstrators. Both justify their violence through references to democracy. Jaar brings us back to Hannah Arendt's uncomfortable questions regarding democracy's seemingly necessary debt to violence. Name any state, she challenges, that has achieved a democracy without setting up a boundary between its own citizens and outsiders through violence, or the threat of violence. And on the other hand, name any state where democracy has been realized without outsiders forcing themselves into the ranks of the citizens by violence or the threat of violence.

[26] With Nails of Gold

Alfredo Jaar once confessed that he never wanted to become an artist, but an architect or a film director.[25] He constructs rooms and environments rather than visual artworks in the usual sense. It is true that the photographic image is always a strong element in his work, but he uses it as a raw material that then undergoes refinement. Jaar cuts, edits, mounts, and dramatizes his images to allow the viewer to experience the exhibition in a cinematographic way. Once finished, the installation contains only oblique allusions to the photographic original.

In the mid-1990s, Alfredo Jaar executed a series of projects that attempted to depict the atrocities in Rwanda. Arriving in August 1994, a couple of months after one of the worst genocides of the twentieth century, he took thousands of photographs of mutilated corpses, devastated villages, and overcrowded refugee camps. He also interviewed some of the survivors. From this material, Jaar has compiled more than twenty exhibitions about the genocide in Rwanda.

An early exhibition consisted of 372 black archive boxes piled on top of each other in various formations on the gallery floor (figure 26.1). Each box contained a photograph from Rwanda. The boxes were arranged so as to prevent the visitor from opening them to see the pictures, and he or she had to make do with the brief caption or description placed on each box. One of these reads:

> Ntarama Church, Nyamata, Rwanda, 40 kilometres south of Kigali, Monday, August 29, 1994.
> This photograph shows Benjamin Musisi, 50, crouched low in the doorway of the church amongst scattered bodies spilling out in the

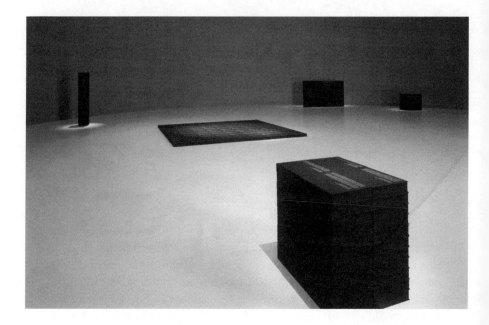

Figure 26.1. Alfredo Jaar, *Real Pictures*, 1995. Installation. Galerie Lelong, New York. Published with the permission of the artist.

daylight. Four hundred Tutsi men, women and children who had come here seeking refuge, were slaughtered during Sunday mass.

Benjamin looks directly into the camera, as if recording what the camera saw. He asked to be photographed amongst the dead. He wanted to prove to his friends in Kampala, Uganda that the atrocities were real and that he had seen the aftermath.[26]

The exhibition was called *Real Pictures*, and yet not a single picture was on display. And in none of the exhibitions that followed did Jaar show any part of his photographic documentation of the violence and its consequences. Here we have evidence of Jaar's mistrust in the power of images to capture reality. He argues that documentary photography has for years been distorted by stereotypes that impede the viewer's comprehension. All of the newsreels from Rwanda deter the audience from investigating the passions of the assassinators and the traumas of the survivors. In *Real Pictures*, Jaar chose to conceal the photos but also to declare what is concealed, all in order to stimulate the viewer's curiosity about what was kept from view. He argues: "If the media and their images fill us with an

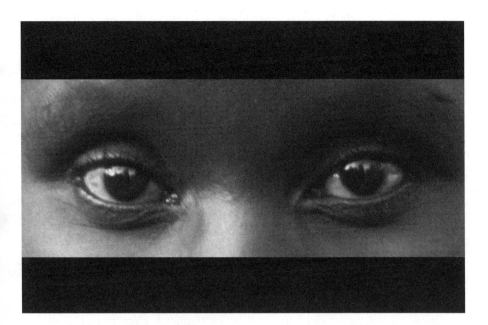

Figure 26.2. Alfredo Jaar, *The Eyes of Gutete Emerita*, 1996. Published with the permission of the artist. Also see color plates.

illusion of presence, which later leaves us with a sense of absence, why not try the opposite? That is, offer an absence that could perhaps provoke a presence."[27]

In another of his projects on Rwanda, Jaar gave us a pair of surrogate eyes through which we might imagine the genocide. In this installation, too, Jaar refrained from showing any photos of massacres, corpses, or survivors. All that was on display was a pair of eyes—the installation is called *The Eyes of Gutete Emerita* (figure 26.2)—and a brief narrative about what they had seen:

Over a five month period in 1994, more than one million Rwandans, mostly members of the Tutsi minority, were systematically slaughtered while the international community closed its eyes to genocide. The killings were largely carried out by Hutu militias who had been armed and trained by the Rwandan military. As a consequence of this genocide, millions of Tutsis and Hutus fled to Zaire, Burundi, Tanzania and Uganda. Many still remain in refugee camps, fearing renewed violence upon their return home. One Sunday morning at a church in Ntarama,

400 Tutsi men, women and children were slaughtered by a Hutu death squad. Gutete Emerita, 30 years old, was attending mass with her family when the massacre began. Killed with machetes in front of her eyes were her husband Tito Kahinamura, 40, and her two sons, Muhoza, 10, and Matirigari, 7. Somehow, Gutete managed to escape with her daughter Marie Louise Unumararunga, 12. They hid in a nearby swamp for three weeks, coming out only at night in search of food. Gutete has returned to the church in the woods because she has nowhere else to go. When she speaks about her lost family, she gestures to corpses on the ground, rotting in the African sun. I remember her eyes. The eyes of Gutete Emerita.[28]

Jaar replicated the image of Gutete Emerita's eyes in countless photographic slides that he then heaped on a large light table placed at the centre of the darkened gallery hall (figure 26.3). A million copies of one and the same image of the eyes of Gutete Emerita to symbolize the million innocent people killed, but also the millions of witnesses who saw it happen and who will perhaps be haunted by the vision for the rest of their lives. These eyes were now turned on visitors to the art galleries of the West, just as they were turned in the moment of capture toward the Western photographer who had flown in to document the genocide.

In other words, the eyes of Gutete Emerita are looking in two directions. They witness the genocide and help us imagine what happened. They also look to the westerners, the international community that closed its eyes and later arrived with its cameras. Gutete Emerita is looking straight into the lens, as though recording what the camera saw, and in this way her eyes become a mirror image of the observer's own means of seeing the genocide in Rwanda and contemporary Africa in general. The enormous pile of slides on the table becomes the result of this way of seeing: a homogeneous mass of images all showing the same thing. In this way, Jaar highlights the true anonymity of the Rwandan people just as Ernest Meissonier depicted the anonymity of the working classes after the rebellion of June 1848. This is an anonymity that has nothing to do with the people themselves. This anonymity is not natural, but artificial. It is an enforced uniformity and homogeneity, brought into being by the gaze from the northwest.

Jaar began his career in Chile in the 1970s, but like many other Latin American intellectuals of his generation, he went into exile and settled in New York.[29] Over the past few decades, he has gradually perfected his own distinct aesthetics of self-reflection. Jaar shifts the viewers' attention

Figure 26.3a. Alfredo Jaar, *The Eyes of Gutete Emerita*, 1996. View of installation. Published with the permission of the artist.
Figure 26.3b. Alfredo Jaar, *The Eyes of Gutete Emerita*, 1996. View of installation. Published with the permission of the artist.

away from the subject, focusing instead on the man or woman behind the camera along with the cultural and political background, such as the conventions of the mass media and art institutions that influence the angle of the camera and the selection of subject. To understand the material and ideological optics of photography is to know why certain subjects are in focus while others are blurred or absent. Jaar's work is not so much about documenting and presenting marginalized aspects of reality as it is about clarifying the very mechanism of marginalization. He wants to shed light on how some things are left in darkness.

Perhaps the best example of this aesthetic is the installation *Lament of the Images*, exhibited at Documenta in Kassel in 2002.[30] Jaar's approach was similar to the one he employed for *Real Pictures*. By emphasizing the absence of an image, Jaar brings to mind the very images that are missing. *Lament of the Images*, too, reflects Jaar's sense of the architecture of aesthetic experience. The visitor enters a room that is completely empty save three captions on the wall. From there, the visitor continues down a pitch black corridor to emerge into a room—only to be blinded by a bright white light projected onto a wall (figure 26.4). The three captions explain the context. The first concerns Nelson Mandela's release from Robben Island in 1990, where he had been imprisoned for twenty-eight years. None of the press photographs that depict his liberation shows him weeping with emotion, not even when he meets friends and family, or even when he receives the tributes of his fellow South Africans and the world. They say his tear glands were destroyed by the sunlight and the white dust he was exposed to during his forced labor in the limestone mines of Robben Island.

The second caption describes how Bill Gates, owner of Microsoft, bought the picture archives of Bettman and United Press International (UPI), totaling 17 million images, and buried them in old limestone mines for future commercial exploitation.

The final caption deals with the images of war. "Just before launching the air strikes, the U.S. Defense Department purchased exclusive rights to all available satellite images of Afghanistan and neighboring countries." Jaar explains how the Pentagon struck a deal with Space Imaging, Inc., through which it acquired all of the pictures taken by the Ikonos satellite.[31] There was no military justification for the purchase. The Pentagon's own satellite photography is far sharper than the commercial satellites. The deal was all about power over the image:

The agreement also produced an effective white-out of the operation, preventing western media from seeing the effects of the bombing, and

Figure 26.4. Alfredo Jaar, *Lament of the Images.* View of exhibition. Documenta XI, Kassel, 2002. Published with the permission of the artist.

eliminating the possibility of independent verification or refutation of government claims. News organizations in the U.S. and Europe were reduced to using archive images to accompany their reports. The CEO of Space Imaging Inc. said, "They are buying all the imagery that is available." There is nothing left to see.[32]

In the exhibition room, the visitor is blinded by the light—a whiteout. Did Jaar want to give us a taste of life at the top of the global pyramid? The inability to cry, the inability to see, while from the depths of the Earth rises the lament of reality or, rather, the images lamenting that they have been buried alive and prevented from bearing witness. *The Lament of the Images* is perhaps the closest Jaar has come to making a film—one consisting of pure white light. If this film symbolizes the eyes of power, then these eyes have a gaze capable of destruction: the light is so strong that it incinerates every person, every country caught in its rays. "There's nothing left to see."

Jaar often takes the titles of his installations from the history of cinema. Three of his projects—*Persona, The Silence,* and *Cries and Whispers*—honor Ingmar Bergman. Other installations, such as *Blow-Up, Homage,* and *Two or Three Things I Imagine About Them,* show that Michelangelo

Antonioni and Jean-Luc Godard have provided Jaar with inspiration. The influence of auteur cinema here is not seen in the content but in the method: it affects the lighting of the exhibition space, the cropping and framing of the images, and the editing of the photographic sequences.

They Loved It So Much, the Revolution also has a cinematographic structure. The light boxes are a raw material, processed inside the viewer, until the artwork is developed in its entirety. This installation on the revolution has no central perspective. Whatever point of view you adopt, some of the images are concealed or reversed. To focus on the entire piece you have to move through the room and walk from image to image. The visitor circling the light boxes is carrying out the same task as the filmmaker editing photographic stills together into a cinematographic sequence. The boots on display in one of the light boxes belong with the police helmets seen in a box some distance away, and the demonstrators they encounter are shown in a third box. Alfredo Jaar gives us the riots of 1968 as a construction kit. Each viewer pieces these picture boxes together into his own film sequence, in the knowledge that in so doing he is excluding other alternatives that are just as valid.

Jaar's debt to Ingmar Bergman is evidenced in his use of close-ups, the ways in which he enlarges and frames facial gestures, eyes, other parts of the human body, or details of an interior or a landscape. Other elements are reminiscent of Antonioni's experiment in *Blow-Up*, in which one area of a photograph is enlarged to the point at which something emerges from the photographic grain, a phantom object (a face, a corpse, a revolver), until the viewer finally has to conclude that it both may and may not be there. By dissolving or concealing the distinction between reality and illusion, Jaar shows that the documentary quality usually attributed to photographs is a "reality effect" caused by specific conventions surrounding the scale of the image and the way in which it is cropped, enlarged, and framed. If the world is framed differently, and on a different scale, it looks unreal.

In his 1987 exhibition *1+1+1*, Jaar constructed his work from three images ordered from a news agency. All three are distinguished by the same cliché: dirty children in rags standing on a mud road somewhere in the Third World (figure 26.5).[33] Jaar cut the pictures in half, enlarged the lower half, and mounted them upside-down on the gallery wall. He then placed a broad, gilded, antique-looking frame on the floor in front of each of the bisected images. The first frame was empty. The second was filled with further frames, covering the entire area within the main frame, and leaving no room for any image. The third frame contained a mirror that partly

Figure 26.5. Alfredo Jaar, *1+1+1*, 1987. View of exhibition. Documenta VIII, Kassel, 1987. The Art Institute of Chicago. Published with the permission of the artist.

reflected the filthy feet of the street children. Look, here we find reality on the wall while art is thrown to the floor, French critic Tzvetan Todorov enthused about the installation.[34]

However, Jaar's aim was not just to stand the relation of art and reality on its head but also to shake up our perceptions of both. Our perception of reality largely depends on *how* reality is visually depicted, just as our perception of art largely depends on *which parts* of reality are deemed worthy of visual representation. In both cases, the decisive element is the frame. Put differently, Jaar questioned not only the institution that goes by the name of Art, but also that agreement that goes by the name of Reality. Both are subject to the same kind of law of perspectives, and this law operates in roughly the same way in the field of aesthetics as in media reports of reality. The mass media often reduce Third World misery to a tired cliché, just as art institutions often exclude the Third World from the set of topics and subjects that are worthy of aesthetic framing. I've never understood the restrictions of the art world, Jaar once said in an interview. "For what reason is a subject like the tree in eighteenth-century landscape painting seen as more worthy of research and resources than the genocide in Rwanda?"[35]

By combining the brutally cropped photographs with the emptiness of the gilded frames, Jaar's installation presents us with a dissonance: on the

one hand, all the life and reality out there in the great wide world, and, on the other, the tiny framed square that serves as our window onto the real world. Virtually speaking, the viewer sees and hears how reality rubs and scrapes against the outer edges of the images. It is a dissonance between that part of the world that is represented—thereby becoming representative of the world as such—and that part of the world that lacks representation. It is the lament of the images, evoking all that was mutilated, cut off, and banished in the editing process.

Typical of Jaar's work is the implausible cropping and arrangement of his images so that they are partly hidden from view or can only be seen through a rippled water surface or a skewed mirror. Or, as we have seen, he removes the image altogether, leaving only the caption behind as a hint of a lost presence. Already in his first major installation, *Gold in the Morning* from 1986, Jaar put the focus on the frame.[36] On the gallery floor laid a large square filled with iron nails (figure 26.6). At the centre of the square was a smaller square, a gilded frame. The nails outside this frame were spray-painted pitch black, those inside the frame were gilded. In the darkness of the gallery, they shone like a golden treasure. On the surrounding walls of the gallery, the artist mounted light boxes that seemed to be equipped with doors or shutters. With the shutters open, the light boxes showed close-ups of miners in an enormous open-pit mine in Serra Pelada, Brazil, where tens of thousands of miners climb up and down to dig gold-bearing clay from the bottom of the pit (figure 26.7). By closing the shutters, the viewer no longer had to confront the miners' faces. Yet the fruits of their labor still lay on the floor. At the center, the nails of gold lay surrounded by the pitch-black nails, yet protected from them by a massive, elegantly carved frame. The golden frame seemed to uphold the order in this universe of nails, ensuring no mixing or blending took place that would compromise the purity of the golden metal.

As is often the case in Jaar's art, the political overtones are clear. But precisely because the symbolism is so explicit and demands no further interpretation, the viewer's attention is drawn toward the entrancing com-

Figure 26.6. (top, opposite page) Alfredo Jaar, *Gold in the Morning*, 1986. The Venice Biennale 1986. Museum of Contemporary Art San Diego. Published with the permission of the artist.
Figure 26.7. (bottom, opposite page) Alfredo Jaar, *Gold in the Morning*, 1986. The Venice Biennale 1986. Museum of Contemporary Art San Diego. Published with the permission of the artist.

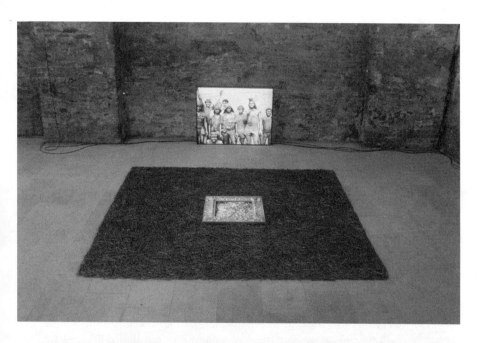

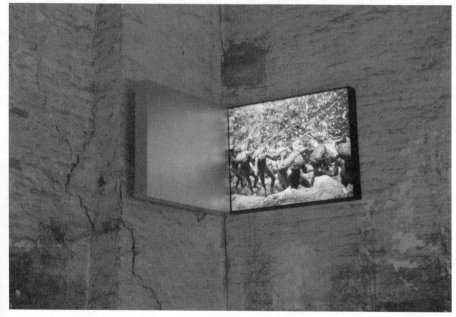

position of form and material. A rectangle of gold set against a rectangle of darkness (figure 26.8). It is a representation of the global conflict between rich and poor. Yet it is also, in an allusion to the black and white squares of Malevitch, a rendering of cosmic harmony.

In three other installations, Jaar explores how the motif is transformed when its frame is displaced. Significantly, the exhibitions are titled *Cries and Whispers*, *Coyote*, and *Out of Balance*. All consist of oblong light panes placed in unexpected positions on the gallery walls, not at eye level but close to the floor, stuck into the corners, or high up right under the ceilings, rendering it almost impossible to see them. The panes radiate with an even, soft light and are blank and empty save for small cutouts of human figures—miners from Brazil or illegal Mexican immigrants in the United States—literally hanging on the frame or split by it. All of them have their center of gravity somewhere outside the frame. These portraits differ from all others: the frame does not serve to hold the subjects together and present them to the viewer but rather to split them up. The relationship between the figure and the frame is not one of inclusion but of exclusion; that is, the figures are not framed in but framed out.

In Jaar's art we do not see the motif placed within the frame, but the frame placed within the motif—not a piece of the world mounted inside a frame, but a frame that cuts the world to pieces. Sometimes, the frame completely blocks the view and obscures the image as a whole. The result is a planned blackout, as in *Real Pictures*, or a blinding whiteout, as in *Lament of the Images*.

At Alfredo Jaar's exhibitions, the gallery interior is toned in chromed metal and off-white plastic and brushed black and grey. The lighting is sparse, the only light source often being the works themselves, that is, photographs mounted onto light boxes. Wandering through this twilight atmosphere, the visitor seeks to focus on hidden images, reconstruct disassembled motifs, or reassemble contents that have been taken apart. Jaar arouses a desire close to that associated with pornography—the desire to lift the veil. Yet this desire is not directed toward intimate parts of the body or sexual acts. It is a desire to see those regions of society that are shrouded in darkness. It is also a political desire to know more about forbidden acts: rebellion, spontaneous political action outside the system, civil disobedience, and revolution. In short, Jaar evokes the desire to transcend the frames of society, and he evokes this desire precisely by directing the viewer's gaze toward the frames of the art itself. Should we call it a realist desire, a desire for reality? If so, it must also be a political desire, a desire for democracy. For what he shows is that democracy, or rather the

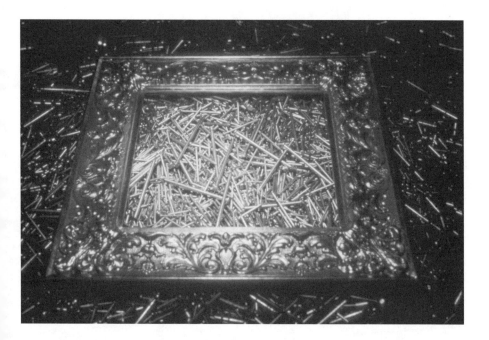

Figure 26.8. Alfredo Jaar, *Gold in the Morning*, 1986. Detail. The Venice Biennale 1986. Museum of Contemporary Art San Diego. Published with the permission of the artist. Also see color plates.

conditions for achieving democracy, exist precisely in the transcendence of those frames by which we unify our image of the world, our pictures of the world, and our political community.

A frame is in itself meaningless, as Jacques Derrida once explored in his *La Verité en peinture*.[37] Its sole function is to stabilize meaning, dividing phenomena and perceptions into those that are afforded meaning and those that are not. The frame separates those parts of the world that offer themselves to our field of vision, that speak to us and are depicted, from those parts of the world that are mute, silent, distant, and anonymous, remaining in their own incomprehensible multiplicity. The frame institutes a border between the meaningful and the meaningless.

By experimenting with the frame surrounding the institution of art and with framing the world in documentary photography, Jaar soon finds himself hard up against the borders of society, where he is able to catch a glimpse of a part of humanity that has no meaning in art nor in mass media, and not even in our political or our economic institutions. But we

might just as well approach his work from the opposite end, that is, from the side of the object depicted rather than from the side of the recording, exploring subject. We then see that Jaar, in exploring the frames that hold our political and economic system together, and in seeking to give voice and representation to those who are marginalized by the system and to the benefits it offers for those on the inside, soon finds himself hard up against the boundaries of art, questioning the representational limits that govern the documentary image. Thus, any strictly aesthetic or formal reading of Jaar's work is bound to confront us quickly with serious political questions concerning the limits of our political and social community. On the other hand, any political interpretation is bound to pose serious question about the demarcations of the very concept of aesthetics and art.[38] The political question and the aesthetic have one thing in common. We might even ask whether they are not two ways of phrasing the same question: How do we represent humanity? The frame defines the limit for the ways in which the world is represented visually, but also for the ways in which humanity is represented politically. What is outside the frame lacks representation and therefore appears meaningless to us.

[27] Of Men and Beasts

Ever since the turbulent days of 1989, all of the major problems of our times have appeared to revolve around boundaries. These boundaries might be territorial: Israel's security wall against the Palestinians, the American fence that keeps out the Mexicans, the frontiers of the European Union against refugees. Then there are the boundaries between civilizations and religions postulated by political scientists and security experts. Then we have the boundaries of the currency unions and customs unions and the barriers to investment debated by economists. And we have the cultural, ethnic, and sexual boundaries investigated by scholars in the social sciences and the humanities.

And some of the hottest topics of social debate—alcohol duties, immigration, trafficking, cultural tribalism, agricultural subsidies, guest workers, capital flows, terrorism, banning the veil, racism, the arms trade, or prison escapes—are ultimately provoked by the fact that somewhere there is a boundary that is too tight or too loose. The boundaries are, quite literally, spreading. Soon, they will be everywhere.

What is a boundary? The existence of boundaries ultimately stems from the existence of identities, Étienne Balibar suggests in his book *La Crainte des masses* (Fear of the masses).[39] He who partitions off a piece of land, a being, a society, or a value gives it an identity and defines its place in the order of things.

The first boundary to be drawn, which is always being drawn and which is now being drawn more firmly than ever, stems from the simple differentiation of like and unlike, us and them, Man and beast. These boundaries are sometimes plainly visible: a fence with a sign: "No trespassing. Keep out." But more often they are invisible: you don't notice them until you transgress. Someone rushes up, calls out "halt," and draws his sword.

You are arrested, interned, thrown out, or, in the worst case, killed. The boundary is the scene of violence, Balibar says.[40] This is where politicians get their hands dirty.

And that's not all, he continues. Boundaries give rise to contempt and cruelty. The behavior of U.S. soldiers in Iraq or the European authorities' expulsion of refugees proves how easily ethical safeguards can be ignored by those charged with maintaining a boundary.

In one of his essays, Balibar quotes the French psychoanalyst André Green: "You can be a citizen or you can be stateless, but it's difficult to imagine how you can be a boundary."[41]

To be a boundary?

Yes, to spend your life out by the fence. You're never let in, and you can't turn back. You get caught by the frame.

Balibar believes that many of the worst conflicts of our time are caused by the fact that a growing number of people are stuck out at the boundary. Ethnic minorities in the West find themselves in this situation, along with the women's movement, and in the long run large sections of the population in the developing world. They set a course for the freedom, equality, welfare, and chance of self-betterment that is raised up as the universal ideal of all humankind. But the road is blocked—first by barbed wire and frontier guards and then by more subtle means of sorting and the apparatus of discrimination. Everyone gets stuck somewhere along the road.

The battle for the frontiers is the battle for identity. And the struggle for identity comes ultimately down to the privileges—or more precisely, the right of first access to influence and success—which for historical reasons are allotted to people of a certain identity, for example, a white Swedish man. How does it happen, Balibar asks, that people of a certain sex, a certain skin color, and a certain background assume a shared identity that means that they identify with one another and often end up in similar positions in society? Balibar has inherited this question from his mentor, the philosopher Louis Althusser. Althusser combined Marxism with the psychoanalysis of Jacques Lacan to explain what happens when individuals are bound together to become the "big Us" in society.

It is ideology that binds them together, Althusser believed.[42] It encourages every individual to identify with different symbols, authorities, and ideals, all depending on their sex, age, skin color, and background. In this way, ideology allocates an identity—as a director, housewife, homosexual, Swede, or the like—an identity that the individual amazingly enough does not see as a limitation but, on the contrary, as the realization of the essence of his or her being.

But we should not even speak in terms of identities, Balibar submits.[43] We should speak of processes of identification in which the members of the community are constantly nodding in recognition at one another and casting suspicious glances at strangers. And since every person moves in a number of communities, he or she will obviously take part in a variety of processes of identification. He or she will have several identities.

All this may seem obvious enough. We have taken for granted that people can move across real and imaginary boundaries and have a share in several identities. But not much longer, perhaps. The dominant ideological apparatuses—mass media, churches, political parties, advertising companies, security agencies—ascribe a uniformity to a person and expect him or her to coincide with his or her identity—as black, Jewish, Arab, teenage girl, Nazi, queer, Swedish, communist, refugee. And so the world is divided up into different blocks, and each person is shut into one of these blocks. The only mortar that binds these blocks together is their mutual hatred. It's not only in urban youth culture that this pattern emerges; it's a characteristic of global politics and the reporting on foreign affairs by major news agencies. The media's depictions of reality tend to confirm the identity of its audience, the border between "us" and "them," and in this way the frames that confine the media's images of reality tend to reinforce the way in which a political community frames itself.

Those who are condemned to remain faceless in our images are usually those who lack a voice in our political institutions. This is a truism, of course, but it's nonetheless a disturbing one, since it implies that the institutions of art and the media are in closer synch with the political and economic system than many like to admit, which is a disheartening observation, especially for those who claim, or take for granted, that art and journalism enjoy autonomy and independence from the powers that govern politics and economy. That part of the world on show in the arts and the media is framed, but the selfsame frame also delimits the part of humanity that our political institutions are able to represent. Together, these cultural and political frames constitute a barrier. Beyond that barrier, the others are waiting.

[28] Desperados

When the nineteenth-century French bourgeois took a disdainful peek into the alleys and spoke of the masses—"*la foule*," "*les voyous*," "*la canaille*," "*la populace*," "*la multitude*," "*la masse*"—he was probably referring to those that later sociologists would divide into four categories, albeit categories that tend to overlap. First, we had the criminal and dangerous elements of the lower classes, *les classes dangereuses*. Second, there were the vagrant and homeless populations without proof of residence, often because they had recently arrived in the capital in search of work. The third group was the poor, suffering destitution and poverty if not starvation, illiterate people without schooling or literacy, those whom Victor Hugo referred to as "*les misérables*." Fourth came the organized factory workers and artisans, known for their militancy as they went on strike and marched for the vote and social justice.

In the public debate of that era, these groups were lumped together as "the masses," caricatured and feared as a source of danger and licentiousness in the midst of society. Today's media are not quite so crude. In the news reports most of us rely on for information, there are no "masses," at least not in the sense used by the educated classes of the nineteenth century and the first half of the twentieth. However, the four categories remain, each of them associated with their own modes of dress and attributes.

The section of the underclass that the nineteenth century feared as dangerous and criminal corresponds in our time not only to international crime and drug syndicates but also to traffickers in sex, arms, or refugees, and of course first and foremost to the "terrorists." The vagrants and homeless that in the nineteenth century were hunted down and expelled for their irresponsible mores, or for having settled in the city without notifying the authorities, correspond in our times to the flow of refugees

from the Third World. Those who once were called *les misérables*, our third category, have their counterparts among Africa's AIDS-afflicted poor, those suffering from floods and hurricanes from Southeast Asia to New Orleans, seamstresses in China's archipelagos of sweatshops, the miners of Brazil (or West Virginia), and the many, many others who belong to the proletariat of global capitalism. The fourth and final category, the members of the nascent workers' movement who fought for the vote and social rights, have their latter-day counterpart in the various *alter-mondialistes*, groups working for an alternative globalization generated from below. Just as early labor movements collaborated in the First International, many of today's movements collaborate in the World Social Forum with its annual congresses in Porto Alegre or elsewhere.

Each category has its own pigeonhole in Western news coverage and political debate. With each pigeonhole comes a specific rhetoric and a predetermined narrative deciding how each respective group is portrayed. Commonly believed to be an illusion of the past, the dangerous masses are still with us in their fourfold manifestation. It would seem that the current world order reproduces the same systems of exclusion that once were defended and incarnated by nineteenth-century European bourgeois culture.

Yet before leveling accusations against our contemporary world order, we should ask whether there has ever been a society that has *not* excluded these elements of their population: criminals, vagrants and refugees, the poor and illiterate, the political militants. It seems as though the four categories represent a timeless quartet—the bandit, the stranger, the beggar, and the insurrectionary—who since time immemorial have been banished outside the city gates. It is hard to imagine a society that would want to count these figures among the members of its polis.

But wasn't the promise of universal democracy precisely the promise of such a society? What other meaning can be conveyed by words like "equality" and "fraternity"? As long as these four groups are excluded from politics, democracy will remain at best a promise, at worst a lie.

Alfredo Jaar's work deals with these four barbarian tribes. He has journeyed to visit them, to study their way of life, and to record their voices, and he has gone on to give them a place within the structure of art in a way that corresponds to their geopolitical position: just outside the frame, just beyond the threshold of our perceptual capacity, in the shadow of *Festung Europa*, in the depths of the darkest forest and far from the bright lights of the city.

Now, the first category of bandits is not very strongly represented in

his work, but they do make an appearance as people traffickers and intermediaries or as "terrorists." By contrast, Jaar's principal subject is the stranger: illegal refugees from Latin America disputing U.S. borders, Vietnamese boat people detained in a camp outside Hong Kong, Turkish guest workers in Germany, Bangladeshi women in London factories, and others. Several of his exhibitions also deal with *les misérables*, the victims of the Rwandan genocide, youth in Lagos, miners in Brazil. The fourth category, the militants, find their place in the 1989 installation *They Loved It So Much, the Revolution*. Among the faces in the crowds we see Martin Luther King, Jean-Paul Sartre, Simone de Beauvoir, Che Guevara, and many others.

As I have already emphasized, in Jaar's art we do not see a subject placed within a frame but rather a frame placed within a subject. I should add that the subject is usually a human being. What characterizes Jaar's treatment of these people is not only that he exposes the political and cultural conventions that make them invisible but also that he focuses on their faces. Commentators have sometimes compared him with classical documentary photographers such as Walker Evans and Dorothea Lange.[44] In terms of the photographic form, he is their opposite. And yet his images exude the same humanist pathos that characterizes the naked realism of their photography: a woman crossing the Rio Grande with a child on her shoulders. A sweating miner in Serra Pelada climbing up a swaying ladder with a sack of gold-rich clay on his back. Two boys hugging each other in a refugee camp in the Congo. An old man resting on the deck of a boat in the port of Hong Kong, while from the hold of the same boat we discern the red-painted lips and frightened eyes of a young woman. "What a thought," Thomas Carlyle exclaimed, "that every unit of these masses is a miraculous Man."

When Jaar arrived at Hong Kong's Pillar Point refugee camp in 1991 to document the conditions experienced by the detainees, he encountered a young child, a girl who had apparently lost her parents. She never said a word. But she clung to the white man from Chile and New York, following Jaar like a shadow on his rounds through the camp to interview people and take their photograph. The only thing he found out about her was her name, Nguyen Thi Thuy. At one point, she allowed herself be photographed. Jaar quickly took four frames. The sequence of images records twenty seconds of a life. From these images Jaar has created an installation, a video, and a book, *A Hundred Times Nguyen*, in which the same four images are repeated in different order, resulting in twenty-five variations of a brief moment in the life of Nguyen Thi Thuy.[45] This work

Figure 28.1. Alfredo Jaar, *Four Times Nguyen*, 1994. Moderna museet, Stockholm. Published with the permission of the artist.

has a unique place in Jaar's portfolio (figure 28.1). On this occasion, he uses the camera in a naïve way, as though against all odds it could capture and preserve a piece of reality. Political rhetoric and the ever-stricter immigration laws of our times tend to erase refugees' names and reduce unlimited numbers of people to a homogeneous mass. In *A Hundred Times Nguyen*, Jaar responds by multiplying a single human being by a hundred, as if to highlight all the innumerable possibilities glittering in the eyes of this orphaned refugee girl.

[29] Autoimmunity

Let us adopt the refugee as a guide to our society, proposes Italian philosopher Giorgio Agamben.[46] If we follow her closely—through the catastrophe of AIDS, droughts, floods, and the new wars, past the surveillance apparatus of the EU, on through the racist propaganda of the Western media, into the interrogation rooms of the airports, to the detention centers at Fuerteventura and Sangette, and beyond—we get an inkling of a future that is worse than we feared.

Agamben's social theory attempts to explain why democracies in the West are becoming increasingly merciless in their border controls and in the way they treat people. Democracy and totalitarianism are not opposites, but two positions on a sliding scale. Agamben emphasizes that, of course, we cannot ignore the huge historical differences between the systems. But neither should we close our eyes to their most striking similarities. Both see the power of the state as centralized and, in principle, absolute. Or, to put it more technically: both systems share the same notion of the nature of sovereignty.[47]

This similarity is remarkable in that all forms of government throughout history, democracies and dictatorships alike, have vested the sovereign with a particular tool of last resort: the state of emergency. In his book on this very subject, Agamben quotes the Swedish political scientist Herbert Tingsten, who wrote that the state of emergency entails the liquidation of democracy. The state of emergency is a paradox for constitutional theorists: it gives the sovereign the legal right to act outside the law. Through this, sovereign power reveals its true nature, Agamben argues. The fact that there is a sovereign requires by definition that there is an absolute power that can bypass the law.[48]

Agamben believes that Tingsten's analysis was proven in the wake of

9/11, when many governments suspended the constitutional rights of their citizens in order to combat threats to national security.[49] Agamben also reminds us that the Nazis' extermination of Jews and other minorities was formally justified using a legal clause allowing states of emergency to safeguard the security of the state.

Why has democracy been unable to get by without a form of authority that can liquidate democracy and deprive the citizens of their rights? This is Agamben's key question, one that he inherits in part from his two major sources of inspiration, Hannah Arendt and Michel Foucault. He uses the question to unwind our political history and to lay bare the primitive core of violence and barbarism still to be found in modern state structures.

Agamben first sets out to find the answer to his question in Aristotle and his distinction between natural life and political life, between what the philosopher called *zoē* (the natural life of reproduction and labor) and *bios* (the social life of humans). From the very beginning, the sphere of politics was differentiated from that of the woman and the servant, that of reproduction and work. Most people struggled on, stuck on a lower plane, faceless and powerless, afflicted by the whims of the powerful but also safe under their protection. The ticket to citizenship and to achieving name, rank, and identity was to take a step upward on the ladder of social life.

The advent of democracy meant that many of the powerless took this step. They even came to be associated with sovereignty itself, the power of the people. But this power, too, emanated from a sphere that was above everyday life. The majority had access to it, but only via representatives who, by grace of their education or fortune, were thought to act in the interests of the entire people and their nation.

In the nineteenth and twentieth centuries a phenomenon arose that Agamben, after Foucault, calls biopolitics. The purpose of politics came to be the care, discipline, and exploitation of the body of the people. For conservatives this popular body became a dangerous mass that must be kept in check; for socialists it was a class that must be elevated through light and education; for industrialists it was a labor force to be used in its factories; for doctors it was an organism to be strengthened and improved; and for the generals it was troops that could be drummed up and drilled into an army. In either case, the population was subjected to a process of political planning in which everyone was branded and typecast, where those who didn't fit in were rejected as sick, delinquent, disenfranchised, and foreign. The pattern identified by Aristotle reappears, the polarization between sovereign power and natural, powerless life.

Agamben believes this conflict is reflected in the very concept of the

people.[50] There is a people with a capital *P*. We are all of this people, the constituting power, the sovereign of society, the democratic ideal and its first principle. One example of this is the subject identified as the power behind the statement that founded the most powerful state in the world: "We, the people of the United States . . ."

Then there is the people with a small *p*: the poor, the working classes, women, children, peasants, the elderly, the jobless, and the faceless masses who are not permitted to speak in the name of the people since they don't live up to its ideals.

When Abraham Lincoln called in 1863 for a "government of the people, by the people, for the people," the president took for granted that the people he referred to were one and the same, a unified and sovereign political subject. In Agamben's reading, however, the meanings of the term "the people" as used by Lincoln turn out to be deeply incongruous. The people that Lincoln was referring to in the phrase "of the people" were not the same as those he meant in "for the people." The people who were to set up the government had a capital *P* and consisted of the educated and well heeled, the people that the government was to govern had a small *p* and consisted of the others, the masses.

This ambiguity of the notion of "the people" has its roots in the very origins of politics. From a once-unified social entity, one group of people splits off with the ambition of speaking in the name of everyone. This schism between a minority that *represents* the people and a majority that *constitutes* the people has always been seen—and still is seen—as a basic necessity in any political structure. By referring to two different parts of the political landscape as one, the concept of the people encapsulates, and conceals, the original conflict that cuts through the political history of the West: the gulf between *bios* and *zoē*, between political life and natural life, between those who speak for society and those who have no voice—and who must have no voice, since society could not otherwise create a state. Agamben believes that democracy is *always* in conflict with itself. Any attempt to unify the people around a party, a project, a state, a culture, or an identity produces another people, a marginalized people who for one reason or another do not fit in and who are therefore banished outside the borders, or interned in camps within them.

There is a simpler way to put this: democracy must be framed and contained. Jacques Derrida writes that democracy is "autoimmune," which is to say that it is always obliged to protect itself against itself.[51] Derrida analyzes the democratic elections in Algeria in 1992. After the first round it seemed likely that religious parties would be in a position to form a

government, and that if they did, they would abolish democracy. Faced with this situation, the government of the day chose to cancel the election. It violated democracy in order to save it. Democracy committed suicide and in so doing avoided execution.[52]

This is the "autoimmunity" of democracy in its rawest form, its blood flowing. Derrida offers a similar vision of the future in France: the ultra-right Front National is able to attract such popular support that it is able to take power and then use that power to rein in democracy. Would it not be right in that case to declare a state of emergency, to ignore the will of the people, and to prevent the party from acceding to power?[53] Such a measure would be undemocratic, and yet still democratic. This is the contradiction of the 1848 revolution, but in reverse: the workers turned against a democratically elected government in order to save democracy itself.

Such scenarios have prompted many thinkers and politicians to assume that the popular will must be tamed and refined. In every democratic society, a boundary must be drawn around the people that establish themselves as the possessors of sovereign power. But how is this boundary drawn? Originally, it was accepted that only free men had the right to vote, that blacks were represented by whites and women by men. And even today it still seems natural that certain people will be left outside: foreigners, most of the population of developing countries, those under eighteen years of age—Derrida also includes unborn children, animals, and plants. His point is not that the unborn, animals, or plants should have the vote. He simply wants to highlight the fact that the boundaries of democracy are arbitrary; no theory can prove that it is "natural" for certain beings to make decisions on behalf of others.[54]

But why should democracy limit itself in this way? Derrida answers with an analysis of the most ancient ideal of the democratic tradition, *fraternité*, or brotherhood.[55] The first two slogans of democracy—liberty and equality—seem incontrovertible. Liberty is the birthright of every individual; equality is born of the instinct that we are all equally free. But brotherhood? The inclusion of this word bears witness to the fact that, thus far, democracy has only existed between brothers and equals, between people of the same sex and the same family, or, these days, between people who share the same national identity. As yet there has never been a democracy that places the foreigner, the refugee, and the outsider on an equal footing with the citizen. Popular power stops at the borders, as soon as we meet foreigners. Democracy renders itself immune to prevent them from participating in democracy on the same terms as the brothers born on the inside. Seen in this way, the journey of democracy from the

agora of ancient Athens to the U.N. building in New York is a sadder saga than we usually like to relate. Popular power has only been able to come into being on condition that the *worse* or *deviant* sections of society have been disenfranchised.

It was easy to justify such borders as long as society was seen as identical to the nation-state. Those who didn't belong to a particular group of people were assumed to belong to another group with their own system of popular power. But in today's globalized society, it is impossible to justify such boundaries. Nowadays, politics must cater to a *demos* that incorporates the population of the entire world. From now on, the only true democracy is a democracy without boundaries.

[30] Saints

For some years, Giorgio Agamben has been working on the multiple volumes of his work *Homo Sacer*—"Holy Man." The term is borrowed from early Roman law, where *homo sacer* is the perpetrator of a severe crime who has been cast out of the community. The criminal is abandoned to the whim of the gods, hence the attribution of "holy." Society may not punish or sacrifice him, since his punishment is complete in his expulsion. But neither can society punish the man who kills him, for he does not enjoy the protection of the law. Most early legal systems have their parallel to *homo sacer*, the outlaw.[56]

Agamben's *homo sacer* is a wolf-man of the type we have already encountered in James Ensor's painting *Christ's Entry Into Brussels in 1889*. The anthropologist Magnus Fiskesjö has examined the connection between *homo sacer* and an old Norse law that prescribed that a criminal who was no longer protected by the law should be seen as a wolf and should be banished to the life of a wolf in the forest.[57] Ensor's painting shows these creatures returning to the city to hail the return of the Messiah. The bear-men, ape-men, rhinoceros-men, and other chimeras flock around the Christ. Agamben would see all of them as *homines sacri*, resurrections from primordial times. They symbolize the outlaws, those who are deported from the city to allow society to be created. Agamben's theory also sheds light on why Ensor and the Belgian labor movement were happy to look on Christ as the incarnation of global revolution. The Crucified personifies *homo sacer*. His return prophesies a new social order.

Homo sacer is a symbol for those who have been cast out so that others can look on themselves as possessing a common identity and create a society. *Homo sacer* is the eternal outcast: the native, the Jew, the refugee, the woman, the monster, and the madman. In the modern era

of nationalism, when many states are guided by the idea that the people, language, culture, territory, and nation should coincide, this process of sorting has accelerated. The most violent example is Nazi Germany, which Agamben analyzes in his book *Remnants of Auschwitz*. Attempts to unify the German people created millions of wolf-people—Jews, gypsies, homosexuals, communists, the handicapped, and others—to be persecuted and murdered.

The difference between modern states and Nazi Germany is only a matter of degree, Agamben says. For him, the concentration camp is the quintessence of the biopolitics of the modern state.[58] Thus, attempts by the United States to unify humanity under the banner of democracy result in the expulsion of those who are regarded as threats to democracy—and these people are put in camps. Similarly, the desire of the European Union to unify the European peoples results in the categorization of certain people, a process that under proposals from Denmark, the United Kingdom, Germany, and others could take the form of banishing those who don't belong to camps in Ukraine or North Africa.

Nowhere is the failure of democracy so visible as in our implementation of human rights, Agamben believes.[59] These rights were drawn up purely to protect the human as a human, regardless of origin, citizenship, class, sex, ethnicity, or intelligence. But if we are now confronted with such a person, reduced to the essence of humanity and without any sign of group membership, these rights become almost impossible to enforce. No political power would have any interest in protecting her, but there would be many who would have her disappear. In practice, human rights only apply to those who are citizens.[60]

As politics becomes a process of permanent border controls and the categorization of humanity, not even human rights are safe. Public authorities in many states are able to freeze bank accounts and arrest people or deprive them of their citizenship without legal redress. The more present this danger, the more people that find themselves in the position of the outlaw. According to Agamben, most people will soon find themselves *homines sacri*, victims of a power acting with the arbitrariness of the state of emergency.[61]

But precisely because there are now so many people who lack a voice in the face of authority, they may foment an idea of how society could be set up if they were allowed to live in that way: left to themselves and to one another, to their own capabilities and talents—to their own authority.

Agamben seems to be saying that for over two thousand years, we have misunderstood democracy. It's not a process of people delegating power

to representatives who then exercise that power from above. Rather, it means unleashing the power that comes from below and that is identical with the very process of life itself, natural life. To distinguish this power from that which is exercised by governments and rulers, Agamben uses the word "potentiality."[62] This is the indefatigable power of people to co-operate, develop their talents, and in this way overcome their limitations and reinvent themselves.

Agamben sheds new light on what is sometimes referred to as autonomy and self-government: a democracy in which power is not delegated but is exercised by each and every one. He also refines the notion of participative democracy: a democracy that is not founded on representation by others but on the participation of the individual, more or less in the way that the Paris Commune began to practice democracy before it was crushed.

Just over the horizon of Agamben's theory beckons the notion of a new global democracy. He refers to it as the "coming community."[63] This type of governance, which for him is the only true form of governance, is heralded every time people come together and unite in the struggle against power from above not to assume power for themselves but to break it down and in this way finally exercise it for themselves.

This was how the revolutions of 1989 began, before they were stopped in their tracks and drained of their life force by new authorities, domestic or western European. This is particularly true of the 1989 revolt on Tiananmen Square in Beijing, Agamben believes.[64] What was really striking was that the demands of the demonstrators were so vague, Agamben argues. They did not represent themselves in the traditional way, through revolutionary programs and spokesmen. It was not ideology or organization that brought them together. They were not even united by the sense that they shared a certain background or identity. The basis of their coordinated action was something more natural: they were people, and as people they demanded the right to come and go, to speak to one another, and to socialize as they wanted. This is perhaps the most dangerous threat that can be directed against authority, Agamben says. People come together and set up a community with no obvious purpose, without common aims or shared visions. They break with the social order not by attacking it but by passively ignoring it and overstepping the boundaries of the community.

Such attempts are usually destined to end in the same way, Agamben writes.[65] The tanks roll in, the police fire tear-gas grenades, and the people are brought to heel by their masters.

[31] Complaints

In 1788 there was famine and unrest in France, and state finances were in massive deficit. Taxes had to be raised, laws had to be changed, and the king's subjects had to be appeased. To gain support for his measures, Louis XVI summoned the three estates for talks—the nobility, the priesthood, and the third estate, the bourgeoisie. Such "parliaments" were only held under exceptional circumstances—the king ruled with absolute power—and had most recently taken place in 1614.

The delegates arriving at Versailles in May 1789 brought with them no fewer than forty thousand *cahiers de doléances* in which the subjects spelled out their grievances and called for reforms. It might be anything from a shortage of bread in Paris or the right to graze livestock on common land to sweeping legal reforms.[66]

A simplistic interpretation of the French Revolution is that the absolute monarchy collapsed under the weight of the suffering and anger represented in these complaints. Their very number lent weight to the demands of the third estate for a new constitution to restrict the monarchy and the privileges of the nobility and the church. Emmanuel-Joseph Sieyès, spokesman for the radical bourgeoisie, claimed that the complaints proved that the king, the priesthood, and the nobility had failed in their duty as guardians of state. They represented only themselves—a mere 200,000 people—while the third estate, which lacked political power, represented the remaining twenty-five million Frenchmen.[67]

Is the world we live in so very different from the France of 1789? That is the question posed by philosophers Michael Hardt and Antonio Negri in their 2004 work *Multitude*.[68] At political summits held in the 1990s and onward by the powerful global institutions—the U.N., the G8, the E.U., the World Bank, the World Trade Organization—official and unofficial

representatives of the various communities of the world have published hundreds and thousands of reports, testimonies, and demands on everything from a shortage of medicine in Botswana and the rate of company bankruptcies in Norrköping to ideas on how financial transactions should be taxed and global politics made democratic. Those who compile the *cahiers de doléances* of our times fear that the powers that be are just as incapable of dealing with the problems as Louis XVI was in his day. The World Bank, the World Trade Organization, the International Monetary Fund, the G8, the E.U., and the U.N. Security Council all represent an extremely privileged minority among mankind. So who speaks for the majority?

Hardt and Negri sprinkle their work with quotations from the liberal thinkers of the eighteenth century, such as James Madison, Thomas Jefferson, and Emmanuel-Joseph Sieyès, and see themselves as standing on the margins of a social transformation, a democratic breakthrough.

The modern era is but a short chapter in the ongoing story of democracy, believe Hardt and Negri, and the future may take many directions. Like Giorgio Agamben, Jacques Derrida, Étienne Balibar, and Pierre Rosanvallon before them, they object to political scientists, thinkers, and social commentators who regard the representative democracy of our times as the optimal model for all societies, as if history had already run its course. Hardt, Negri, and the others represent the opposite view: democracy does not develop in a rational way but through the dynamics of social movements; democracy is never the finished article but is a work in progress; democracy cannot be automatically derived from principles but from the desire of people to influence the society they live in. Or, as Pierre Rosanvallon puts it: "Democracy has no history, democracy *is* history itself."[69]

If you put our representative democracies based on nation-states in the perspective of the protracted cycles of political development, they appear as a short phase in the historical movement of democracy. This phase is beginning to reach an end. Democracy will either take on a new life beyond the institutions of the nation-state, or it will be replaced by the supranational exercise of power with no democratic legitimacy. One sign of the political change now afoot is that many of the fundamental concepts of democratic theory have become ambiguous. Our political language invites misuse.

Citizenship is once again the inherited privilege of certain ethnic groups.

The general will is now a code word for the will of Western countries.

Democracy has degenerated into a procedure of voting through which we accept our subjugation to the empire.

We increasingly accept police action and military occupation as acceptable political measures for use in the promotion of democracy.

We have instituted global apartheid, masquerading under less controversial names.

Maybe things aren't quite as bad as all that. But the fact that we cannot dismiss these allegations simply and directly demonstrates that they are acutely relevant. This in turn means that many of the institutions that were set up in the West to implement democracy today have a more ambiguous function in the global context.

Because behind these issues we detect the hand of globalization, which has brought the societies of the world closer together and revealed their differences. The powerless and the powerful are within reach of each other, and the friction is growing. Hundreds of thousands of *cahiers de doléances* prove the shortcomings of our political institutions every year and demonstrate how these institutions prop up a world order that is unfair and undemocratic. And all the time, despite their extraordinary privileges, the Western powers cling on to their role as lecturers in democracy to humankind.

One key concept in the debate surrounding globalization has long been "global governance." Those who have attempted to define a future form of governance for the world have perhaps plumped for the invisible hand of the market, or the enlightened universalism of the United States, or the multilateral cooperation of the U.N., the Kyoto agreement and the International Court of Human Rights. The U.N. Security Council in particular has been seen as the potential genesis of a future world government. All of these scenarios involve power being concentrated even further away from the citizens. The difficulties in envisaging democracy on a global scale would appear insurmountable. Regardless of what form a global government would take, it's hard to escape the conclusion that it would involve a fount of authority that raises above all people and nations and that this new sovereign would be so powerful that it would inevitably betray democracy. Jacques Derrida shows how the superpowers of our time—and in particular the permanent members of the Security Council—already refer to the universal interests of humanity at every opportunity. But if we scrape the surface, we find that these "universal interests" are oddly enough identical to those of the superpowers themselves.

The most interesting thinkers of our time seek a structure for future global governance elsewhere. They do not try to uncover political truths through discussion of how power should be organized or how the sovereign body of the future should be appointed. Instead, they take Victor

Hugo's exhortation—"Peer through the heart of the people and you will discover truth"—and construct a political ontology, a body of learning on the ultimate essence of politics: the nature of collective life. They drill down into the mystery of democracy toward the level that Agamben calls "natural life," society degree zero.

Like their Italian colleague Paolo Virno, Hardt and Negri refer in this context to "the multitude," a philosophical concept that can be traced back to the seventeenth-century thinker Baruch Spinoza.[70] He saw the multitude as the basic component of society: the human passions and needs that result in people living in a community. From this, Spinoza postulated an idea on absolute democracy: the governance of all through all, a society in which politics is simply the process of living together.[71]

Hardt and Negri decide that "the people" is a tired concept. As soon as there is a people, there is a leader and a boundary drawn to shut out those who do not belong. The multitude, on the other hand, is open, manifold, limitless. The multitude is a swarm, a network, a community of communities. In short, the multitude is the motley essence of humanity, a multitudinous subject that produces what Hardt and Negri call the "common," which is language, communications, genes, images, feelings, and all the other things that must come together in the generation of a society.[72]

But it is now this common that is in danger. The driving force behind today's economy is the production and enclosure of the types of immaterial values that were once regarded as common property: communication, experiences, imagination, lifestyles, relations, care, concern, and service. Economic production is transformed into "social production," Hardt and Negri believe. This means, on the one hand, that the common is refined and extended on a global scale and, on the other hand, that it is privatized and patented, since it would otherwise be impossible to garner some form of financial profit from it. And when the common is privatized, society is paralyzed, the development of production is inhibited, and democracy, as a life form, is extinguished. People stop cooperating.

Social critics such as Vandana Shiva, Arundhati Roy, and Naomi Klein have identified the remains of the common as the decisive issue of our time. In the modern economy, what is at stake is power over communication systems, genes, water, air, language, images, feelings, and imagination. The contribution of Hardt and Negri to this debate is that they identify the political subject that defends the common. Wherever people rise up to defend the common, they see the invisible hands of the multitude, whether in Seattle, Genoa, Prague, Gothenburg, Porto Alegre, or Buenos Aires, or in the worldwide demonstrations on February 15, 2003, against

the Iraq war. These can be seen as experiments in a new type of democracy that subsists in a flat network of interconnected groups, without a centralized power. The social transformation of tomorrow will be different from political crises of the past, Hardt and Negri believe. There will be no social class, people, or political party that steps up to assume power. Instead, it will be a myriad of groupings that relinquish power—the empire of networks of states, companies, institutions and armies that Hardt and Negri believe control the world order—so that it collapses like an empty shell and rots away. Is this the huge rebellion of the future? Billions of people deserting the system?

First and foremost, the multitude show themselves in the movement of bodies, Hardt and Negri believe, in streams of refugees and mass migration, in working to rule and strikes, in the flight of people from a social structure that doesn't allow them to live and produce as free subjects. When economic and political conditions are transformed into compulsion and oppression, people have a tendency to revolt. But before they take to the streets, they generally try all the other options first. They carry on in search of more tolerable conditions somewhere else. How many revolts and revolutions was Europe spared when millions of people from the lower classes emigrated to America a century ago?

The political activist Amir Heidari, who for long periods has been imprisoned in Sweden, maintains that the present-day migration to the West is not primarily a search for personal security. Rather, the movement should be seen as a political act in its own right. Heidari is himself a "refugee smuggler." He claims to have helped 37,000 people gain entry to Sweden, and as many again to other European countries. He does this not for financial gain but as an act of resistance. "Refugees are a new military power without weapons," he says. "They neither rely on nor believe in the world order that has been created. Neither do they recognize where the borders have been drawn."[73]

Heidari speaks of the collective intelligence in the networks of the migrants and the self-sacrificial attitude of their members. His account of their paths to Europe could quite easily have been taken from one of the classical debates of European history on the nature of democracy. As Heidari speaks of the refugees of our time, so the philosophers of liberty from ancient Athens to the revolutions of 1989 have spoken of *demos*, the people. And so speak Hardt and Negri of the invisible movement of the multitude through the space that is our world. As refugees, the multitude flow over frontiers and back and forth between various political communities, and in this way the multitude in transit lays the foundations of

a future, transnational society. When Heidari describes the migrations of our times, he depicts a democratic revolt that is taking place outside the framework of our vision of the world. This is the essential life force of society: "It's like water, finding new ways around obstacles in nature. If you dam up one stream, people will find another. It's quite idiotic to believe that the stream can be dammed. The only thing that happens when you build walls is that you shut yourself in. The migrants will always find a way through."[74]

It's difficult to imagine what type of politics these migrants, the global dissidents, workers, and the poor, would practice and what type of political organization they would create together. When Hardt and Negri speak of the multitude, they often change focus, and the political implications remain diffuse. Sometimes, their definition seems self-evident and banal: we are all the multitude! And sometimes it seems utopian: the multitude will be the global democracy of the future! The word is as difficult to capture as the people—no, more so.

Is there a multitude? Is there a people? Is the notion of collective action a figment of the imagination of the political Left? The liberal imagination offers a way out; it speaks of society only in terms of individuals.

The idea that Agamben, Derrida, Balibar, Rosanvallon, and Hardt and Negri promote is among the most controversial in modern political thought: that real men and women can under certain circumstances come together and merge into a unified political subject, the people, or the multitude; that this subject embodies a political principle, democracy; and that this democracy takes expression in defined historical events called revolutions.

Thinkers in the tradition of political conservatism have generally rejected the idea. Like Edmund Burke, they see collective action as an expression of the short-term interests and instincts of the people. In traditional liberalism, too, many have shunned the idea, but this time on the grounds that the essence of democracy is the ability of individuals to align their own interests in a social contract.

But how can we explain the dramatic events that occur when society is re-created, perhaps most recently in Ukraine in 2004, if you deny that *demos* sometimes strives for power? Well, there is a popular will, the liberals allow, but it is not out there in society, not on the streets and squares, but only as the sum of the will of individuals: the average as expressed by the opinion pollsters. The popular will is the average man, *l'homme moyen*.

This would appear to be a tenable position, particularly if you remember that the worst crimes in modern history have been justified through

references to a collective subject—the people, the class, the nation—that has staked out the course of history in advance and awarded itself the right to crush all that stand in its way. The fact that collective ideologies have had such fateful consequences is, on the other hand, as good a reason as any to seriously examine the various theories surrounding the existence of the collective. Leading thinkers like Tocqueville and Hegel noted early on that history becomes incomprehensible if you deny the possibility that the people, the many, can under certain circumstances meld together into a unified movement that embodies a certain political principle. In fact, modern social science and historical narrative first arose with the aim of understanding the sudden emergence of popular power. The first sociologists—Auguste Comte, Émile Durkheim, Ferdinand Tönnies, Georg Simmel—all recognized it was the tangible presence of the people, that is, men and women who had for long remained invisible but who were now moving across territorial, cultural, social, and professional boundaries, that incited political theorists to discover "society" and posit it as a category of scientific study in the first place.

There is also another reason to investigate the political secret of the collective and the revolutionary legacy of humankind. The liberal-democratic tradition to which most people today pledge allegiance would never have arisen if people in the past had not acted as they did in Tiananmen Square in Beijing and outside the Nikolai-Kirche in Leipzig in 1989, or in Seattle in 1999. No aggregation of the will of individuals, no matter how detailed, and no summation of individual interests, no matter how carefully executed, is able to explain why ordinary people sometimes come out onto the streets in their thousands to state their implacable demand: bring us the head of the ruler!

[32] The Baggage of the Barbarians

History is written by the vanquishers. The vanquished ones give their testimony or atone for their political sins. Daniel Cohn-Bendit was one of the 142 students who on March 22, 1968, occupied the administration building at the University of Nanterre in Paris. The immediate reason for their action was the arrest by police of six students who were active in the anti-imperialist movement. Nobody suspected that their protest would stoke to a nationwide revolt that shook the French state to the core. Cohn-Bendit became one of the most adept spokesmen of the rebellion of the Left. On May 20, 1968, the minister of the interior expelled him, citing reasons of public order.

This militant transformed himself gradually into a highly polished politician. Cohn-Bendit is now a respected member of the European Parliament, where he represents Germany's Green Party. Partway through this metamorphosis, he took time out for a reckoning with the past. In 1985 and 1986, he traveled the world to find some of the people who had stood alongside him at the vanguard of the 1968 rebellions, visiting Frankfurt, Rio de Janeiro, Paris, New York, Philadelphia, Rome, Amsterdam, Warsaw, the French Basque region, Rüsselheim, and many other places. "I wanted to visit my 'political family,'" he wrote.

Cohn-Bendit sought to record what had happened to his comrades after those dramatic years and find out what they thought they had achieved. They had put body and soul into creating a new society. What price had they paid, what had they had to give up, what had they learned as they were forced to bow down and subjugate themselves to the society they once had rejected?

The result of Cohn-Bendit's endeavors was a television series and a book, *Nous l'avons tant aimée, la révolution* (We loved it so much, the

revolution), filled with detailed eyewitness accounts and intimate exercises in self-criticism. What emerges is a profoundly contradictory picture of 1968—bitter, humble, resigned, ragged, sober, optimistic, nostalgic, dismissive, loyal, militant—depending entirely on the identity of Cohn Bendit's interlocutor. In less than twenty years, people who once had been in similar circumstances as student leaders and political activists in a struggle with bourgeois society had spread to the far reaches of the world. Some became pacifists; others chose armed struggle. Some stayed in the factories; others became capitalist entrepreneurs. Some became ministers; others were sentenced to life imprisonment. Some have changed little; others have changed lives. One thing unites them: loss.

"I wanted to revive the fantastic and utopian idealism that all of these people possessed," Alfredo Jaar said of his installation *They Loved It So Much, the Revolution*.[75] The title is taken directly from Cohn-Bendit's book—along with two or three of the images in the installation. At about the same time, Jaar created a similar piece for the Brooklyn Museum in New York using pictures from the protest marches of the black civil rights movement. For the American installation, Jaar borrowed the title of James Baldwin's famous work on racial conflict in the United States, *The Fire Next Time*.

It you look simply at the materials used, these installations consist only of a dozen or so press photographs and about twenty large light boxes. The effect of the piece subsists entirely in the fragmentation and the framing of the pictures. Jaar disassembles an image of the world and gives it back to us as a collection of fragments so that we reassemble it once more. The elements in his installation that convey meaning are not the subjects but the cracks, the empty spaces, and the seams that separate the pieces. In this regard, *They Loved It So Much, the Revolution* bears a likeness to Jaar's other installations. The visitor encounters a world of boundaries—between rich and poor, natives and foreigners, demonstrators and policemen; boundaries between the meaningful and the meaningless, those who are included and those who are excluded; the boundary of the scope of art, of our images of the world, and our ability to empathize. The installation on the revolution also draws attention to the violence caused by these boundaries: anger, fury, riot, and oppression; riot police, demonstrators in wild charges, violent gestures, batons crashing down again and again. The violence that Jaar indirectly hints at in his other installations explodes here in full view. *They Loved It So Much, the Revolution* rises up out of its time and becomes an allegorical presentation of every revolt in every era.

Was it this image that finally materialized inside visitors to Jaar's work at the ARC in Paris in 1989: an image in which 1968 takes on the mantle of the archetypal rebellion of our times?

If so, it's a rather hackneyed depiction of 1968. But if we reverse our perspective, the interpretation becomes all the more interesting. Jaar presents 1968 in such a way that our times are seen as an era of rebellion. *They Loved It So Much, the Revolution* would seem to suggest that the most telling characteristic of modern society is division and conflict. Society is always divided and subdivided.

Daniel Cohn-Bendit's interviews with the revolutionaries of 1968 have two striking themes. One of these relates to their view of the relationship of democracy with the revolution. In 1968, we dismissed democracy as a bourgeois lie, Cohn-Bendit says. "These days we're trying to reformulate democracy since it appears to be the only possible way forward," he continues.[76]

It appears that the achievements of the revolutionaries of 1968 were more important than they themselves believed. What appeared to Cohn-Bendit in 1968 to be a revolution against democracy proves twenty years later to have been a revolution *for* democracy. The revolutionary effort to bring down bourgeois democracy was unsuccessful, but the defeat led to the successful expansion of democracy. Sections of the population and issues that had not previously enjoyed political representation found a voice in the public arena. The conflict between the revolution and parliamentary democracy was in the long run to the benefit of the progressive renewal of democracy. Jean-Pierre Duteuil, Cohn-Bendit's closest confidant during the years at Nanterre, summarizes the lesson of history: "Democracy with a capital D?—there's no such thing. The Revolution?—there's no such thing. Free Society?—none of these things exist. The interesting thing are the social movements. People taking charge of the situation and fighting to take control of something."[77] Gaby Ceroni, another of Cohn-Bendit's comrades, draws the same conclusion: "The struggles will always continue, but on a small scale. Factory by factory."[78]

Joschka Fischer, another one of Cohn-Bendit's close friends, and at the time of their conversation in 1985 a recently elected member of the German parliament for the Greens, draws a Hegelian conclusion from the events of 1968: "We failed. It's not wrong to have tried . . . we struggled to the limits of exhaustion, and I'm convinced that the struggle wasn't in vain. We pushed things as far as we could. We reached a threshold beyond which we were unable to continue. We were forced to begin searching for something else."[79]

"You mean, something else like the parliamentary system?" Cohn-Bendit interrupts, incredulously.

"I can't find of a better solution," Joschka Fischer responds.

One conclusion of Cohn-Bendit's odyssey is that those activists who emerged more or less unscathed from their time in the extreme Left achieved a more profound insight into democracy. They no longer connect democracy with the representative system—the despised "bourgeois democracy"—nor with the dream that the many will one day merge into a unified popular front. Democracy no longer appears to be the pregiven basis and constitutional framework for all politics but rather its necessary if unattainable goal. Democracy is, to put it simply, one with history, a history of ceaseless conflict.

This, too, is a hackneyed analysis. But there is much to suggest that it is correct. In some cases, citizenship and political rights were attained in a calm and civilized manner. But for the bourgeois themselves it required civil war and bloody revolution. And the process was no more peaceful when the women's movement, the labor movement, the black civil rights movement, and Third World liberation movements won their political rights. They were forced to break the law; they were called fanatics, brutes, terrorists, agitators, witches, niggers, and barbarians; they were suppressed, but they came back. Not until much later did it become clear what they had brought with them—democracy.

I said that there were two striking themes in Cohn-Bendit's conversations with the revolutionaries of 1968. The second theme would appear to contradict the first: most of the revolutionaries in Cohn-Bendit's "family" have realized that democracy is in a continual process of change, but even so none of them can conceive of politics beyond the parliamentary framework of the nation-states. The generation of 1968 looks on the mid-1980s as the end of history. When the book was written, a great part of intellectual life in the West was in thrall to postmodernism, and this is reflected in Cohn-Bendit's writing. The scope for radical political change appears to be exhausted, and the only remaining alternative is to realize smaller-scale utopias on a local or private level. As Jean-François Lyotard put it, the "grand narratives" are over. As Cohn-Bendit is speaking with Michel Chemin at a Paris restaurant, they are interrupted by a young blonde woman who voices the fate of the revolution—it is broken down into sects and enclaves, finally turning out to be a wholly private matter. "You don't need a Maoist label to exist. Freedom is in your own head."[80]

In Jaar's idealism, too, the resignation shines through. His conscious effort to keep the memory of the revolution alive proves in the final analy-

sis that the memory of 1968 is fading. The construction of the light boxes is reminiscent of coffins.

And so modern readers are left with the same impression of Cohn-Bendit's book as of French political writings dating from just before 1789. You can't predict revolutions. Cohn-Bendit and his friends assume that the last revolution has taken place and that political life has become established in a form that will remain unchanged for the foreseeable future. Cohn-Bendit's final conversation takes place in 1986, just three years before the next wave of revolutions; in Jaar's case, it's only a matter of a few months. In the Paliano prison outside Rome, Cohn-Bendit puts a question to Adriana Farranda, who is serving thirty years for her links with the Red Brigade.

"What does the word 'revolution' mean today?"

"Nothing. The word has no meaning. I believe there is a possibility that society will evolve. But I no longer believe in rapid transformation of any sort."[81]

[33] Departure

In 1990, the French philosopher Jacques Rancière published an unusual travelogue. *Short Voyages to the Land of the People* was his title; *Courts voyages au pays du peuple.*

So where is this land? Not on some remote island or in exotic regions, Rancière says. "Just across the straits, away from the river, off the beaten path, at the end of the subway line, there lives another people (unless it is, quite simply, the people)."[82]

In his book, Rancière introduces us to a motley group of individuals. Famous poets like William Wordsworth, Georg Büchner, and Rainer Maria Rilke rub shoulders unexpectedly with the French sailor Gaude Genoux, historian Jules Michelet, a gaggle of Saint-Simonian missionaries and, alongside them, Ingrid Bergman and Roberto Rossellini. What have they got to do with one another? All of them have found their own path to the land of the people, and the impressions they have garnered on their travels bear little resemblance to what sociologists, historians, and political scientists teach us about "the people."

The people? That word again. It seems simple, almost banal. All modern political theory assumes that "the people" is something real, the very foundation of society, but the word remains a mystery, hopelessly elusive, since this reality never makes itself felt by direct means but only via intermediaries and representations in the form of political spokesmen, parties, statistics, opinion polls, social theorists, aesthetic symbols, myths, and archives.

No, we can never know anything about the people in itself, Rancière suggests. Anyone speaking in the name of the people or even speaking of the people is only creating yet another representation that makes itself a surrogate for the people or, even worse, shoves them to one side.

Like Étienne Balibar, Rancière studied under Louis Althusser and co-authored his influential book *Reading Capital* in 1965. But he soon broke with his mentor since he did not share the conviction that only the Communist Party and the Marxist theorist can see reality as it is, while the masses are mired in ideological meanderings. Althusser's theory helped to keep the masses down, Rancière maintained.[83]

In 1975, he founded the periodical *Révoltes Logiques*, "Logical revolts."[84] The title itself was an intervention into the debates about the political strategy of the post-1968 Left. The long-term plan was the organized assumption of power, classified by many groupings of the Left as "revolution." Acts of political violence that diverged from or could not be predicted by the plan were in general dubbed revolts or riots, and were seen as spontaneous expressions of discontent of the type that had marked human history since the slave revolts and hunger riots of the past. This distinction between revolution and revolt evinced the high esteem held for the political elite of the Left, which was seen as directing the revolutionary process, and the downgrading of the grass roots, who were apparently only capable of impulsive actions that were immediately crushed by the forces of law and order. In short, the contrast between revolution and revolt reflected the old divisions between politics led by the clarity of vision of its leaders, and politics led astray by the suffering of the people.

Rancière aimed to dissolve this pairing of opposites. He argued that even revolts follow a strict logic, just as revolutions always have an element of spontaneity. In the midst of unfolding events, it's impossible to see exactly what is what. Once events have settled into a pattern, it may turn out that the revolution developed out of a successful revolt, or that a carefully planned revolutionary attempt was but a meaningless riot.

Révoltes Logiques also played on a Maoist slogan often used to sum up the events of 1968: "it's right to revolt." This may sound like an assertion of moral values, or as an exhortation to exert one's moral or political rights. Its original meaning is more crass, however, less of an interjection and more of a description: it's logical to revolt. The French version of the expression—"on a raison de se révolter"—is somewhere between the two: "there is always *reason* to revolt." In any case, the underlying idea is based on a simple syllogism: all people value justice; society is unjust; therefore people revolt against society.

But ultimately, the title of Rancière's publication was a tribute to the first poet of rebellion. With biting sarcasm and under the ironic title of "Democracy," Arthur Rimbaud imagined the mood among the government

soldiers as they were about to crush the Paris Commune: "We will mas-
sacre all logical revolts. . . . This is true progress. Forward . . . March!"[85]

Révoltes Logiques sought an "alternative historical memory"—a memory
that was not defined by the universities or the political parties but was
based on "a process of thought from below." For Rancière, this meant that
he delved into the archives of the roots of the French labor movement in
the 1830s and 1840s. The result was a revision of the prevailing version of
history, which, roughly speaking, assumed that the workers of the nine-
teenth century held the class-consciousness and the weltanschauung pre-
scribed by Marxism. This was not the case, as Rancière shows in his book
Nights of Labor (*La Nuit des prolétaires*), evocatively subtitled "Archive of
a worker's dreams."[86]

La Nuit des prolétaires is exactly that: an entire archive that sums up
the everyday existence of the workers in the Paris of 1830. But it is not the
story of their daily grind, their work, or their social situation but of their
dreams of liberty that flared up once the working day was done. From the
drafted poems, articles, diaries, and novels of some twenty young work-
ers, Rancière re-creates the "thought from below"—from the land of the
people, the same regions that Victor Hugo attempted to explore in *Les
Misérables*. Rancière is careful not to systematize the ideas of the workers.
Their proletarian dreams are wild and untutored. They don't fit into any
of the pigeonholes of socialist thought. The most obstinate feature of these
workers is their implacable demand for equality. This expresses itself most
readily as a desire for the good things in bourgeois life. The young pro-
letariat is seeking liberation, but not the type of liberation meant by the
socialists when they talk about the emancipation of the working classes.
They want freedom from having to go out and beg for work every day.
They want freedom from the cold, from seeing their children fall sick and
die. In short, they want freedom from being workers.

What drives these people to rise up is not their consciousness of them-
selves as an oppressed working class; nor is it the realization that the very
structure of the economy is biased against them. The decisive factor is
their daily encounters with another, better world to which they are denied
access: the world of the bourgeoisie. The fact that this bourgeoisie also
insults them by acting like a well-intentioned guardian only reinforces
their desire to rebel.

Rancière acknowledges the revolt of the people against their benefac-
tors, the refusal of the people to obey orders, and their right to escape
from the framework that those in authority have placed them in. The very
essence of democracy is exposed in moments such as this. In its pur-

est form, democracy exists exclusively as contradiction and negation, in the ability of the people to stand up to those who represent the people, Rancière argues.[87] Democracy is the universal right of veto and of revoking authority as the people act to rectify the development of society, and depending on the circumstances, this right is exercised through elections, riots, strikes, or revolutions.

How can we know that those who stand up and rebel represent the popular will more closely than the official representatives of the people? We can't, says Rancière. We are caught in an endless cycle of surrogates, each of which claims to be the true voice of the people. Strictly speaking, there is no *vox populi*. There are voices—angry, tense, polemical, and desperate—that always color and frame the essence of the people as they wish it to be seen. The people always take on the dialect of their spokesmen. No one has ever heard the true voice of the people.[88]

We are stuck in this cycle of surrogates, of frames within frames within frames, and, in the end, the thing itself remains concealed. The land of the people is to be found where these surrogates are no more, at the place where the people is content in its own existence without the need for political, aesthetic, or scientific representation. Hugo got right to the border of this land in *Les Misérables*, but his way was blocked by the huge barricade in the suburb of Saint-Antoine. And what he saw there was "beyond reason."[89]

From the barricade, Hugo heard the shouting of commands, battle songs, the roll of drums, the sobbing of women, and the dark raucous laughter of the half-starved—all of it resembling "the voice of God." For two hundred years, the people have been depicted as the absent god, the structure that ultimately governs all other structures, a power that only exists through its effects.

The extent to which a text or a work of art has a political dimension depends on its ability to register and record these effects. Jacques-Louis David, James Ensor, and Alfredo Jaar are three good examples. Jacques Rancière practices the same art, but in the role of a historian and philosopher. He achieves in his writing what Alfredo Jaar achieves through the media of images and architecture: he freezes the moments when the people escape from their framework or destroy the established social structure. True equality emerges in a flash, scandalous and dangerous in the way that it breaks down accepted classes and identities. In his travelogues from the land of the people, Rancière describes how such turbulent events were staged by Ingrid Bergman in Rossellini's *Europa 51*, and how they are recorded by Wordsworth in poems from his travels through France in

the revolutionary summer of 1790, or in Rilke's letters and poems about Marthe, the working-class girl he befriended in Paris.[90] The people asserts itself through these works as a discordant tone or a dramatic shift in perspective that breaks down the solid illusion of reality and provides the viewer or reader with a fragmentary glimpse of a history that lies outside the framework of representation.

According to Rancière, the French historian Jules Michelet was the first person to engage in a systematic effort to liberate the people from the pigeonholes into which they had been forced by politicians and intellectuals. In Michelet's writings on the history of France and the French revolution, the people are the least predictable force in the story, in the manner of a jester or hero who always holds an extra trump card in the game of justice. When the course of history stands in the balance and tyranny takes the upper hand, that is when the people of the streets will take a stand and the farmers will turn their pitchforks on those in authority, Michelet believes. His accounts of the great days of the revolution are imbued with literary tension and vitality. In historical miniature, he captures the people as a multitude in unison.

More recent historians who have attempted to present an image of the people as event owe a great deal to Michelet. This applies not least to Rancière, who, in *The Names of History* (*Les Noms de l'histoire*), examines and lauds Michelet's ability to give names to the nameless.[91] Rancière takes as his prime example a short work published by Michelet in 1846 entitled *The People* (*Le Peuple*). "This book is more than a book; it is myself," Michelet underscored in his foreword.[92] It was written at a time when "the social question" was being debated for the first time in England and France. The contemporary novels of Balzac, Hugo, and Sue noted the pressure of "the dangerous classes." They are the barbarians, Sue declared in *Les Mystères de Paris*—and they are right here "in the midst of us."

Michelet reacted strongly to the demonization of the under classes in the novels of the period: "I closed my books and went among the people again as much as I could; the solitary writer plunged again into the crowd and listened to the noise and noted the words. It was indeed the same people as ever."[93]

Michelet's book is written as a journey upward through the strata of society, from the peasant through the factory worker, craftsman, entrepreneur, trader, and public official to "the rich and the bourgeoisie." The higher up the ladder, the more sterile and contrived the lifestyle. But on the highest rung, we break through the clouds, and this is where Michelet finds the wise man. Standing above the fog of ideology, the sage holds

the insight that the true values of society are to be found at its depths. At the lowest levels of society, we find the simple and pure passions that in Michelet's eyes are the driving force behind both French history and individual human life. The final link in society, the wise man's understanding of social duty, connects with the first link, the child who instinctively embodies these virtues. And so the chain of society is closed in a ring.

This is a romantic vision whose roots are to be found in Rousseau. Michelet is usually regarded as one of the great romantics who drank his fill at the clear waters of the people. But he sets himself apart through the sophistication of his vision and his spirit of militancy: "I had been born like a blade of grass without sun between two cobblestones of Paris."[94]

Michelet was the son of a bankrupt book printer but gradually rose to become a professor at the Collège de France.[95] The more he distanced himself from the poverty of his childhood, the more he identified spiritually with the underclass. Unlike almost every other French intellectual, Michelet consistently took sides with the people of the fields and the factories. When social conflict began to flare—in 1830, 1832, 1848—Michelet defended the right of the people to rebel. He traces this right back to the revolution of 1789, which he regarded as the beating heart of all of Europe. His political beliefs led to his suspension from the Collège de France in March 1851, and just a year later, after Napoleon III had appointed himself as autocratic ruler, he was stripped of his professorship.

Through the revolution, "the people" took on shape, body, substance, Michelet explained.[96] In retrospect, the revolution appears to have been an incarnation of "the people," an event that subsequently made it possible to construct a political system around the voice of the people. But how should a democratic society be governed during the long periods when the people doesn't assert its presence? If democracy is to avoid settling into an empty electoral process, there must be a collective memory serving as a constant reminder of the political presence and potential of "the people." This is where history has a role to play, Michelet holds. The task of the historian is not primarily to recount the past or to explain it. The purpose of writing history is *résurrection*, and the being that the historian summons back to life is the people—the guiding light of society, the engine of progress, and the font of sovereign power. In his foreword to the 1866 edition of *Le Peuple*, Michelet sums up what he calls "the deepest foundation of society." He argues that democracy rests on three pillars: the instinctive sense of justice of the simple people, the inspiration of the masses, and the naïve voice of the conscience. His duty as a historian is to show how these inextinguishable passions smash through

political and social institutions at regular intervals and alter the course of political events.[97]

The first occasion on which this occurred was on June 20, 1789, Michelet asserts. He described the Jeu de Paume at Versailles as "the cradle of the new religion, its stable in Bethlehem."[98] It's a striking comparison. Until this moment, the people have repeatedly been denied access to the corridors of power; and in June 1789, the representatives of the people have been literally locked out by Louis XVI, who wants at any price to prevent the delegates of the third estate from discussing how his autocracy should be limited. The only meeting room the delegates can find is a cold tennis hall, the court's recreation room, the Jeu de Paume, and they have to make do with that. "A miserable place, ugly, unfurnished, bare," Michelet says, "but that was all for the good. The gathering was revealed in its poverty there, and thus represented the people all the more faithfully. They remained standing all day, with hardly a wooden bench at their disposal." The Jeu de Paume bore no sign of the finery of the court, no dark corners in which the myths of the past could remain unchallenged. Everything is laid bare, naked, unfurnished and, as Michelet puts it, "utterly modern." And so, the future has all the more room to unfold: "the pure spirit, common sense, justice."[99]

Michelet describes the Jeu de Paume at Versailles as a simple place of refuge where the homeless find a temporary shelter that gives them time to bring democracy to the world and to found the new religion of the people. His history of the revolution tells how the people are soon expelled once again from the political scene and, after a few happy days, continue to live in exile, incognito, browbeaten, and exploited, always looking for a refuge, an institution, a form of government that answers to their will. On the endless journey toward the allure of asylum, the people become a stateless refugee.

Jacques Rancière puts Michelet at the source of the intellectual tradition to which he is committed himself. Since "his majesty the people," as Heinrich Heine put it, rarely appears in person but is distinguished either as an abstract principle or as a shapeless mass, it is the duty of the intellectuals to report back from the land of the people during these protracted interregnums. This is not to present an authentic picture of the people—this, after all, is impossible—but to remind us of the potentiality of the people and to show that the many can be and in fact always are the constituting force of society: democracy.

Jules Michelet, the historian of 1848, and Jacques Rancière, the philosopher of 1968, here intervene into the twenty-first century debate on the

world order. The current debates on the clash of civilizations, the war on terror, and on the endless flows of migrants and refugees is evidence of everything that threatens the Western world and Western dominance over the world. What is in danger, among other things, is a political privilege for long taken for granted by Western leaders: to act as a spokesman for all of humanity, civilization, and democracy.

And *don't* we use this privilege to promote our own interests?

Don't the marginalized masses of the world have reason to revolt?

Jules Michelet recognized the process: "Today the rise and progress of the people are often compared to the invasion of the barbarians," he wrote. "I like the word, and I accept the term. Barbarians! That is to say, full of new, vital, and regenerating vigor. Barbarians! That is to say, travelers marching toward the future Rome."[100]

They are many. Move closer! The door to democracy is on the left. In Jacques-Louis David's painting you can see it in the bottom corner. A handful of boys have managed to get into the tennis hall from the street to witness the birth of democracy and the revolution: four, wide-eyed, boyish faces peering over the stone wall just inside the door to the hall.

And now, over 200 years later, the old tennis hall at Versailles is as bare as it ever was. You won't see it if you're not looking for it, even though the street itself is the rue Jeu de Paume.

The building is about twenty feet high and one hundred and fifteen feet long. The upper sections of the long walls are windows, like an old-fashioned school gymnasium. *Has anyone played tennis here since 1789?* I ask myself once I've found the place. Michelet was right. The hall is dismal and ugly. And these days, it's got an air of neglect as well, like an old bus garage or a workshop that has been closed down and is awaiting demolition. The grubby windows are painted in a rusty color that has begun to peel and flake. One of the long walls flanks an untidy back yard, the other runs along the street, an extended grey edifice with a simple door at one end. This is the same door as was used by the representatives of the people on the morning of June 20, 1789.

In David's *The Tennis Court Oath*, you can make out the roof of the Palace of Versailles through the furthest window on the left. The tennis hall is in the shadow of the royal palace, outside the palace complex itself, which is located on the heights above the confusion of the city. Michelet emphasizes the contrast between the finery of the court and the simple meeting place of the delegates. The difference is just as striking today. Up at the palace, thousands of tourists from around the world wait in line to admire the gold leaf, purple velvet, and crystal. On rue Jeu de Paume, the

plaster is hanging from the walls; not a single soul is in sight. Few visitors come to the birthplace of French democracy. In fact there's nothing to see, just a building like all the others on a street like all the others, as commonplace and well worn as everything else in the invisible history of the people. But the proximity to the grandeur of the palace suddenly forces you to see the shabbiness of the rue Jeu de Paume. Outside the simple tennis hall, it becomes easy to understand the revolution, not just the French revolution, but every revolution: the logical revolts. When I arrive on this day in May, the door to the home of democracy is locked. There is a bell by the doorway, and when I press, I hear how its ringing echoes through the empty space. Above the door is a short inscription stating that it was in this building that the people seized the right to speak and swore to one another that they would take power in the country: *Ils ont tenu parole*—they kept their word.

Afterword

A Brief History of the Masses is part of a larger study devoted to the idea and image of "the masses" in European culture. From the French Revolution until our present day, politicians, social scientists, intellectuals, artists, and people in general have conjured up the specter of the masses when discussing art, culture, political events, or the future of civilization. In times of social unrest, the upper classes have feared the masses, approaching them as a hostile power or as a force of destruction.

But, as I seek to show in this book, the masses have never existed. The same is true of the people. Indeed, neither the masses nor the people are a social *fact*. The mass should rather be seen as a recurring *theme* of a particular cultural discourse and social ideology. At stake in this discourse is a fundamental question. How should society be represented? And by whom should it be represented? As I maintain in this book, the mass owes its phantom existence to the ways in which these issues have been addressed. Stated differently, the habit of construing certain parts of humanity as masses is rooted in a repeated failure to resolve the fundamental question of democratic representation.

The people is the foundation of power. This much is asserted by the constitution of every democratic regime. But before we can have any knowledge about the people upon whom sovereign power is founded, or by whom sovereign power is instituted, this people must make itself known. And as soon as the people makes itself known, that is, at the very moment it constitutes itself as political subject, it divides itself into two. Some groups or individuals act as the people's representatives, appearing as the visible incarnation of an invisible social body, which means that the rest, the vast majority, is represented and hence rendered invisible by these same groups or individuals. During the nineteenth century and a good

part of the twentieth, this division of power manifested itself through a certain distinction between individual citizens and masses. While the former were seen as reasonable and trustworthy and hence able to represent the people as a whole, the latter were believed to be governed by emotions and instincts, acting spontaneously and irresponsibly.

Why did politicians, intellectuals, and artists of the past describe the popular majority as irresponsible masses? The appearance of the masses in literature, the arts, and public discourse is a sure sign of a social, cultural, and political crisis: the *systems of representation* that structure society are faltering. The crisis may concern the aesthetic representation of society: there is no normative symbol or hegemonic narrative that may serve as a plausible depiction of social reality. The crisis may also bear upon the methods of political representation: there is no consensus on how to go about building institutions and making laws that work in accord with the general interest. The crisis may, moreover, involve the mechanisms of economic representation: there is no agreement on the right way of managing society's natural resources or the surplus value extracted from its labor.

Few societies have been so deeply affected by such crises of representation as interwar Germany and Austria. After World War I, their imperial administrations were dismantled, and both Germany and Austria were left without political and cultural structures that could legitimately claim to reflect the will of the population as a whole. In the power vacuum that ensued, rivaling parties and groups struggled violently, each seeking to impose its own method of representing the nation and of manifesting the will of the people. Consequently, it is in Germany's Weimar Republic (1918–1933) and Austria's first republic (1919–1934) that we find the most intensive discussion about the masses in Western history. Piercing analyses of the nature of collective life were developed by, for instance, Hannah Arendt, Hermann Broch, Elias Canetti, Walter Benjamin, Robert Musil, Bertolt Brecht, Karl Jaspers, Arnold Zweig, Theodor Geiger, Wilhelm Reich, Sigmund Freud, and Theodor W. Adorno. In the same milieu, right-wing or conservative writers such as Oswald Spengler, Martin Heidegger, Carl Schmitt, and Ernst Jünger contributed to fascism's mobilization of the masses. Meanwhile, many modernist vanguards in art, literature, theater, cinema, design, architecture, and dance sought to transform their aesthetic expressions so as to respond to the needs of the new life forms of urban modernity. Interwar culture was thus the climax of an age, the age of the crowd.

The great debates about the masses in the interwar period—and here

we may also allude to Gandhi's popular movement of independence in India and the rise of Maoism in China—is the topic of my forthcoming study, *Cultures of the Crowd*. In the present book, by contrast, I have sought to chart the longer cycle in the modern history of the masses. I have foregrounded how three artworks, conceived in 1789, 1889, and 1989, intervene into a still ongoing dispute about popular sovereignty and revolutionary action. The debate on the masses of the interwar period is in many ways the culmination of this set of developments.

The visual artists at the center of my study address the same problem as did the politicians and social theorists of their respective period: how to represent the social world? The solutions suggested by the artists deviate in interesting ways from the views circulating in the political and scholarly sphere. An artist enjoys greater imaginative and expressive freedom than does a politician or social theorist. The artist may therefore push his or her exploration of society beyond the discursive and ideological limits that they must not cross. This helps explain why Jacques-Louis David, James Ensor, and Alfredo Jaar succeed in disclosing fundamental political mechanisms that tend to be neglected, ignored, or repressed in politics and political science. The political mechanisms revealed in their visual work are usually not discussed as proper political matters. In fact, they must not be addressed as political matters because they constitute the very arena in which political matters are settled, as well as the silent presumptions determining who is allowed into the discussion. To put things simply, David, Ensor, and Jaar expose the exclusion at the heart of every existing political system. For society to become a political community, some of its members must be excommunicated. More often than not, the majority is included among those excluded.

This is not to imply that the works of David, Ensor, and Jaar launch proposals for improving our systems of political representation so as to make them more inclusive, or democratic. For better or worse, the possibilities discovered by art are located beyond the range of political possibilities. What I am implying, however, is that their aesthetic representations should be taken seriously by social thought and political theory, for they serve as correctives of the political imagination and as testimonials of its shortcomings. David, Ensor, and Jaar express what the political establishment and the surrounding society never wanted to know about itself. They indicate democracy's eternal failure, the ways in which it inevitably corrupts its own foundational principles.

But democracy's failure is also the motivation for its continuous renewal. What we learn from David, Ensor, and Jaar, then, is that democracy

can't do without its utopia: the idea of a government by all, and for the benefit of all; a society in which power is executed not from above but from below. Just as this radicalized notion of democracy has inspired past revolutions, so it continues to guide insurrectionary movements in the present, fueling the principle of popular sovereignty with new meaning and new momentum. Democracy, in this sense, may arise in any corner or margin of society, though rarely at its center. Wherever and whenever it emerges, it manifests itself in language and demands that prove hard to translate into the vocabulary of liberal democracy. True, there are also long periods in which democracy doesn't disturb political power, to the degree that it may seem to have vanished altogether or been rooted out by a more oppressive form of government. But we can be sure that it survives, in subterranean form, in the poet's dream of a clear day, or in the heads of people clasping their fists behind their backs and exercising the art of resistance. In writing this book, I have adhered to principles of form—cyclical rather than linear, paratactic rather than hierarchic—corresponding to this notion of democracy excavated by David, Ensor, and Jaar: a project constantly betrayed, and yet continuously reinvigorated by political rebellions, aesthetic transformations, and crises of representation that keep alive the great political issue around which history revolves: Who are the people? What makes us a people?

A Brief History of the Masses, first published in Swedish as *Tre revolutioner. En kort historia om folket—1789, 1889, 1989* in 2005, is here translated in slightly revised form. I thank Trevor Datson for having translated part three. Sections of the book have been published in preliminary form in *Crowds*, ed. Jeffrey Schnapp and Matthew Tiews (Stanford, Calif.: Stanford University Press, 2006), and *Representations*, no. 75 (2001).

I conceived my project on the history of the masses during a two-year fellowship at the Getty Research Institute in Los Angeles. I remain indebted to this institution not just because Ensor's *Christ's Entry* happens to be housed in the neighboring J. Paul Getty Museum but also, and above all, because of the intellectual milieu I encountered there. I want to thank the staff at the GRI, not least its librarians, and especially its former associate director, Michael Roth, as well as Charles Salas and Thomas Crow; they were all tremendously supportive and inspiring. Among my colleagues in Los Angeles was Tim Clark, who encouraged me to embark on this project. I also want to thank other colleagues at the Getty, in particular Francesco d'Angelis, Heinrich Dilly, Cathy Soussloff, Ernst Osterkamp, Lydia Goehr, Juliet Koss, Robert Nelson, Meng Yue, Elspeth Brown, Martha Feldman, Page Dubois, Tapati Guha-Thakurta, David Carrier, Charles Merewether,

and Reinhart Meyer-Kalkus. In Los Angeles, I also benefited from discussions with Allan Sekula and Norman Klein. For comments and suggestions at later stages, I'm grateful to Aris Fioretos, Wolf Lepenies, Fredric Jameson, Stephen Farran-Lee, Peter Karlsson, and the two anonymous readers at Columbia University Press. I have also learned much from my collaboration with Jeffrey Schnapp and Matthew Tiews, the directors of the Crowds Project at the Stanford University Humanities Laboratory. Above all, I want to thank Sara Danius, my wife and colleague. Without her encouragement, support, and good humor, I would not have undertaken this project. Her expertise in visual history and nineteenth-century realism, and her keen sense of style have been indispensable. For practical assistance, I thank Musée de la Ville de Paris, Musée du Château de Versailles, the City of Montreuil, The J. Paul Getty Museum, the library at the Wissenschaftskolleg zu Berlin, and *Dagens Nyheter* in Stockholm. I'm particularly grateful to Alfredo Jaar for generously accommodating my requests for information and visual material. Finally, I want to thank my agent Linda Altrov Berg and the editors at Columbia University Press, Wendy Lochner, Christine Mortlock, and Michael Haskell. I have received financial assistance from Helge Ax:son Johnson Foundation, and the Photo-Copying Fund of the Swedish Writers' Union. The Bank of Sweden Tercentenary Fund has assisted with the publication of this book. I acknowledge these sources with gratitude.

S.J., Stockholm, November, 2007

Notes

Unless otherwise noted, all translations from non-English-language sources are my own

1789: Jacques-Louis David, *The Tennis Court Oath*

1. Seizing the Floor

1. Victor Hugo, *Les Misérables*, trans. Norman Denny (London: Penguin Books, 1982), 509. Published in French as *Les Misérables* (1862), ed. Maurice Allem (Paris: Gallimard, Editions de la Pléiade, 1951), 632. Page references in notes show English edition first, French edition second.

3. The Number of People

2. Thomas Hardy, *Memoir of Thomas Hardy . . . Written by Himself* (1832), 16. Quoted in E. P. Thompson, *The Making of the English Working Class* (London: Victor Gollancz, 1963), 17.

3. Thompson, *The Making of the English Working Class*, 21.

4. See Pierre Rosanvallon, *Le Peuple introuvable: Histoire de la représentation démocratique en France* (Paris: Gallimard, 1998), 14–35.

5. For concise discussions of both reforms, see Mona Ozouf's articles, "Département" and "Revolutionary Calendar," in *A Critical Dictionary of the French Revolution*, ed. Francois Furet and Mona Ozouf, trans. Arthur Goldhammer (Cambridge, Mass.: Harvard University Press, 1989), 494–503, 538–47.

6. Edmund Burke, *Reflections on the Revolution in France* (Oxford: Oxford University Press, 1993), 174, 183–84.

7. On the introduction of the metric system, see Ken Alder, *The Measure of All Things: The Seven-Year Odyssey That Transformed the World* (London: Little, Brown, 2002).

8. Louis Chevalier, *Classes laborieuses et classes dangereuses à Paris pendant la première moitié du XIXe siècle* (Paris: Plon, 1958), 24.

9. Paul Rabinow, *French Modern: Norms and Forms of the Social Environment* (Cambridge, Mass.: The MIT Press, 1989), 59.

10. Chevalier, *Classes laborieuses et classes dangereuses*, 22.

11. Keith Michael Baker, *Condorcet: From National Philosophy to Social Mathematics* (Chicago: The University of Chicago Press, 1975), 225–44, 330–42.

12. Emmanuel Joseph Sieyès, *Qu'est-ce que le tiers état?* (Paris: Société de la révolution française; Editions Edme Champion, 1888), 37–40. There is also an out-of-print English translation: Emmanuel Joseph Sieyès, *What Is the Third Estate?* trans. M. Blondel, ed. S. E. Finer (London: Pall Mall, 1963).

13. Quételet developed his theory of *l'homme moyen* in several investigations and presented it in fully developed form in his major work of 1869: *Physique sociale: Ou essai sur le développement des facultés de l'homme*, ed. Éric Vilquin and Jean-Paul Sanderson (Brussels: Académie Royale de Belgique, 1997), 411–567. See also Georges Canguilhem, *The Normal and the Pathological*, trans. Carolyn R. Fawcett with Robert S. Cohen (New York: Zone Books, 1989), 151–62; and Rabinow, *French Modern*, 63–67.

14. Charles Baudelaire, *Intimate Journals*, trans. Christopher Isherwood (London: The Blackamore Press, 1930), 29. Originally published under the title "Journaux intimes. Fusées," in *Oeuvres complètes* (Paris: Éditions de la Nouvelle Revue Française, 1937), 6:249.

15. Gustave Flaubert, letter to George Sand, 8 September 1871, in *Flaubert–Sand: The Correspondence*, trans. Francis Steegmuller and Barbara Bray (New York: Alfred A. Knopf, 1993), 240. Originally published in Flaubert, *Correspondance*, ed. Jean Bruneau (Paris: Gallimard, Bibliothèque de la Pléiade, 1999), 4:376: "un seul élément prévaut au détriment de tous les autres; le Nombre domine l'esprit, l'instruction, la race, et même l'argent, qui vaut mieux que le Nombre."

4. The Swinish Multitude

16. Burke, *Reflections on the Revolution in France*, 33.

17. Burke, *Reflections on the Revolution in France*, 246.

18. Burke, *Reflections on the Revolution in France*, 185.

19. Burke, *Reflections on the Revolution in France*, 186.

20. Burke, *Reflections on the Revolution in France*, 40.

21. Burke, *Reflections on the Revolution in France*, 52.

22. In general, the reception of Burke's work was critical, if not outright dismissive, and not only among radicals and liberals but also within Burke's own conservative party. The book confounded and outraged its readers not because of its theoretical argument but because of gross inaccuracies in the description of French politics. See L. G. Mitchell's introduction to Burke, *Reflections on the Revolution in France*, viii–xi.

23. Burke, *Reflections on the Revolution in France*, 73.

24. In the French *Encyclopédie* (1751–1780), the monument and Bible of the Enlightenment, "mass" (*masse*) is nowhere defined as a social phenomenon but refers exclusively to a physical mass or to an unknown quantity of matter: *Encyclopédie, ou Dictionnaire Raisonné des sciences des arts et des métiers* (Stuttgart–Bad Cannstatt: Friedrich Frommann Verlag, 1966), 10:178. There is also no entry on *"foule,"* the more common French expression for "mass" and "crowd," in the *Encyclopédie*.

25. Alexis de Tocqueville, *Democracy in America*, trans. Harvey C. Mansfield and Delba Winthrop (Chicago: The University of Chicago Press, 2000), 483.

26. Tocqueville, *Democracy in America*, 239–42.

5. Social Depths

27. For pioneering works on the social history of the French Revolution that are of direct relevance to the discussion of "the masses," see Georges Lefebvre, "Les Foules révolutionnaires," in Paul Alphandéry, Georges Bohn, Georges Hardy, Georges Lefebvre, and Eugène Dupréel, *La Foule: Quatrième semaine internationale de synthèse* (Paris: Félix Alcan, 1934), 79–107; and George Rudé, *The Crowd in the French Revolution* (Oxford: Oxford University Press, 1959). See also Alfred Cobban, *The Social Interpretation of the French Revolution* (Cambridge: Cambridge University Press, 1964; 2nd ed. 1999).

28. Thomas Carlyle, *The French Revolution: A History* (1837; New York: The Modern Library, 2002), 29.

29. Carlyle, *The French Revolution*, 178–79.

30. Carlyle, *The French Revolution*, 179.

6. The Hydra

31. My interpretation of *The Tennis Court Oath* is indebted to the following scholarly works: Philippe Bordes, *Le Serment du Jeu de Paume de Jacques Louis David. Le peintre, son milieu et son temps* (Paris: Ministère de la culture, Editions de la Réunion des musées nationaux, 1983); T. J. Clark, *Farewell to an Idea: Episodes from a History of Modernism* (New Haven, Conn.: Yale University Press, 1999), 15–53; Simon Lee, *David* (Paris: Phaidon, 2002); Susanne von Falkenhausen, "Vom 'Ballhausschwur' zum 'Duce': Visuelle Repräsentation von Volkssouveränität zwischen Demokratie und Autokratie," in *Das Volk: Abbild, Konstruktion, Phantasma*, ed. Annette Graczyk (Berlin: Akademie Verlag, 1996): 3–17; Régis Michel, *David. L'art et le politique* (Paris: Gallimard/Réunion des musées nationaux, 1988); and *David contre David: Actes du colloque organisé au musée du Louvre*, 2 vols., ed. Régis Michel (Paris: La Documentation française, 1993).

32. See Falkenhausen, "Vom 'Ballhausschwur' zum 'Duce'"; Michel, *David. L'art et le politique*, 58–68; and Antoine de Baecque, *"Le Serment du Jeu de paume*: Le corps politique idéal," in *David contre David*, 2:776–80.

33. Antoine de Baecque, *"Le Serment du Jeu de paume."*

34. Rosanvallon, *Le Peuple introuvable*, 35–55.

35. Rosanvallon, *Le Peuple introuvable*, 53–54.

7. Marianne

36. Cited in Michel, *David. L'art et le politique*, 67.

37. On this point, see Lee, *David*, 140–44.

38. For a remarkable analysis, see Clark, *Farewell to an Idea*, 15–53.

39. Susanne von Falkenhausen, "Vom 'Ballhausschwur' zum 'Duce,'" 15.

40. See Joan B. Landes, *Visualizing the Nation: Gender, Representation, and Revolution in Eighteenth-Century France* (Ithaca, N.Y.: Cornell University Press, 2001); Maurice Agulhon and Pierre Bonte, *Marianne: Les visages de la république* (Paris: Gallimard, 1992).

8. Les Misérables

41. Christopher Prendergast discusses the image of Paris as a vertically organized topos, with particular attention to all the nineteenth-century descriptions of the underworld of the French capital: *Paris in the Nineteenth Century* (Oxford: Blackwell, 1992). For another excellent cultural history of the French capital of the period, see David Harvey, *Paris, Capital of Modernity* (New York: Routledge, 2003), 1–89.

42. Jules Michelet, *The People*, trans. John P. McKay (Urbana: University of Illinois Press, 1973), 92. Originally published under the title *Le Peuple* (1846), ed. Lucien Refort (Paris: Marcel Didier, 1946), 121–22: "En nationalité, c'est tout comme en géologie, la chaleur est en bas. Descendez, vous troverez qu'elle augmente; aux couches inférieures, elle brûle."

43. Honoré de Balzac, *The Girl with the Golden Eyes*, in *History of the Thirteen*, trans. Herbert J. Hunt (Harmondsworth: Penguin, 1974), 312. Published in French under the title *Histoire des treize*, in *La Comédie humaine* (Paris: Gallimard, 1977), vol. 5.

44. Hugo, *Les Misérables*, 619–20; 757–58.

45. Hugo, *Les Misérables*, 621; 759.

46. Chevalier, *Classes dangereuses et classes laborieuses*, 68–163, 451–68

47. Honoré-Antoine Frégier, *Des Classes dangereuses de la population des grandes villes* (Paris, 1840), quoted in Chevalier, *Classes dangereuses et classes laborieuses*, 159. "Les classes pauvres et vicieuses ont toujours été et seront toujours la pépenière la plus productive des toutes les sortes de malfaiteurs; ce sont elles que nous désignerons plus particulièrement sous le titre de classes dangereuses; car, lors même que le vice n'est pas accompagné de la perversité, par celà qu'il s'allie à la pauvreté dans la même individu, il est un just sujet de crainte pour la société, il est dangereux."

48. For an analysis of the debt owed by nineteenth-century sociology to the novel, see Wolf Lepenies, *Die Drei Kulturen: Soziologie zwischen Literatur und Wissenschaft* (Reinbek bei Hamburg: Rowohlt, 1988), i–102.

49. Hugo, *Les Misérables*, 508–9; 632.

50. Hugo, *Les Misérables*, 886; 1099–1100.

51. Hugo, *Les Misérables*, 887; 1100.

52. The distinction between passions and reason is one of the oldest and most debated topics of political theory, prevalent already in Plato and Aristotle. In the early modern era, the distinction becomes politically crucial with Hobbes. In his view, social order depends on the intrusion of a sovereign who forces everyone to restrain their self-centered passions. Most theorists of absolutist monarchy, however, including Machiavelli, believed that it was the upper echelons of society that posed the greatest difficulty in the sovereign's attempts to uphold social peace. The aristocracy was perceived as men of strong passions who did not easily submit to law. The common people, by contrast, subjected themselves more willingly to sovereign rule because their behavior was less emotional and hence more predictable. In the industrial age, the contents of the categories have shifted. The upper classes legitimize their power by investing themselves with the attributes of reason and social concord, and they justify the exclusion of the majority by portraying the lower classes as ruled by passions and hence incapable of acting in the interest of society.

53. See Helmut König, *Zivilisation und Leidenschaften: Die Masse im bürgerlichen Zeitalter* (Reinbek: Rowohlt, 1992), 56.

9. The Barricade

54. The debate is vividly rendered by Jules Michelet in *Histoire de la révolution française*, 2 vols., ed. Gérard Walter (Paris: Gallimard, Bibliothèque de la Pléiade, 1952), 1:99–106.

55. Jules Michelet, *The People*, 105; *Le Peuple*, 137: "Vous allez, la loupe à la main, vous cherchez dans les ruisseaux, vous trouvez là je ne sais quoi de sale et d'immonde, et vous nous le rapportez: 'Triomphe! Triomphe! Nous avons trouvé le peuple!'"

56. Flora Tristan, *Journal*, quoted in Chevalier, *Classes laborieuses et classes dangereuses*, 525: "ce peuple si brute, si ignorant, si vaniteux, si désagréable à frayer, si dégoûtant à voir de près."

57. Daniel Stern, *Histoire de la révolution de 1848* (1850; Paris: Éditions Balland, 1985), 240.

58. Eugène Sue, *Les Mystères de Paris*. Oeuvres illustrées d'Eugène Sue (Paris, 1851), 1.

59. Girardin, cited in T. J. Clark, *The Absolute Bourgeois: Artists and Politics in France 1848–1851* (1982; Berkeley: University of California Press, 1999), 11.

60. Daniel Stern, *Histoire de la révolution de 1848*, 241.

61. Eugène Buret, *De la Misère des classes laborieuses en Angleterre et en France. De la nature de la misère, de son existence, de ses effets, de ses causes, et de l'insuffisance des remèdes qu'on lui a opposés jusqu'ici : avec l'indication des moyens propre à en affranchir les sociétés* (Paris: Paulin, 1840): "Les ouvriers sont aussi libres de devoirs envers leurs maîtres que ceux-ci le sont envers eux; ils les considèrent comme des hommes d'une

classe différente, opposée et même ennemie. Isolés de la nation, mis en dehors de la communauté sociale et politique, seuls avec leurs besoins et leurs misères, ils s'agitent pour sortir de cette effrayante solitude, et, comme les barbares auxquels on les a comparés, ils méditent peut-être une invasion."

62. Hugo, *Les Misérables*, 987; 1217.

63. Hugo, *Les Misérables*, 988; 1218.

64. Victor Hugo, *Choses vues: Souvenirs, journaux, cahiers 1830–1885*, ed. Hubert Juin (Paris: Gallimard, 2002), 567.

65. Hugo, *Choses vues*, 554.

66. Hugo, *Choses vues*, 463–64.

67. Hugo, *Les Misérables*, 988; 1218.

68. Hugo, *Les Misérables*, 988–89; 1219. Jacques Derrida quotes Hugo's description of the Saint-Antoine barricade at some length but offers none of the analysis that the passage deserves (*Specters of Marx: The State of the Debt, the Work of Mourning, and the New International*, trans. Peggy Kamuf [New York: Routledge, 1994], 95–96).

69. Hugo, *Les Misérables*, 989–90; 1221.

70. Hugo, *Les Misérables*, 989–90; 1221.

71. Hugo, *Les Misérables*, 509; 632.

10. Making Monkey

72. Gustave Flaubert, *Sentimental Education*, trans. Robert Baldick (Harmondsworth: Penguin, 1964), 151. Published in French as *L'Education sentimentale: Histoire d'un jeune homme*, ed. A. Thibaudet and R. Dumesnil (Paris: Gallimard, Bibliothèque de la Pléiade, 1952), 177.

73. Flaubert, *Sentimental Education*, 289; *L'Education sentimentale*, 320–21.

74. Flaubert, *Sentimental Education*, 288–89; *L'Education sentimentale*, 320:
Et poussés malgré eux, ils entrèrent dans un appartement où s'étendait, au plafond, un dais de velours rouge. Sur le trône, en dessous, était assis un prolétaire à barbe noire, la chemise entr'ouverte, l'air hilaire et stupide comme un magot. D'autres gravissaient l'estrade pour s'asseoir à sa place.
—Quel mythe! dit Hussonnet. Voilà le peuple souverain!
Le fauteil fut enlevé à bout de bras, et traversa toute la salle en se balançant.
—Saprelotte! Comme il chaloupe! Le vaisseau de l'État est ballotté sur une mer orageuse! Cancane-t-il! Cancane-t-il!
On l'avait approché d'une fenêtre, et, au milieu des sifflets, on le lança.
—Pauvre viuex! dit Hussonnet, en le voyant tomber dans le jardin, où il fut repris vivement pour être promené ensuite à la Bastille, et brulé.

75. Flaubert, *Sentimental Education*, 290; *L'Education sentimentale*, 321: "Dans l'antichambre, debout sur un tas de vêtements, se tenait une fille publique, en statue de la liberté,—immobile, les yeux grands ouverts, effrayante."

76. Flaubert, *Sentimental Education*, 286; *L'Education sentimentale*, 318: "Les tam-

bours battaient la charge. Des cris aigus, des hourras de triomphe s'élevaient. Un remous continuel faisait osciller la mutlitude. Frédéric, pris entre deux masses profondes, ne bougeait pas, fasciné d'ailleurs et s'amusant extrêmement. Les blessés qui tombaient, les morts étendus n'avaient pas l'air de vrais blessés, de vrais morts. Il lui semblait assister à un spectacle."

77. Flaubert, *Sentimental Education*, 287; *L'Education sentimentale*, 318: "Cela faisait rire."

78. Gisèle Séginger, *Flaubert: Une poétique de l'histoire* (Strasbourg: Presses Universitaires de Strasbourg, 2000), 105.

79. Flaubert, letter to George Sand, 8 September 1871, in *Flaubert–Sand: The Correspondence*, 240; *Correspondance*, 4:375–76: "Je crois que la foule, le nombre, le troupeau sera toujours haïssable."

80. Flaubert, *Sentimental Education*, 282, translation modified; *L'Education sentimentale*, 314–15: "Ils passèrent l'après-midi à regarder, de leur fenêtre, le peuple dans la rue."

81. Flaubert, *Sentimental Education*, 276, 282–83, 288; *L'Education sentimentale*, 308, 315, 319–20: "la foule tassée semblait, de loin, un champ d'épis noirs qui oscillaient"; "un fourmillement confus s'agitait en dessous; au milieu de cette ombre, par endroits, brillaient des blancheurs de baïonnettes"; "flots vertigineux des têtes nues, des casques, des bonnets rouges, des baïonnettes et des épaules, si impétueusement que des gens disparaissaient dans cette masse grouillante qui montait toujours, comme un fleuve refoulé par une marée d'équinoxe, avec un long mugissement, sous une impulsion irrésistible."

82. Flaubert, *Sentimental Education*, 283; *L'Education sentimentale*, 315: "car il y a des situations où l'homme le moins cruel est si détaché des autres, qu'il verrait périr le genre humain sans un battement de cœur."

11. Smokescreens

83. Adolphe Thiers, cited in Chevalier, *Classes laborieuses et classes dangereuses*, 459: "C'est la multitude, c'est n'est pas le peuple que nous voulons exclure, c'est cette multitude confuse, cette multitude de vagabonds dont on ne peut la saisir nulle part, qui n'ont pas su créer pour leur famille un asile appréciable: c'est cette multitude que la loi a pour but d'éloigner."

84. Susanne von Falkenhausen argues that *Le Serment du Jeu de Paume* above all is a reflection of this opposition: David represents the sovereignty of the people as an ideal, but only at the cost of expelling the people outside the frame ("Vom 'Ballhaus-schwur' zum 'Duce,'" 3–17).

85. See Clark, *The Absolute Bourgeois*, 18–30.

12. Mass Grave

86. Quoted in Clark, *The Absolute Bourgeois*, 27.

87. Quoted in Clark, *The Absolute Bourgeois*, 28.

88. Clark, *The Absolute Bourgeois*, 28: "This is the real anonymity of the People, a *created* sameness, the result of violence and not a 'natural' fact."

1889: James Ensor, *Christ's Entry Into Brussels in 1889*

13. The Crucified

1. Strindberg's letter to Nietzsche: *Briefe an Friedrich Nietzsche: Januar 1887-Januar 1889*, in Friedrich Nietzsche, *Briefwechsel: Kritische Gesamtausgabe*, part 3, vol. 6, ed. Giorgio Colli and Mazzini Montinari (Berlin: Walter de Guyter, 1984), 414. Strindberg's letter is a montage of quotations from the anonymous Hellenic script entitled *Anacreontea*, parts 9 and 12, and from Horace, *Odes*, nos. 10 and 19.

2. Nietzsche's reply to Strindberg: *Briefwechsel: Kritische Gesamtausgabe*, part 3, vol. 5, 572.

3. Nietzsche's letter to von Salis: *Briefwechsel: Kritische Gesamtausgabe*, part 3, vol. 5, 572: "Die Welt ist verklärt, denn Gott ist auf der Erde. Sehen Sie nicht, wie alle Himmel sich Freuen?"

4. August Strindberg, *Ensam*, in *Samlade Verk*, vol. 52, ed. Ola Östin (Stockholm: Norsteds, 1994), 55. Translated into English in *Inferno, Alone, and Other Writings: In New Translations*, ed. Evert Sprinchorn (Garden City, N.Y.: Anchor Books, 1968). The translation used here is my own.

5. Strindberg, *Ensam*, 56.

6. Wilhelm Fraenger, "James Ensor: Die Kathedrale," *Die graphischen Kunste* (Vienna) 49 (1926): 92.

14. The Belgian's Glory

7. *La Plume: Littéraire, Artistique et Sociale*, nos. 228–232 (1898). These five special issues were published as a book in 1899: *James Ensor—peintre et graveur* (Paris: La Plume).

15. Divorce

8. Boissy is quoted in Jacques Rancière, *The Nights of Labor: The Workers' Dream in Nineteenth-Century France*, trans. John Drury (Philadelphia: Temple University Press, 1989), 186. Originally published under the title *La Nuit des prolétaires: Archives du rêve ouvrier* (Paris: Arthème Fayard, 1981), 195–96: "Quittez, quittez, cette société pour qui vous faites tout et qui ne fait rien pour vous, cette société où ceux qui font tout n'ont rien; où ceux qui ne font rien possèdent tout."

9. The letter was published 17 February 1863 in *L'Opinion nationale*. Quoted in

Pierre Rosanvallon, *Le Peuple introuvable: Histoire de la représentation démocratique en France* (Paris: Gallimard, 1998), 95–96: "On a répété à satiété qu'il n'y a plus de classes et que depuis 1789 tous les Français sont égaux devant la loi. Mais nous qui n'avons d'autre propriété que nos bras, nous qui subissons tous les jours les conditions légitimes ou arbitraires du capital . . . , il nous est bien difficile de croire à cette affirmation."

10. See Susanna Barrows, *Distorting Mirrors: Visions of the Crowd in Late-Nine-teenth-Century France* (New Haven, Conn.: Yale University Press, 1981).

11. See Paul Lidsky, *Les Écrivains contre la Commune* (Paris: François Maspero, 1982).

12. Gustave Flaubert, letter to George Sand, 30 April, 1871, in *Flaubert–Sand: The Correspondence*, trans. Francis Steegmuller and Barbara Bray (New York: Alfred A. Knopf, 1993), 228; *Correspondance*, ed. Jean Bruneau (Paris: Gallimard, Bibliothèque de la Pléiade, 1999), 4:314: "Le peuple est un éternel mineur, et il sera toujours (dans la hiérarchie des éléments sociaux) au dernier rang, puisqu'il est le nombre, le masse, l'illimité."

13. Marc Angenot, *1889: Un État du discours social* (Montreal: Éditions de Préambule, 1989), 462.

16. Hallucinations

14. Gustave Le Bon, *La Vie: Physiologie humaine appliqué à l'hygiène et à la médicine* (Paris, 1872). Quoted in Robert Nye, *The Origins of Crowd Psychology: Gustave Le Bon and the Crisis of Mass Democracy in the Third Republic* (London: Sage, 1975), 28.

15. For the intellectual and political background of Le Bon's theory, see Barrows, *Distorting Mirrors*, and Nye, *The Origins of Crowd Psychology*.

16. See Gustave Le Bon, *The Crowd: A Study of the Popular Mind*, reprint of 2nd ed. (Marietta, Ga., 1982), xiii–xxii, 67–69. Originally published under the title *Psychologie des foules* (1895; Paris: Presses Universitaires de France, 1963), 9–15, 45–46.

17. Nye, *The Origins of Crowd Psychology*, 68.

18. Gustave Le Bon, *The Crowd*, 123; *Psychologie des foules*, 74.

19. Nye, *The Origins of Crowd Psychology*, 71.

20. Le Bon, *The Crowd*, 12; *Psychologie des foules*, 14.

21. As Le Bon argues: "Whoever be the individuals that compose it, however like or unlike be their mode of life, their occupations, their character, or their intelligence, the fact that they have been transformed into a crowd puts them in possession of a sort of collective mind which makes them feel, think, and act in a manner quite different from that in which each individual of them would feel, think, and act were he in a state of isolation" (*The Crowd*, 5–6.; *Psychologie des foules*, 11).

22. Le Bon, *The Crowd*, 17; *Psychologie des foules*, 17. Le Bon concludes that the crowd "is a servile flock that is incapable of ever doing without a master;" the masses "are so bent on obedience that they instinctively submit to whoever declares himself to be their master" (*The Crowd*, 113, 117; *Psychologie des foules*, 69, 71).

23. Hippolyte Taine, *Histoire de la littérature anglaise*, 4 vols. (Paris: Hachette, 1902–1907), 1:viii.

24. Categories from the natural sciences continue to be used by social theorists who analyze crowd behavior. In the least convincing part of Stanley Tambiah's extraordinary book on collective violence in South Asia, the author borrows from theories of the Doppler effect: "The waves of prejudice, accusations, and rumors increase in frequency, and the preparedness for violence intensifies, as the waves cumulatively back into each other and create the 'blue shift' effect—the high frequency of blue—and white-hot intensity. . . . The collision produces maximum noise and heat, generating a destructive explosion" (Stanley J. Tambiah, *Leveling Crowds: Ethnonationalist Conflicts and Collective Violence in South Asia* [Berkeley: University of California Press, 1996], 292). Jean Baudrillard's analysis of the masses excels in metaphors borrowed from physics and mathematics, most notably his idea of "the masses" as a site of "implosion" of "social energy" (*A l'ombre des majorités silencieuses; ou, La Fin du social* [Paris: Denoël/Gonthier, 1982], 62–66). Peter Sloterdijk similarly characterizes "the masses" as "an easily inflammable psychopolitical explosive" (*Die Verachtung der Massen: Versuch über Kulturkämpfe in der modernen Gesellschaft* [Frankfurt: Suhrkamp, 2000], 30).

25. On Le Bon's influence on Hitler's *Mein Kampf*, see Alfred Stein, "Adolf Hitler und Gustave Le Bon," *Geschichte in Wissenschaft und Unterricht* 6 (1955): 362–68.

26. On Mussolini's admiration for Le Bon, see Pierre Chanlaine, *Les Horizons de la science* (Paris: Flammarion, 1928), 17; quoted in Nye, *The Origins of Crowd Psychology*, 178.

27. This ambiguity accounts for the immense influence of mass psychological theories. As Serge Moscovici maintains, "along with economics, mass psychology is one of the two sciences which have provided ideas that have made history" (*The Age of the Crowd: A Historical Treatise on Mass Psychology*, trans. J. C. Whitehouse [Cambridge: Cambridge University Press; Paris: Editions de la Maison des Sciences de l'Homme, 1985], 4).

28. Michel Foucault, *Histoire de la folie à l'âge classique* (Paris: Gallimard, 1972), 56–91.

29. Lucien Nass, *Le Siège de Paris et la commune* (Paris: Plon, 1914), 352–53.

30. Alexandre Calerre, "Les Psychoses dans l'Histoire," *Archives internationales de neurologie* 34 (1912), 1:229–49, 299–311, 359–70; 2:23–36, 89–110, 162–77, 211–24.

31. Quoted in Nye, *The Origins of Crowd Psychology*, 51.

17. Society Degree Zero

32. For a typical example, see Jonathan Crary, *Suspensions of Perception: Attention, Spectacle, and Modern Culture* (Cambridge, Mass.: MIT Press, 1999), 240–47, which uncritically applies Le Bon's theory in an interpretation of Seurat's 1888 painting *Parade de Cirque*.

33. Hanna Deinhard, "Daumier et sa représentation de la foule moderne," *Histoire et Critique des Arts*, nos. 13–14 (1980): 98.

34. Some steps toward an iconology of the crowd have recently been taken by Christine Poggi, but she, too, depends far too much on ideas inherited from classical mass psychology ("Mass, Pack, and Mob: Art in the Age of the Crowd," in *Crowds*, ed. Jeffrey Schnapp and Matthew Tiews [Stanford, Calif.: Stanford University Press, 2006], 159–202).

35. The examples following in the main text illustrate the dominant view of art historical scholarship. In more journalistic descriptions of *Christ's Entry*, the century-old idea of mass psychology is even more explicit. A survey by Edward Lucie-Smith asserts that "the implication of the picture is, of course, that if Christ returned to earth, the Belgians would undoubtedly treat him in the same way as did the Jews of Jerusalem" (*Symbolist Art* [New York: Praeger, 1972], 178). John Walsh, former director of the J. Paul Getty Museum, repeats the view in an interview: "It's a mob; it's a city mob, and it's being led by rabble-rousers under banners with slogans. [The painting] is obviously intended as a kind of bitter warning of the dangers of giving over your individuality, your identity" (Daryl H. Miller, "Getty Museum Plans with Reverence Its Unveiling of James Ensor's 'Christ,'" *Daily News* [Los Angeles], 16 October 1987). In the in-flight magazine of Thai Airlines, finally, we are frontally exposed to the fear of the masses that resonates in this interpretative tradition: "The uneasy surge of the crowd and its implicit instinct for violence fills Ensor's masterpiece" (Susan E. James, "Among the Ghosts and Skeletons," *Sawasdee* [April 1995]: 41).

36. Jean Stevo, *James Ensor* (Brussels: Editions Germinal, 1947), 20.

37. Georg Heard Hamilton, *Painting and Sculpture in Europe, 1880–1940* (Harmondsworth: Penguin, 1967), 71.

38. Patrik Reuterswärd, "Barnet, fågeln och havet," in *En liten bok om Ensor* (Stockholm: Nationalmuseum, 1970), 40–41.

39. Stephen C. McGough, *James Ensor's "The Entry of Christ into Brussels in 1889,"* (New York: Garland Publishing, 1985), 204.

40. Joachim Heusinger von Waldegg, *James Ensor: Legende vom Ich* (Cologne: DuMont, 1991), 141–42.

41. Michel Draguet, *James Ensor; ou, la fantasmagorie* (Paris: Gallimard, 1999), 180.

42. Waldemar George, "James Ensor," in *Exposition James Ensor 1926* (Paris: Galerie Barbazanges, 1926), 11. See also Walther Vanbeslaere, *L'Entrée du Christ a Bruxelles* (Brussels: Weissenbruch, 1957), 29 ff.

43. Georges Sorel, *Le Devenir Sociale* (November 1895): 769–70. Quoted in Nye, *The Origins of Crowd Psychology*, 105.

44. James Ensor, "Discours prononcé au banquet offert à Ensor par 'La Flandre Littéraire,'" in *Mes Ecrits*, 5th ed. (Liège: Éditions nationales, 1974), 76. See also James Ensor, *Discours aux masques, loyaux et autres* (Liège: P. Aelberts, 1950).

45. André de Ridder, *James Ensor* (Paris: Éditions Rieder, 1930), 51.

46. For good accounts of the direct influence of the Ostende carnival on Ensor, see Emile Verhaeren, *James Ensor*, Collection des artistes belges contemporains (Brussels: Librairie nationale d'art et d'historie. G. van Oest, 1908), 10–11.; and Robert Croquez, *Ensor en son temps* (Ostende: Erel, 1970), 43–57.

47. On the carnivalesque in Ensor, see Draguet, *James Ensor*, 137–82; and Timothy Hyman, "James Ensor: A Carnival Sense of the World," in *James Ensor, 1860–1949: Theater of Masks*, ed. Carol Brown (London: Barbican Art Gallery, 1997), 76–86.

48. On the history and meaning of Marianne, see Maurice Agulhon, *Marianne Into Battle: Republican Imagery and Symbolism in France, 1790–1880*, trans. Janet Lloyd (Cambridge: Cambridge University Press; Paris: Editions de la Maison des sciences de l'homme, 1981). Also see this volume, page 32.

49. See McGough, *James Ensor's "The Entry of Christ into Brussels in 1889,"* 154; for a similar but less pejorative reading, see Diane Lesko, *James Ensor: The Creative Years* (Princeton, N.J.: Princeton University Press, 1985), 142–43.

50. See Giorgio Agamben, *Homo Sacer: Sovereign Power and Bare Life*, trans. Daniel Heller-Roazen (Stanford, Calif.: Stanford University Press, 1998), 104–11.

51. Walter Benjamin, "James Ensor wird 70 Jahre" (1930), in *Gesammelte Schriften*, ed. Rolf Tiedemann and Hermann Schweppenhäuser, vol. 4, part. 1, ed. Tillman Rexroth (Frankfurt: Suhrkamp, 1981), 567.

52. I am indebted to Heinrich Dilly for this observation.

53. According to Fredric Jameson, what characterizes authentic utopian narratives is not that they give a picture of what the perfect society really is like, for this picture would necessarily be tainted by the ideological constraints of the author's own society and hence deviate from the desired perfection. Most writers have therefore restricted their textual production to a different kind of operation, "namely the construction of material mechanisms that would alone enable freedom to come into existence all around them. The mechanism itself has nothing to do with freedom, except to release it; it exists to neutralize what blocks freedom, such as matter, labor, and the requirements of their accompanying social machinery (such as power, training and discipline, enforcement, habits of obedience, respect, and so forth)" (*The Seeds of Time* [New York: Columbia University Press, 1994], 56–57).

18. The Nigger

54. Arthur Rimbaud, letter to Paul Demeny, in *Complete Works*, trans. Paul Schmidt (New York: Perennial Classics, 2000), 116. Originally published in *Oeuvres complètes: Poésie, prose et correspondance*, ed. Pierre Brunel (Paris: Livre de poche, 2001), 242.

55. Rimbaud, "Parisian War Cry," in *Complete Works*, 64; "Chant de guerre Parisien," in *Oeuvres complètes*, 239–41.

56. Kristin Ross, *The Emergence of Social Space: Rimbaud and the Paris Commune* (Minneapolis: University of Minnesota Press, 1988), 123.

57. True democracy, Marx wrote in response to Hegel's philosophy of law, does not

recognize a separation between the state, as the representative of the people, and civil society. In a truly democratic system every task and function would instead be representative of the social body as a whole—"in the sense in which the shoemaker, insofar as he satisfies a social need, is my representative, in which every particular social activity as a species-activity merely represents the species, i.e. my own nature, and in which every person is the representative of every other. He is here representative not because of something else which he represents but because of what he *is* and *does*" ("Contribution to the Critique of Hegel's Philosophy of Law," in Karl Marx and Friedrich Engels, *Collected Works*, vol. 3 [New York: International Publishers, 1975], 119).

58. Rimbaud, "The Impossible," in *Collected Works*, 239; "L'Impossible," in *Oeuvres complètes*, 436.

59. Rimbaud, "Bad Blood," in *Collected Works*, 221; "Mauvais Sang," in *Oeuvres complètes*, 416.

60. Rimbaud, "Bad Blood," in *Collected Works*, 223; "Mauvais Sang," in *Oeuvres complètes*, 417.

61. Rimbaud, "Bad Blood," in *Collected Works*, 223; "Mauvais Sang," in *Oeuvres complètes*, 417.

62. Rimbaud, "Bad Blood," in *Complete Works*, 223; "Mauvais Sang," in *Oeuvres complètes*, 417.

63. Rimbaud, "Morning," in *Collected Works*, 242; "Matin," in *Oeuvres complètes*, 439–40.

64. Rimbaud, "Parade," in *Complete Works*, 178. "Parade," in *Oeuvres complètes*, 462: "Chinois, Hottentots, bohémiens, niais, hyènes, Molochs, vieilles démences, démons sinistres, ils mêlent les tours populaires, maternels, avec les poses et les tendresses bestiales. Ils interpréteraient des pièces nouvelles et des chansons 'bonnes filles.' Maîtres jongleurs, ils transforment le lieu et les personnes et usent de la comédie magnétique. Les yeux flambent, le sang chante, les os s'élargissent, les larmes et des filets rouges ruisselent. Leur raillerie ou leur terreur dure une minute, ou des mois entiers. J'ai seul la clef de cette parade sauvage."

19. The Modern Breakthrough

65. Emile Verhaeren, *James Ensor*, 100.

66. Marcel Liebman, *Les Socialistes belges, 1885–1914: La Révolte et l'organisation*, vol. 3 of *Histoire du mouvement ouvrier en Belgique* (Brussels: Vie ouvrière, 1979), 53–74; Jules Destrée and Emile Vandervelde, *Le Socialisme en Belgique* (Paris: V. Girard and E. Brière, 1898), 58–75; Léon Delsinne, *Le Parti Ouvrier Belge, dès origines à 1894* (Brussels: La Renaissance du livre, 1955), 69–83.

67. Louis Bertrand, *La Belgique en 1886*, 2 vols. (Brussels, 1887), 1:5–7.

68. Jules Brouez, "Du Problème social," *La Société Nouvelle* 2 (1886): 1:30.

69. V. Arnould, "La Dérive," *La Société Nouvelle* 2 (1886): 2:111.

70. Edmond Picard, "L'Art et la révolution," *La Société Nouvelle* 2 (1886): 2:208.

71. "Chronique de la Ville," *L'Etoile Belge*, 5 February 1888. Quoted in Jane Block, *Les XX and Belgian Avant-Gardism, 1868–1894* (Ann Arbor: UMI Research Press, 1984), 37.

72. Camille Lemonnier, *L'Ecole belge de peinture, 1830–1905* (Brussels: G. van Oest & Cie, 1906), 160–89; Richard Muther, *Die belgische Maleriei im neunzehnten Jahrhundert* (Berlin: S. Fischer, 1904), 86 ff.

73. Despite the explicitness of the political content in these images, Susan M. Canning and, more recently, Patricia G. Berman, are the only scholars who has discussed it in detail. Canning's pioneering analyses are an invaluable corrective to the antihistorical doxa of the postwar reception of Ensor. Often, however, Canning makes Ensor's politics too simple and explicit, attributing to Ensor's images an activist intention that renders any closer visual analysis superfluous. See Susan M. Canning, "The Ordure of Anarchy: Scatological Signs of Self and Society in the Art of James Ensor," *Art Journal* 52, no. 3 (Fall 1993): 47–53; "Visionary Politics: The Social Subtext of James Ensor's Religious Imagery," in *James Ensor, 1860–1949: Theater of Masks*, ed. Carol Brown (London: Barbican Art Gallery, 1997), 58–69; "La Foule et le Boulevard: James Ensor and the Street Politics of Everyday Life," in *Belgium: The Golden Decades, 1880–1914*, ed. Jane Block (New York: Lang, 1997), 41–64; and "In the Realm of the Social," *Art in America* 88, no. 2 (February 2000): 74–83, 141. As for Berman's excellent study, published after the conception of the present book, it is the first up-to-date comprehensive analysis of *Christ's Entry*, remarkably strong in its account of the art-historical and cultural context of Ensor's painting, including an important chapter on Ensor's rebellion against Belgium's political and cultural establishment. However, Berman neglects the nature of Ensor's political christology and its relation to a wide range of similar messianic figures and narratives in Belgian art, literature, and socialism of the 1880s, and she therefore fails to register the essential gesture of Ensor's symbolic act. See Patricia G. Berman, *James Ensor: Christ's Entry Into Brussels in 1889*, Getty Museum Studies on Art (Los Angeles: The J. Paul Getty Museum, 2002).

74. Georg Brandes, *Det moderne gjennembruds maend, en raekke portraeter* (Copenhagen, 1883).

75. Cornelius Castoriadis, *The Imaginary Institution of Society*, trans. Kathleen Blamey (Cambridge: Polity Press, 1987), esp. 353–73.

76. McGough, *James Ensor's "The Entry of Christ Into Brussels in 1889,"* 160 ff and 229.

77. Jules Destrée, "Les Troubles de Charleroi," *La Société Nouvelle* 2 (1886): 1:427. See also Destree's chronicle of the events of 1886 in *Pages d'un journal*, ed. Richard Dupierreux (Brussels: Editions de la Connaissance, 1937).

78. Liebman, *Les Socialistes belges, 1885–1914*, 53.

20. Songs of the Fool

79. See Fraenger, "James Ensor: Die Kathedrale"; G. F. Hartlaub, "Zur Wertung der

Kunst James Ensors," in *James Ensor: Ausstellung* (Mannheim: Walther, 1928), 3–8; Heusinger von Waldegg, *James Ensor*; and Draguet, *James Ensor*, passim.

80. A. Mabille de Poncheville, *Vie de Verhaeren* (Paris: Mercure de France, 1953), 105.

81. Roger van Gindertael, *Ensor*, trans. Vivienne Menkes (London: Studio Vista, 1975), 125.

82. Lesko, *James Ensor*, 3. Although Lesko extends Ensor's period of creativity to 1899, there is no disagreement among scholars that he produces his most important work in the late 1880s and the early 1890s.

83. Draguet, *James Ensor*, 9–12.

84. Ensor, "Contre le swimming-pool," *Mes Ecrits*, 137–38.

85. Apart from *Contes d'Yperdamme* (Brussels, 1891), Demolder also published and republished his short stories in other books: *Impressions d'art: Etudes, critiques, transpositions* (Brussels, 1889); *Les Récits de Nazareth* (Brussels, 1893); *Quatuor* (Paris, 1897); *La Légende d'Yperdamme* (Paris, 1897); *Le Royaume authentique du grand saint Nicolas* (Paris, 1896).

86. Hubert Krains, "Chronique littéraire," *La Société nouvelle* 7 (1891): 227–28.

87. James Ensor, *Lettres*, ed. Xavier Tricot (Brussels: Labor, 1999), 114.

88. Eugène Demolder, "James Ensor," *La Société nouvelle* 7 (1891): 588. Demolder also remarks that Ensor's trinity is not the celestial group of Father, Son, and Holy Spirit, but the earth-bound trio of St. Francis, the Virgin, and Jesus. When describing Ensor's drawing *The Alive and Radiant. The Entry Into Jerusalem*, Demolder argues that we see "a God of the humble ones" making an impression of sadness and purity "in the midst of a crowd where all is confusion and delirium" (ibid.). Demolder further asserts that Ensor's paradoxical spirit is marked by an infinite love for all expressions of life, human and animal, combined with a revolutionary call to arms against society as a whole (591).

89. Destrée and Vandervelde, *Le Socialisme en Belgique*, 237.

90. Picard inserted Ensor as a sympathetic painter in his novel *Psuké* (1903). Ensor reciprocated by inserting Picard in several of his images. Ensor did not paint Picard sympathetically but ranged him with critics that he viewed as torturers. Yet he always recognized Picard as a supporter, calling on him for help several times. In a letter of February 16, 1924, written just days before Picard's death, Ensor acknowledges his lasting devotion (*Lettres*, 609–10).

91. It is remarkable that no Ensor scholar has observed the resonances between Ensor's Christian myths and those of Belgian writers contemporary with him, many of whom were his close friends. Xavier Tricot has described the intricate web of collaborations and influences among Ensor, Demolder, Picard, and others but without asking how this may have affected Ensor's work. Tricot repeats the idea, by now a commonplace, that Ensor's main literary sources of inspiration were Edgar Allan Poe, François Rabelais, and, especially, Balzac's 1831 tale *Jésus-Christ en Flandre* (*Ensoriana*, Cahier 1 [Antwerp: Pandora, 1995], 5–35). Though Diane Lesko devotes a full chapter

to "Literature as Inspiration for Ensor's Art," she fails to note that the works of Ensor's friends contain a messianic-socialist symbolism similar to his (*James Ensor*, 83–114). Curiously, this crucial aspect is also neglected by both Patricia Berman and Michel Draguet, authors of the two most comprehensive studies on Ensor in recent years.

92. See Paul Aron, *Les Écrivains belges et le socialisme (1880–1913): L'expérience de l'art social d'Edmond Picard à Émile Verhaeren*, 2nd ed. (Brussels: Labor, 1997), 230; and T. J. Clark, *The Absolute Bourgeois: Artists and Politics in France 1848–1851* (1982; Berkeley: University of California Press, 1999), 54 ff.

93. Destrée, *Semailles* (Brussels: Henri Lamartin, 1913), 4.

94. Destrée, *Semailles*, 139–61, and Destrée, "Le Secret de Frédéric Marcinel," in *Jules Destrée* (Brussels: Editions de l'association des écrivains Belges, 1906), 55. Destrée also stipulated a direct relation between the diminishing religious faith and the increasing faith in socialism (*Art et socialisme* [Brussels, 1896], 32).

95. Quoted in Aron, *Les Écrivains belges et le socialisme*, 230.

96. Georges Rodenbach, *Le Livre de Jésus*, in *Oeuvres* (Geneva: Slatkine Reprints, 1978), 151–73.

97. Aron, *Les Écrivains belges et le socialisme*, 76.

98. For a discussion of Verhaeren's trilogy, see Eva-Karin Josefson, *La Vision citadine et sociale dans l'oeuvre d'Emile Verhaeren*, Études romanes de Lund (Lund: Gleerup [Diss.], 1982), 37–114; Aron, *Les Écrivains belges et le socialisme*, 173–213; and Hans Joachim Lope, "Emile Verhaeren, poète de la ville," in *Emile Verhaeren: Poète, dramaturge, critique*, ed. Peter-Eckhard Knabe and Raymond Trousson (Brussels: L'Université, 1984), 19–40.

99. Emile Verhaeren, *Les Aubes*, in *Hélène de Spart /Les Aubes* (Paris: Mercure de France, 1920), 108.

100. Emile Verhaeren, "Les Cathédrales," in *Les Villes tentaculaires* (1895), in *Oeuvres* (Geneva: Slatkine Reprints, 1977), 1:118: "O ces foules, ces foules / Et la misère et la détresse qui les foulent."

101. Emile Verhaeren, "Chanson de fou," in *Les Campagnes hallucinées* (1893), *Oeuvres* (Geneva: Slatkine Reprints, 1977), 1:49: "Je suis le fou des longues plaines, / Infiniment, que bat le vent / A grands coups d'ailes, / Comme les peines éternelles; / Le fou qui veut rester debout, / Avec sa tête jusqu'au bout / Des temps futurs, où Jésus-Christ / Viendra juger l'âme et l'esprit, / Comme il est dit. / Ainsi soit-il."

102. Emile Verhaeren, "L'Ame de la ville," in *Les Villes tentaculaires*, in *Oeuvres* (Geneva: Slatkine Reprints, 1977), 1:111–12: "Et qu'importent les maux et les heures démentes, / . . . / Si quelque jour, . . . / Surgit un nouveau Christ, en lumière sculpté, / Qui soulève vers lui l'humanité / Et la baptise au feu de nouvelles étoiles."

103. Emile Verhaeren, "Le Forgeron," in *Les Villages illusoires* (1894), in *Oeuvres* (Geneva: Slatkine Reprints, 1977), 2:289: "La foule et sa fureur . . . / Fera surgir, avec ses bras impitoyables, / L'Univers neuf de l'utopie insatiable; / Les minutes s'envoleront d'ombre et de sang / Et l'ordre éclora doux, généreux et puissant, / puisqu'il sera, au jour, la pure essence de la vie."

104. In recent scholarship, Susan Canning and Patricia Berman, again, are the only ones who have discussed the broader dimensions of Ensor's religious imagery. But they fail to observe the striking similarities between Ensor's figure of Christ and identical themes in the writers closest to him, such as Demolder, Verhaeren, Picard, Rodenbach, and Destrée. See Canning, "Visionary Politics," 58–69, and Berman, *James Ensor*, 71–90.

1989:Alfredo Jaar, *They Loved It So Much, the Revolution*

22. The Beloved

1. Alfredo Jaar's installation was shown together with works by Dennis Adams, Louis Jammes, and Jeff Wall at the exhibition *Images critiques*, curated by Béatrice Parent, January 14–March 12, 1989. For documentation, see *Adams, Jaar, Jammes, Wall. Images critiques* (Paris: ARC–Musée d'art moderne de la Ville de Paris, 1989); and Jaar, *It Is Difficult: Ten Years* (Barcelona: Actar, 1998), 98–107. My description and interpretation are based on interviews with the artist and documentation he has placed at my disposal, as well as on archival material at ARC–Musée d'Art Moderne de la Ville de Paris.

2. See Marcel Proust, *Remembrance of Things Past*, 3 vols., trans. C. K. Scott Moncrieff and Terence Kilmartin (New York: Vintage, 1982), 2:826. *A la recherche du temps perdu*, ed. Jean-Yves Tadie, 4 vols., Bibliothèque de la Pléiade (Paris: Gallimard, 1988), 3:193.

3. August Strindberg, *August Strindbergs Lilla katekes för underklassen* (Lund: Bakhåll, 2003), 23.

23. The Backside of State

4. At least, this is what Danton says in George Büchner's drama *The Death of Danton* (*Dantons Tod. Ein Drama*, in *Werke und Briefe*, ed. Franz Josef Görtz [Zürich: Diogenes Verlag, 1988], 44). In Jules Michelet's history of the French Revolution, it is the historian himself who utters this phrase as he relates the beginning of the process against Danton (*Histoire de la révolution française*, ed Gérard Walter [Paris: Gallimard, Bibliothèque de la Pléiade, 1952], 2:444). Today, we know that the expression was coined by Pierre-Victurnien Vergniaud, delegate to the National Assembly, who was executed around the same time that Danton was brought to the scaffold. It alludes to the tale of Saturn, who devoured his own offspring.

5. See for instance G. Dreyfus-Armand, *Les Années 68. Le Temps de la contestation* (Paris: Éditions Complexe, 2000); Fredric Jameson, "Periodizing the 60s," in *The Ideologies of Theory, Essays 1971–1986*, vol. 2, *Syntax of History* (Minneapolis: University

of Minnesota Press, 1988), 178–208; and Kjell Östberg, *1968 när allting var i rörelse. Sextiotalsradikaliseringen och de sociala rörelserna* (Stockholm: Prisma, 2002).

6. On the cultural importance of 1968, see Kristin Ross, *May '68 and Its Afterlives* (Chicago: University of Chicago Press, 2002); Östberg, *1968*.

7. Herbert Marcuse, "Repressive Tolerance," in Robert Paul Wolff, Barrington Moore Jr., and Herbert Marcuse, *A Critique of Pure Tolerance* (Boston: Beacon Press, 1965; new ed. 1968), 95–137. Key texts in which Marcuse's concept of repressive tolerance is prepared are *Eros and Civilization: A Philosophical Inquiry Into Freud* (Boston: Beacon Press, 1955, 1966), 78–105; and *One-Dimensional Man: Studies in the Ideology of Advanced Industrial Society* (Boston: Beacon Press, 1964), 1–18.

8. Marcuse, *One-Dimensional Man*, 1.

9. Marcuse, "Repressive Tolerance," 133.

10. Marcuse, *One-Dimensional Man*, 52–53.

11. In Jaar's sketches for the installation at ARC in Paris, he describes his work as a "'reconstitution' of 2 or 3 violent scenes from '68' events" (archive files for the exhibition *Images critiques*, Musée d'Art Moderne de la Ville de Paris).

12. Büchner, *Dantons Tod*, 26.

24. The Empty Throne

13. This is not to claim that artists made no efforts to visually represent the Paris Commune. None of their representations has been canonized by the art institutions, however, nor did any of them conquer the status as an emblematic image of this historical event. See Bertrand Tillier, *La Commune de Paris—révolution sans images? Politique et représentations dans la France républicaine (1871–1914)* (Seyssel: Champ Vallon, 2004).

14. See Dirk Fredriksen, *We Are the People* (Durham, N.C.: Duke University Press, 1993).

15. See Slavoj Zizek, *For They Know Not What They Do: Enjoyment as a Political Factor* (London: Verso, 1991), 267–70.

16. See Michael Novak, *Choosing Our King: Powerful Symbols in Presidential Politics* (New York: MacMillan, 1974), 21.

17. Horst Bredekamp, *Thomas Hobbes visuelle Strategien: Der Leviathan: Urbild des modernen Staates* (Berlin: Akademie, 1999), 56–57.

25. Political Violence

18. Hannah Arendt, *On Revolution* (1963; London: Penguin, 1990), 19–20.

19. The distinction between "politics" and "the political" is based on the discussion within French political theory about the relation of "*le politique*" and "*la politique*." See, for instance, Alain Badiou, *Peut-on penser la politique* (Paris: Seuil, 1985); Claude Lefort, "La Question de la démocratie," in *Le Retrait du politique: Travaux du centre de recherches philosophiques sur le politique* (Paris: Éditions Galilée, 1983), 71–88.

20. For a quick guide to this debate, see the contributions in *Perspektiven der Welt-gesellschaft*, ed. Ulrich Beck (Frankfurt: Suhrkamp, 1998). For a more comprehensive analysis: Manuel Castells, *The Information Age: Economy, Society, and Culture*, 3 vols. (Oxford: Blackwell, 1996–1998), 2:243–353; 3:206–354.

21. See Fredric Jameson, "Notes on Globalization as a Philosophical Issue," in *The Cultures of Globalization*, ed. Fredric Jameson and Masao Miyoshi (Durham, N.C.: Duke University Press, 1998), 54–77; Ulrich Beck, *Was ist Globalisierung? Irrtümer des Globalismus—Antworten auf Globalisierung* (Frankfurt: Suhrkamp, 1997); Zygmunt Bauman, *Globalization: The Human Consequences* (New York: Columbia University Press, 1998).

22. Gilles Deleuze and Félix Guattari, *Anti-Oedipus: Capitalism and Schizophrenia*, trans. Robert Hurley, Mark Seem, and Helen R. Lane (Minneapolis: University of Minnesota Press, 1983); Martha C. Nussbaum, *Love's Knowledge: Essays on Philosophy and Literature* (Oxford: Oxford University Press, 1990); Terence Irwin and Martha Nussbaum, eds., *Virtue, Love, and Form: Essays in Memory of Gregory Vlastos* (Edmonton, Alb.: Academic Printing and Publishing, 1994). On communitarian virtues and passions, see *The Essential Communitarian Reader*, ed. Amitai Etzioni (Lanham, Md.: Rowman and Littlefield, 1998); and Francis Fukuyama, *Trust: Social Virtues and the Creation of Prosperity* (New York: Free Press, 1995). On ethnonationalist passions, see Zizek, *For They Know Not What They Do*; Stanley J. Tambiah, *Leveling Crowds: Ethnonationalist Conflicts and Collective Violence in South Asia* (Berkeley: University of California Press, 1996); and Martin Riesebrodt, *Pious Passion: The Emergence of Modern Fundamentalism in the United States and Iran*, trans. Don Reneu (Berkeley: University of California Press, 1993). Sloterdijk's work is entitled *Die Verachtung der Massen: Versuch über Kulturkämpfe in der modernen Gesellschaft* (Frankfurt: Suhrkamp, 2000).

23. Serge Moscovici, *The Invention of Society: Psychological Explanations for Social Phenomena*, trans. W. D. Halls (Cambridge: Polity Press, 1993), 20–21. Originally published under the title *La Machine à faire des dieux* (Paris: Librairie Arthème Fayard, 1988).

24. Josef Goebbels, *Michael: Ein deutsches Schicksal in Tagebuchblättern* (Munich, 1929), 21. Quoted in Klaus Theweleit, *Male Fantasies*, vol. 2, *Male Bodies: Psychoanalyzing White Terror*, trans. Stephan Conway, Erica Carter, and Chris Turner (Minneapolis: University of Minnesota Press, 1989), 94 (translation modified). Originally published as *Männerphantasien*, vol. 2: *Männerkörper: zur Psychoanalyse des weißen Terrors* (Frankfurt: Roter Stern, 1978), 111.

26. With Nails of Gold

25. See Debra Bricker Balken, *Alfredo Jaar: Lament of the Images* (Cambridge, Mass.: List Visual Arts Center, Massachusetts Institute of Technology, 1999), 32.

26. Quoted in Alfredo Jaar, *Let There Be Light: The Rwanda Project, 1994–1998* (Barcelona: Actar, 1998), unpaginated.

27. Quoted in Ruben Gallo, "Representations of Violence, Violence of Representation," *Trans*, nos. 3/4 (1997): 59.

28. Jaar, *Let There Be Light*.

29. For useful introductions to Jaar's work, see Jan-Erik Lundström, "Alfredo Jaar och De andra," in *Alfredo Jaar* (Stockholm: Moderna Museet, 1994); and the texts by Patricia C. Phillips in Jaar, *It Is Difficult*.

30. On Jaar's *Lament of the Images*, see Jan-Erik Lundström, "Alfredo Jaar: Bilders klagan," *Paletten* 63, nos. 249–250 (2002): 12–18.

31. Alfredo Jaar, "Lament of the Images" (exhibition brochure), Documenta 11, Kassel 2002.

32. Jaar, "Lament of the Images."

33. On Jaar's *1+1+1*, see Jaar, *It Is Difficult*, unpaginated.

34. Tzvetan Todorov, *Alfredo Jaar, 1+1+1* (exhibition catalog), Documenta 8, Kassel (New York, 1987), 14.

35. Alfredo Jaar, "The Mise-en Scène Is Fundamental: A Conversation with Wolfgang Brückle and Rachel Mader," *Camera Austria International*, no. 86 (2004): 47.

36. On Jaar's *Gold in the Morning*, see Madeleine Grynsztejn, "Alfredo Jaar," in *Alfredo Jaar* (La Jolla: San Diego Museum of Contemporary Art, 1990); and Phillips in Jaar, *It Is Difficult*, unpaginated.

37. Derrida's essay is the poststructuralist classic on the ways in which the frames of the art institution and of the individual work of art stabilize both meaning and general opinions on beauty (*La Verité en peinture* [Paris: Flammarion, 1978], 19–168).

38. Discussing this feature of his work, Alfredo Jaar has several times referred to Jean-Luc Godard's statement on the impossibility of placing aesthetic concerns before ethical ones, and vice versa. See, for instance, Anne-Marie Ninacs, "Le Regard responsable: Correspondence avec Alfredo Jaar," in *Le Souci du document: Le mois de la photo à Montreal 1999*, ed. Pierre Blache, Marie-Josée Jean, and Anne-Marie Ninacs (Montreal, Québec: Vox, Centre de diffusion de la photographie; Laval, Québec: Les Editions les 400 coups, 1999), 53–62.

27. Of Men and Beasts

39. Etienne Balibar, *La crainte des masses: Politique et philosophie avant et après Marx* (Paris: Éditions Galilée, 1997), 372.

40. Balibar, *La crainte des masses*, 397–418; and Balibar, *We, the People ofEurope: Reflections on Transnational Citizenship*, trans. James Swenson (Princeton, N.J.: Princeton University Press, 2004).

41. Balibar, "Les frontières de l'Europé," in *La crainte des masses*, 382–384.

42. Louis Althusser, "Ideology and Ideological State Apparatuses (Notes Toward and Investigation)," in *Lenin and Philosophy and Other Essays*, trans. Ben Brewster (New York: Monthly Review Press, 1971), 127–86.

43. Balibar, *La crainte des masses*, 363–64.

28. Desperados

44. Margaret Sundell, "Alfredo Jaar," *Artforum* (January 2003).

45. This is also the title of the book, published by the Museum of Modern Art in Stockholm (2000); see also Phillips, in Jaar, *It Is Difficult*, unpaginated.

29. Autoimmunity

46. For Giorgio Agamben's remarks on the refugee as a guide in the current world order, see, for instance, "Beyond Human Rights," in *Means Without End: Notes on Politics*, trans. Vincenzo Binetti and Cesare Casarino (Minneapolis: University of Minnesota Press, 2000), 15–25; *Homo Sacer*, 126–35.

47. See Giorgio Agamben, *Homo Sacer*; *Means Without End*; *Language and Death: The Place of Negativity*, trans. Karen E. Pinkus with Michael Hardt (Minneapolis: University of Minnesota Press, 1991); *The Coming Community*, trans. Michael Hardt (Minneapolis: University of Minnesota Press, 1993); *Potentialities: Collected Essays in Philosophy*, trans. Daniel Heller-Roazen (Stanford, Calif.: Stanford University Press, 1999); *Remnants of Auschwitz: The Witness and the Archive*, trans. Daniel Heller-Roazen (New York: Zone Books, 1999).

48. Giorgio Agamben, *State of Exception*, trans. Kevin Attell (Chicago: University of Chicago Press, 2005), 3–22.

49. Agamben, *State of Exception*, 21–22.

50. For Agamben's analysis of the notion of the people, see *Homo Sacer*, 176–80; *Means Without End*, 28–34.

51. Jacques Derrida, *Voyous: Deux essais sur la raison* (Paris: Éditions Galilée, 2003), 51–66.

52. Derrida, *Voyous*, 57–58.

53. Derrida, *Voyous*, 53–54.

54. Derrida, *Voyous*, 82.

55. Derrida, *Voyous*, 85–93.

30. Saints

56. Agamben, *Homo Sacer*, 71–86.

57. Magnus Fiskesjö, "Barbarerna, de fredlösa och *homo sacer*," *Res publica*, nos. 62/63 (2004): 107–25.

58. Agamben, *Homo Sacer*, 166–88. This also explains why the third and final part of the multivolume *Homo Sacer* deals almost exclusively with the question of Auschwitz and the possibility of witnessing and experiencing life as it was lived and extinguished in the concentration camp (see *Remnants of Auschwitz*).

59. Agamben, *Homo Sacer*, 126–35; *Means Without End*, 14–25.

60. See also Balibar, "What Is a Politics of the Rights of Man?" in *Masses, Classes,*

Ideas: Studies on Politics and Philosophy Before and After Marx, trans. James Swenson (New York: Routledge, 1994), 205–25.

61. Agamben, *Means Without End*, 131.

62. Agamben, "On Potentiality," in *Potentialities*, 177–84; see also Agamben, *The Coming Community*, 42–43, 104.

63. Agamben, *The Coming Community*, esp. 84–86; *Means Without End*, 108–17, 140–41.

64. Agamben on Tianmen Square: *The Coming Community*, 84–86; *Means Without End*, 85–88.

65. Agamben, *The Coming Community*, 86; *Means Without End*, 88.

31. Complaints

66. Many of these dossiers of complaints have subsequently been published in various contexts and formats. For an accessible selection, see *1789. Les Français ont la parole . . . Cahiers de doléances des États generaux*, ed. Pierre Goubert and Michel Denis (Paris: Éditions Gallimard/Juliard, 1973).

67. Emmanuel Sieyès, *Qu'est-ce que le tiers état?* (Paris: Société de la révolution française; Editions Edme Champion, 1888), 25–55.

68. Michael Hardt and Antonio Negri, *Multitude: War and Democracy in the Age of Empire* (New York: Penguin Press, 2004), 268–73.

69. Pierre Rosanvallon, *Pour une histoire conceptuelle du politique: Leçon inaugurale au College de France faite le jeudi 28 mars 2002* (Paris: Seuil, 2003), 17.

70. See Hardt and Negri, *Multitude*, 97–227; Paolo Virno, *A Grammar of the Multitude: For an Analysis of Contemporary Forms of Life*, trans. Isabella Bertoletti, James Cascaito och Andrea Casson (Los Angeles: Semiotext[e], 2004).

71. On Spinoza's conception of the multitude, see Balibar, *Spinoza et la politique* (Paris: Presses universitaires de France, 1985).

72. Hardt and Negri, *Multitude*, 196–219.

73. On Amir Heidari, see the remarkable interview by Karolina Ramqvist and Per Wirtén in the Swedish periodical *Arena*: Karolina Ramqvist and Per Wirtén: "Är han Sveriges fiende?" *Arena* (Stockholm), no. 6 (2005): 12–17.

74. Ramqvist and Wirtén, "Är han Sveriges fiende?" 17.

32. The Baggage of the Barbarians

75. Alfredo Jaar, unpublished interview with Stefan Jonsson, January 11, 2005.

76. Dany [Daniel] Cohn-Bendit, *Nous l'avons tant aimée, la révolution* (Paris: Editions Bernard Barrault, 1986), 90.

77. Jean-Pierre Duteuil, quoted in Cohn-Bendit, *Nous l'avons tant aimée, la révolution*, 72.

78. Gaby Ceroni, quoted in Cohn-Bendit, *Nous l'avons tant aimée, la révolution*, 95.

79. Joschka Fischer, quoted in Cohn-Bendit, *Nous l'avons tant aimée, la révolution*, 169.

80. Cohn-Bendit, *Nous l'avons tant aimée, la révolution*, 80.

81. Adriana Farranda, quoted in Cohn-Bendit, *Nous l'avons tant aimée, la révolution*, 157.

33. Departure

82. Jacques Rancière, *Short Voyages to the Land of the People*, trans. James B. Swenson (Stanford, Calif.: Stanford University Press, 2003), 1.

83. On Rancière's critique of Althusser's theory, see Donald Reid, introduction to Rancière, *The Nights of Labor: The Worker's Dream in Nineteenth-Century France*, trans. John Drury (Philadelphia: Temple University Press, 1989), xviii–xxiv.

84. Rancière provides the historical and theoretical background to the journal, as well as the explanation of its title, in a recently published selection of articles, *Révoltes logiques: Les Scènes du peuple (Les Révoltes Logiques, 1975/1985)* (Lyon: Horlieu éditions, 2003), 7–18.

85. Arthur Rimbaud, *Complete Works*, trans. Paul Schmidt (New York: Perennial Classics, 2000), 189 [translation modified]; published in French under the title *Oeuvres complètes: Poésie, prose et correspondance*, ed. Pierre Brunel (Paris: Livre de poche, 2001), 498–99.

86. Rancière, *The Nights of Labor: The Worker's Dream in the Nineteenth Century*, trans. John Drury (Atlanta: Temple University Press, 1989). Originally published under the title *La Nuit des prolétaires: Archives du rêve ouvrier* (Paris: Arthème Fayard, 1981).

87. Jacques Rancière, "Dix thèses sur la politique," in *Aux Bords du politique* (1998; Paris: Gallimard, 2004), 231–37.

88. Jacques Rancière, "Le Theâtre du peuple: une histoire interminable," in *Les Scènes du peuple*, 167–201. See also the special issue of the journal *Multitudes*, no. 9 (May–June 2002), where Rancière, in dialogue with Michael Hardt and Antonio Negri, among others, discusses whether the subject of democracy ought to be conceptualized as people (*le peuple*) or as multitude (*la multitude*).

89. See my chapter 9, "The Barricade."

90. Rancière, *Short Voyages to the Land of the People.*

91. Rancière, *The Names of History: On the Poetics of Knowledge*, trans. Hassan Melehy (Minneapolis: University of Minnesota Press, 1994), 42–75, 88–103. Originally published under the title *Les Noms de l'histoire: Essai de poétique du savoir* (Paris: Seuil, 1992), 89–152, 177–208.

92. Jules Michelet, *The People*, trans. John P. McKay (Urbana: University of Illinois Press, 1973), 3. Originally published under the title *Le Peuple* (1846), ed. Lucien Refort (Paris: Marcel Didier, 1946), 3.

93. Michelet, *The People*, 4; *Le Peuple*, 4–5.

94. Michelet, *The People*, 14; *Le Peuple*, 19.

95. On Michelet' life and his philosophy of the people, see Paul Viallaneix, *La Voie royale. Essai sur l'idée de peuple dans l'œuvre de Michelet* (Paris: Librairie Delagrave, 1959), 11–107. See also Rancière, *Short Voyages to the Land of the People*, 69–85.

96. See Rosanvallon, *Le peuple introuvable*, 74–80.

97. Michelet, *Le Peuple*, 273.

98. Michelet, *Histoire de la révolution française*, 1:110.

99. All quotations in the paragraph are from Michelet, *Histoire de la révolution française*, 1:110–11.

100. Michelet, *The People*, 18; *Le Peuple*, 24.

Index

Page references in italics indicate illustrations

bourgeoisie (*continued*)
of the masses, 158; and conditions in Belgium in 1886, 102–3; Delacroix's depiction, 44, *45*; and Ensor, 92, 94; and insurrection of 1832, 44–45; and Paris Commune, 76–77, 97; as representative of the third estate, 42–43, 170; self-understanding of, 44; struggle with working class, 58, 60, 103, 184–85

Brandes, Georg, 103

brotherhood, 165

Brouez, Jules, 102

Brueghel, Pieter, the elder, 91, 94–95, 115

Büchner, Georg, 129, 182, 213n4

Buret, Eugène, 46

Burke, Edmund, 175, 198n22; on democracy, 16–17; and the French preoccupation with numbers, 10, 12–13; and mass psychology, 16; on social classes, 14–16

Cabanis, Pierre, 36

Calerre, Alexandre, 83

Campagnes hallucinées, Les (Verhaeren), 115

Canning, Susan M., 210n73

Carlyle, Thomas, 18–20, 35, 160

carnivals, 88–89, 91–92, 105

Catechism of the People (Defuisseaux), 110

Cathedral, The (Ensor), 92, *93*

Ceroni, Gaby, 179

Chemin, Michel, 180

Chevalier, Louis, 11, 35–36

Children's Games (Brueghel), 95

Christianity, 110–17, 211nn 88, 91

Christ's Entry Into Brussels in 1889 (Ensor), *66–67*, 91, 102, 207n34, 210n73; art historians' interpretations of, 72–73; Benjamin's interpretation, 92, 94; carnival imagery, 89, 105; Christ figure in, 94–95, 112; and collective memory of society at degree zero, 90–92; compared to Rimbaud's work, 99–100; conflicting perspectives in, 85–87, 94–95; and Ensor's view of history, 92, 94–95; features undermining assumptions of mass psychology, 85, 89–90; as fusion of Ensor's personal fantasy narrative and narrative of Belgian history, 107–9; interpretations marked by views from mass psychology, 84–85, 207n35; Marianne image, 90; and political representation, 105; religious message, 110–17; revolutionary nature of, 70–71, 101–6

Clark, T. J., 61, 63

Cohn-Bendit, Daniel, 177–81

collective hallucinations, 78–83

"common, the," Hardt and Negri's concept, 173–74

communism, 131

complaints and grievances, 170–71

Comte, Auguste, 176

conservatism, 175

Contes d'Yperdamme (Demolder), 110–11

Corday, Charlotte, 29

Courts voyages au pays du peuple (Rancière), 182–86

Coyote (Jaar), 152

Crainte des masses, La (Balibar), 155–57

Cries and Whispers (Jaar), 152

criminals: Frégier on, 36–37; *homo sacer*, 167–69; and *misère*, 35–37; modern equivalents of early sociological categories, 158–60; wolfmen and other half-human creatures, 91–92, 167

Crowd, The: A Study of the Popular Mind (Le Bon). *See Psychologie des foules*

crowd consciousness/soul, 79–81, 205n21

crucifixion imagery, 69–70, 167

cultural revolutions, 27, 128

Danton, Georges Jacques, 127

Darwin, Charles, 79

Daudet, Alphonse, 99

David, Jacques-Louis, 21–25, 73, 185, 193, 203n84; *Death of Marat*, 29, *31*; inability to finish *The Tennis Court Oath*, 27–29; motivations of, 21–22; and Napoleon, 32; political responsibilities, 30, 32. *See also Tennis Court Oath, The*

Death of Danton, The (Büchner), 129, 213n4

Death of Marat (David), 29, *31*

de Baecque, Antoine, 22–23

Defuisseaux, Alfred, 110

Deinhard, Hanna, 84

Delacroix, Eugène, 44, *45*, 60

Deleuze, Gilles, 136

Demeny, Paul, 96, 97

democracy: Adams on, 132–33; ambiguity of fundamental concepts, 171–72; autoimmunity (self-protection) of, 162–66; autonomy and self-government, 169; Burke on, 16–17; conflict between liberal parliamentarianism and socialism, 75; democratization in France halted for 1830 and 1848 revolutions, 43; failure of, 168, 172, 192–94; in Flaubert's *Sentimental Education*, 52–56; future of, 169, 172–76, 189, 193–94; Hardt and Negri on, 171–76; historical perspective, 171–76, 180; ideals of, 165; and Jaar's installations, 152–53; and locus of power, 139; Marx on, 208n57; Michelet on, 187–88; and mob rule, 7–8, 16–17; and the nature of the political in modern society, 139; as nemesis of mass psychology, 138; pillars of, 187–88; Rancière on, 184–85; and "repressive tolerance," 128; Rosanvallon on, 171; and Ross's conception of the Paris Commune as a swarm, 97–98; and social movements of 1968, 127–28, 178–79; Spinoza on, 173; and states of emergency,

162–65; and symbolism, 132–33; Tocqueville on, 16; and velvet revolutions, 138; and violence, 139–40, 180. *See also* exclusion of elements of society; political representation; political rights; popular sovereignty

Democracy in America (Tocqueville), 16

demography, 8, 9–13

Demolder, Eugène, 72, 110–11, 211n88

de Poncheville, Mabille, 107

de Ridder, André, 88

Derrida, Jacques, 153, 164–65, 172, 175

Desmoulins, Camille, 134

Destrée, Jules, 106, 112

Doctrinal Nourishment (Ensor), 103

Draguet, Michel, 85, 108, 212n91

Durkheim, Emile, 80, 176

Duteuil, Jean-Pierre, 179

education, 40–41

Emerita, Gutete, *143*, 143–44, *145*

Enlightenment, 40–41

Ensor, James, 185, 193, 210n73; and Agamben's *homo sacer*, 167; *The Alive and Radiant. The Entry Into Jerusalem*, 112, *113*; background of, 88–89; and carnival imagery, 88–89; *The Cathedral*, 92, *93*; and Christianity, 110–17, 211nn 88, 91; *Christ's Entry* as greatest achievement, 70–71; and collective memory of society at degree zero, 90–92; compared to Rimbaud, 99–100; contrast to Le Bon, 89–90; and crucifixion, 69–70; cultural environment, 110; and Demolder, 110–11, 211nn 88, 91; enigma of short career, 107–9; group portraits, 86, *87*; and human identity, 87–88; later life, 108–9; and madness, 69–70, 72, 90–91, 107; and the "modern breakthrough," 101–6; personal narrative fantasy, 107–9; and Picard, 211nn90, 91; *La Plume* article on, 72; use of

Ensor, James (*continued*)
masks, 86–88; Verhaeren on, 101;
view of "the masses," 89–90. *See also*
Christ's Entry Into Brussels in 1889
European Union, 168, 170–71
Evans, Walker, 160
exclusion of elements of society: and au-
toimmunity (self-protection) of de-
mocracy, 165–66; and "average man"
concept, 12; and biopolitics, 164; and
conditions in Belgium in 1886, 102–3;
criteria for qualification for politi-
cal rights, 40–41; dangers of giving
"the passions" political influence, 41,
137–38; and democracy's boundary
setting through violence, 139–40; four
categories of outcasts, 158–61; "Great
Internment" of undesirable elements,
82–83; and *homo sacer*, 167–69; and
Jaar's installations, 146–54; two types
of banishment, 58; working class
excluded from "society" in Frégier's
terminology, 37
Eyes of Gutete Emerita, The (Jaar), *143,*
143–44, 145

Falkenhausen, Susanne, 32
Farranda, Adriana, 181
fascism, 138, 192
February Revolution of 1848 (France),
43, 46–47, 52–53, 74
Fire Next Time, The (Baldwin), 178
Fischer, Joschka, 179
Fiskesjö, Magnus, 167
Flaubert, Gustave: on history, 54–55; and
individualism, 58; on insurrection
of June 1848, 52–56; the masses as
aesthetic object, 55–56; on numbers,
13; on Paris Commune, 76; on "the
people," 54–55
Foucault, Michel, 82–83, 135, 163
fourth estate, 74
Fraenger, Wilhelm, 70

frames: boundaries and identity, 157; and
Jaar's installations, 148–54, 160; and
The Tennis Court Oath, 203n84
France: constitution of 1831, 40; fourth
estate, 74; "Great Internment" of un-
desirable elements of society, 82–83;
insurrection of 1832, 44; insurrection
of June 1848, 46–56, 61, 62, 63, 74;
Marianne icon, 32, 44, 60; restora-
tion period, 33–41, 43; revolution of
February 1848, 43, 46–47, 52–53, 74;
revolution of July 1830, 43, 44, *45;*
revolution of May 1968, 123, 127–28,
177–81; "The Sixty's Manifesto"
(1864), 74; struggle between the
working class and the bourgeoisie, 58,
60; third estate, 11, 42–43, 74, 170. *See*
also bourgeoisie; French Revolution;
"masses, the"; Paris; Paris Commune;
working classes
Frégier, Honoré-Antoine, 36–37
French Revolution: beginning of, 5, 170;
Burke on, 14–17; Carlyle on, 18–20;
causes of, 13; death of Louis XVI,
28; death of Marat, 29, *31;* disuniting
of the assembly, 28–29; Hugo on,
38–39; Michelet on, 186–89; and mob
rule, 7–8, 16–17; preoccupation with
numbers, 10–13, 63; "the revolution
devours its children" statement, 127;
and social chaos/violence, 14–17,
19–20; the Terror, 28; third estate, 11,
42–43, 74, 170; and urbanization, 13.
See also Tennis Court Oath, The
French Revolution, The (Carlyle), 18–20
Freud, Sigmund, 79
Fridolin and Gragapança of Yperdamme
(Ensor), 110

Gall, Franz Joseph, 36
Gates, Bill, 146
G8, 170–71
Gendarmes, The (Ensor), 103

Genoux, Gaude, 182
George, Waldemar, 85
Germany, interwar period, 192–93
Germinal (Zola), 60
Girardin, Saint-Marc, 45
"global governance," 172–73
globalization, 136, 159, 172
Godard, Jean-Luc, 148
Goebbels, Joseph, 138
Gold in the Morning (Jaar), 150, *151*, 152, *153*
Good Judges, The (Ensor), 86
Green, André, 156
Guattari, Felix, 136

half-human creatures, 91–92, 167
hallucinations, collective, 78–83
Hamilton, Georg Heard, 84
Hardt, Michael, 170–76
Hardy, Thomas, 9
hate-speech, 63
Havel, Václav, 131
Hegel, G. W. F., 19, 176
Heine, Heinrich, 188
history: Carlyle's view, 19–20; and democracy, 171–76, 180; Ensor's view, 92, 94–95; Flaubert's view, 54–55; Hegel's view, 19; Hugo's view, 38–39; meanings of historical events, 124; and modern equivalents of early sociological categories, 159; "the political" vs. "politics," 135; Roseanvallon's view, 171. *See also* Burke, Edmund
History of the Thirteen, The (Balzac), 34
Hitler, Adolf, 82
Hobbes, Thomas, 92, 133, 134, 202n52
homeless population, 36, 37, 57, 82, 158–59
homme moyen, 11–12, 175
Homo Sacer (Agamben), 167–69, 217n58
Horta, Victor, 112
Hugo, Victor, 6, 33–41, 45, 172–73, 185, 186; choice of title for *Les Misérables*,

37; philosophy of history, 38–39; view of "the masses," 38–39; on violence, 38–39; on working classes and insurrection of June 1848, 46–51
human rights, 168
Hundred Times Nguyen, A (Jaar), 160, *161*
hypnosis, 80–81

Ibsen, Henrik, 79
idées reçues, 54
identity: and boundaries, 155–57; and democracy, 163; and ideology, 156–57; individual's membership in multiple communities, 157
ideology, 156–57
"I is an other" statement (Rimbaud), 96, 97, 98
individualism: and Ensor, 70; and Flaubert, 58; Rimbaud's "I is an other" statement, 96, 97, 98; Tocqueville on, 16
insurrection of 1832 (France), 44
insurrection of June 1848 (France), 46–56, 74; *The Barricade* (Meissonier), 61, *62*, 63; Flaubert on, 52–56; Hugo on, 46–51
International Monetary Fund, 171
Intrigue, The (Ensor), 86, *87*
Iraq War, 156

Jaar, Alfredo, 141–54, 160, 185, 193, 216n38; background of, 144, 146; *Coyote*, 152; *Cries and Whispers*, 152; and democracy's debt to political violence, 140; exploration of frames, 148–54; and four categories of outcasts, 159–61; *Gold in the Morning*, 150, *151*, 152, *153*; *A Hundred Times Nguyen*, 160–61, *161*; inspiration for titles, 147–48; *Lament of the Images*, 146–47, *147*; lighting of exhibitions, 152; and mechanisms of marginalization, 146–54; *Out of Balance*, 152;

158; categories from the natural sciences, 206n24; changing meaning of word, 8, 12–13, 16–17, 44, 63, 199n24; and democratic sovereignty, 21–25; demographic/numerical meaning, 8–13; depiction of masses in times of stability, 27; distinction between the people and the masses, 57–58; as enemy of the well-ordered state, 138; Ensor's view of, 89–90; as entity ruled by passions, 17, 41, 84, 137–38; and interwar period, 192–93; leadership of, 81–82, 138, 205n22; Le Bon's idea of a crowd soul, 79–81, 205n21; and the man in the crowd, 12; as *les misérables*, 8, 33–41, 45, 63; mob rule as the shadow of democracy, 7–8; modern equivalents of early sociological categories, 158–61; as organized labor, 8, 63, 74–76; as pathological elements, 8, 70, 78–83; as seedbed for prejudices and stereotypes, 54; and social chaos/violence, 14–17, 38–39, 84, 127, 206n24; as "swinish multitude," 14–17; as theme rather than fact, 191; upper-class fears of, 75–77; in Verhaeren's epic poems, 115–16. *See also* exclusion of elements of society; "people, the"; political rights; revolutions; working classes; *specific artists and writers*

mass media, 157–59

"mass ornament," 55

mass psychology, 78–93; and Burke, 16; and *Christ's Entry Into Brussels in 1889*, 84–85, 89–90, 207n35; democracy as nemesis of, 138; and fascism, 138; hypnosis, 80–81; and Le Bon, 78–83, 205n21; and masks, 87; "the masses" associated with mass insanity, 8, 78–83, 107, 205n21; mental contagion, 80; microdynamics of interpersonal interactions, 136–37;

and "the passions," 137–38; and social chaos/violence, 84; and Sorel, 87; and strong leaders, 81–82; suggestibility, 80–81

McGough, Stephen, 84–85

Meissonier, Ernest, 61, 62, 63, 144

mental contagion, 80

Michelet, Jules, 34, 44, 45, 182, 186–89, 213n4

migration, 174–75. *See also* refugees

misérables, les, 8, 33–41, 45, 63; and Jaar's installations, 160; modern equivalents of, 158–60

Misérables, Les (Hugo), 34–41, 185

misère, la, 35–37, 40–41

mob rule, 7–8, 15

"modern breakthrough," 101–6, 111

"moral arithmetic," 11

Moscovici, Serge, 136, 206n27

"multitude, the," 173

Multitude (Hardt and Negri), 170–71

Musisi, Benjamin, 141–42

Mussolini, Benito, 82

Muther, Richard, 103

Mystères de Paris, Les (Sue), 34, 45, 186

Napoleon Bonaparte, 32, 39

Napoleon Bonaparte III, 43

Nass, Lucien, 83

nation-states: and autoimmunity (self-protection) of democracy, 166; and changing meaning of "society," 135–36; and "the political" vs. "politics," 135; totalitarian states, 133–34, 162

Nazis, 163, 168

Negri, Antonio, 170–76

Nietzsche, Friedrich, 69, 117

nigger, and Paris Commune, 99

Noms de l'histoire, Les (Rancière), 186

Nous l'avons tant aimée, la révolution (Cohn-Bendit), 177–78

Nuit des prolétaires, La (Rancière), 184

numbers, preoccupation with, 10–13, 63

Rancière, Jacques, 182–86, 188–89
reality, perceptions of, 148–54
Real Pictures (Jaar), 141–43, *142*, 152
Reclus, Elisée, 101
Reflections on the Revolution in France
 (Burke), 14–17
refugees, 156, 158–61, 162–64, 174–75
religion, 110–17
Remnants of Auschwitz (Agamben), 168,
 217n58
representation systems. *See* political
 representation
"repressive tolerance," 128
republicanism, 53
Reuterswärd, Patrik, 84
Révoltes Logiques (periodical), 183–84
revolution of February 1848 (France), 43,
 46–47, 52–53, 74
revolution of July 1830 (France), 43, 44,
 45
revolution of May 1968 (France), 123,
 127–28, 177–81
revolutions: crises of legitimacy and
 crises of representation, 26; cultural
 revolutions, 27, 128; and legitimate
 vs. criminal political violence, 38–39,
 124–26; and meanings of histori-
 cal events, 124; natural succession
 of rebellions, 129; perception of the
 "end" of history, 180–81; revolution
 devoured by its children, 128; "the
 revolution devours its children" state-
 ment, 127; social movements of 1968,
 127–28; Strindberg on "legality" of,
 124–25. *See also* insurrection of 1832;
 insurrection of June 1848; *specific
 revolutions*
revolutions of 1989, 134, 138, 169
Rilke, Rainer Maria, 182, 186
Rimbaud, Arthur, 96–100, 183–84
Robespierre, Maximilien-Marie-Isadore
 de, 22
Rodenbach, Georges, 112

Roman Empire, 83
Romania, 131
Roosevelt, Theodore, 82
Rosanvallon, Pierre, 23, 74, 171, 175
Ross, Kristin, 97–98
Rossellini, Roberto, 182
Roy, Arundhati, 173
Ruttman, Walther, 55
Rwanda installations of Alfredo Jaar,
 141–44

Sand, George, 54
Sansculottism, 19–20, 35
Schmitt, Carl, 135
Season in Hell, A (Rimbaud), 99
Séginger, Gisèle, 54
Sentimental Education (Flaubert), 52–56
Shiva, Vandana, 173
Sieyès, Emmanuel Joseph, 11, 15, 42–43,
 74, 170
Signac, Paul, 112, *114*
Simmel, Georg, 176
"Sixty's Manifesto, The" (1864), 74–75
Sloterdijk, Peter, 136, 206n24
social class: aristocracy and royal court
 as many-headed hydra, 22–23; Burke
 on, 14–16; and conditions in Belgium
 in 1886, 100–106; "dangerous classes,"
 35–37; early explanations for, 36–37;
 fourth estate, 74; and history of
 distinction between the passions and
 reason, 202n52; and political radi-
 calization of the avant-garde, 102–3;
 third estate, 11, 42–43, 74, 170. *See also*
 bourgeoisie; exclusion of elements
 of society; *misérables, les*; working
 classes
social contract, 40–41
socialism, 75, 111–12
society: boundaries of, 155–57, 178–79;
 changing meaning of, 135–40; and
 early sociology, 176; and explanations
 for collective behavior, 136–37; and

Weininger, Otto, 79
What Is the Third Estate? (Sieyès), 11, 42–43
Wiertz, Antoine, 112, *114*
wolfman image, 91, 167
Wollstonecraft, Mary, 14
women's suffrage, 17
Wordsworth, William, 182, 185
working classes: bourgeoisie attitude toward, 46, 107, 138; as "dangerous class," 35–37; Delacroix's depiction, 44, *45*; excluded from political rights, 41, 57; excluded from "society" in Frégier's terminology, 37; and insurrection of 1832, 44–45; and insurrection of June 1848, 46–56, 61, *62, 63*; "the masses" as organized labor, 8, 63, 74–76; and political radicalization of the avant-garde, 103; struggle with bourgeoisie, 58, 60, 103, 184–85; and urbanization, 13; secession of, 74. *See also* labor movements; Paris Commune; revolution of May 1968
World Bank, 170–71
World Social Forum, 159
World Trade Organization, 170–71
World War I, 192–93

Zola, Émile, 60, 79